The Circulation of Elite
LONGQUAN CELADON CERAMICS
from China to Japan

To
my Husband and Son

The Circulation of Elite
LONGQUAN CELADON CERAMICS
from China to Japan

An Interdisciplinary and Cross-Cultural Study

Meili Yang

sussex
ACADEMIC
PRESS
Brighton • Portland • Toronto

Copyright © Meili Yang, 2018.

The right of Meili Yang to be identified as Author of this work has been asserted in accordance with the Copyright, Designs and Patents Act 1988.

2 4 6 8 10 9 7 5 3 1

First published in 2018 in Great Britain by
SUSSEX ACADEMIC PRESS
P.O. Box 139
Eastbourne BN24 9BP

Distributed in North America by
SUSSEX ACADEMIC PRESS
ISBS Publisher Services
920 NE 58th Ave #300, Portland, OR 97213, USA

All rights reserved. Except for the quotation of short passages for the purposes of criticism and review, no part of this publication may be reproduced, stored in a retrieval system or transmitted in any form or by any means, electronic, mechanical, photocopying, recording or otherwise, without the prior permission of the publisher.

British Library Cataloguing in Publication Data
A CIP catalogue record for this book is available from the British Library.

Library of Congress Cataloging-in-Publication Data
Names: Yang, Meili, author.
Title: The circulation of elite Longquan celadon ceramics from China to Japan: an interdisciplinary and cross-cultural study / Meili Yang.
Description: Portland, OR : Sussex Academic Press, 2018. | Includes bibliographical references and index
Identifiers: LCCN 2018015964 | ISBN 9781845199326 (hbk : alk. paper)
Subjects: LCSH: Longquan ware. | Art and society—China—History—Song dynasty, 960–1279. | Art and society—China—History—Yuan dynasty, 1260–1368. | China—Commerce—Japan. | Japan—Commerce—China.
Classification: LCC NK4340.C44 Y355 2018 | DDC 701/.03–dc23
LC record available at https://lccn.loc.gov/2018015964

MIX
Paper from
responsible sources
FSC
www.fsc.org
FSC® C013056

Typeset and designed by Sussex Academic Press, Brighton & Eastbourne
Printed by TJ International, Padstow, Cornwall

Contents

List of Illustrations — vii
Acknowledgments — xv

Preface — xvii

Part I: Elite Longquan Celadon in China's Song and Yuan — 1

1 From Popular to Elite Art: Worshiping Objects' Evolution — 3
2 Technological Particularity: As an Elite Commercial Ceramic — 21
3 Marketing and Market Value: Hoards in Eastern Sichuan — 33
4 Single-Generation Technology: SSG-style Elite Products — 47
5 Production Center Shift: Local Ecological Environment — 59
6 Behind Style Change: A Contemporary Social Atmosphere — 71

Part II: Elite Longquan Celadon in Japan's Medieval Age — 83

7 Kamakura Period: Choice of Elite Longquan Celadon — 85
8 Muromachi and Sengoku Periods: SSG-style and *Kinuta* — 101
9 Edo Period: Elite Longquan Celadon Survivals — 123
10 From China to Japan: A Cross-Cultural Transmission Case — 137

Appendix: Samples and Analytical Data — 151

Bibliography — 201
Chronology of China and Japan — 219
Index — 221

List of Illustrations

Cover illustrations. Front – Longquan celadon wine jar, 14th century. Idemitsu Museum of Arts. Back – Mallet-shaped vase with phoenix décor, 13th century. Yomei Bunko; Incense burner with applied peony scroll design, 13th–14th century. Nezu Museum.

The color plate section is presented after page 62. Captions and sources are in situ on the plate pages.

CHAPTER 1

1a, 1b and 1c.	Five tube barn jar, wine vase and pot. Longquan Celadon Museum (After Zhu 1998, Pls. 36, 37, 38).
2.	Seven tube barn jar unearthed from Wang Zhijin's tomb in Chatian, Longquan. Longquan Celadon Museum (After Zhu 1998, Pl. 41).
3a and 3b.	Five tube barn jar and vase, 1078, unearthed from Tashi, Longquan. Longquan Celadon Museum (After Zhejiang Provincial Museum 2000, Pls. 201, 202).
4.	Five tube barn jar with writing in ink on the interior of cover, 1070, unearthed from a tomb at Lanju, Longquan. Longquan Celadon Museum (After Zhejiang Provincial Museum 2000, Pl. 200).
5.	Five tube barn jar with writing in ink on the interior of cover. Longquan Celadon Museum (After Zhu 1998, Pl. 56).
6.	#4 and 5 are two jars (Figures 6a and 6b) placed close to the tomb host's head; #1 and 2 are a incense burner and bowl, prepared on worshiping platform close to the tomb door (Figures 6c and 6d) (After HPIACR 2013, 9).
6a and 6b.	Two jars (After HPIACR 2013, Pls. 120, 112).
6c and 6d.	An incense burner and bowl (After HPIACR 2013, Pls. 124, 126).
7.	*Long-hu-pin* vase unearthed from Chatian, Longquan. Longquan Celadon Museum (After Zhu 1998, Pl. 99).
8.	Song tomb wall painting on the rear wall, Youxi, Fujian province today, a dog and chicken figures accompanied the tomb host (After Fujian Provincial Museum and Youxi County Museum 1991, 347).
9.	A pair of Jingdezhen Qingbai porcelain *long-hu-pin* jars, 1118 (After Yang 1992, Pl. 4–3).

10.	A *long-hu-pin* jar unearthed from Wuyi, 1083. Wuyi County Musuem (After Zhejiang Provincial Museum 2000, Pl. 203).
11.	A *meipin* vase unearthed from Chen Daya's tomb in Songyang, 1195. Songyang County Museum (After Zhejiang Provincial Museum 2000, Pl. 210).
12.	A Song tomb wall painting found in Anyang, Henan, 1077 (After Su 1957, 20).
13a.	A vase collected by Longquan Museum with writing in ink on the bottom exterior, stating this vase was Mr. Wu Sange's worshiping object (After Zhu 1998, Pl. 70).
13b.	A vase with same design and form unearthed from Dayao kiln site, Longquan (After Zhu 1989, 52).
14.	A SSG vase unearthed from Laohudong kiln site, Hangzhou, one of SS imperial kilns, early SS (After Tang 2004, 179).
15a.	A vase unearthed from Dayao kiln site, Longquan, dated early SS (After Zhu 1989, 52).
15b.	A vase with same form unearthed from Suichang, Longquan (After Zhu 1998, Pl. 86).
16a.	A *long-hu-pin* vase collected by Shanghai Museum, middle or late SS (After Zhu 1998, Pl. 102).
16b.	A *long-hu-pin* vase collected by Longquna Celadon Museum, middle or late SS (After Zhu 1998, Pl. 105).
17.	A SSG-style elite Longquan celadon *long-hu-pin* vase collected by V&A Museum, late SS. V&A Museum, C.28–1935.
18a.	A SSG-style Longquan celadon *long-hu-pin* vase with tiger and bird décor unearthed from Longquan, middle or late SS. Longquan Celadon Museum (After Zhu 1998, Pl. 104).
18b.	An identical *long-hu-pin* vase with dragon and dog décor unearthed from Longquan. Longquan Celadon Museum (After Zhu 1998, Pl. 103).
19a.	A SSG-style elite Longquan celadon mallet-shaped vase with a pair of phoenix décor unearthed from Songyang. Songyang County Museum (After Zhu 1998, Pl. 115).
19b.	A SSG-style elite Longquan celadon mallet-shaped vase with a pair of fish décor unearthed from Songyang. Songyang County Museum (After Zhu 1998, Pl. 116).
20a and 20b.	A *meipin* vase and jar unearthed from Hu Hong and his wife's tomb, 1203 (After ZPICRA and Commission for Preservation of Ancient Monuments, Qingquan County 2015, cover photos).
21.	A SSG-style Longquan celadon incense burner unearthed from Wu Ao's tomb, 1268. Deqing County Museum (After Zhu 1998, Pl. 122).
22a and 22b.	A SSG-style Longquan celadon jar and box unearthed from Li Hou wife's tomb in Longquan, 1222. Lishui City Musuem (After Zhang 2008, Pls. 183, 184).

List of Illustrations | ix

CHAPTER 2

1.	*Fen-qing* SSG vase. National Palace Museum, Taipei.
2a and 2b.	*Fen-qing* and *meizi-qing* SSG-style Longquan celadon vase and incense burner. Suining City Museum, Kyoto National Museum (After Asahi Shimbun 1998, Pl. 5; Mori et al. 2012, Pl. 39).
3a.	Type I glaze's phase structure in OCT image, Dayao-6. (The upper arrow points to the interface between two layers of glaze, and the lower arrow points to the interface between glaze and body.)
3b.	Guan-1 glaze's phase structure in OCT image with a crack line (white circle).
4a.	Type II glaze's phase structure in OCT image, Dayao-1. (The upper arrow points to the interface between two layers of glaze, and the lower arrow points to the interface between glaze and body.)
4b.	Aotou-1 glaze's phase structure in OCT image.
5a.	Dayao-6 body's microstructure in SEM image. (Light gray particles are quartz (Q), and dark gray or black in various shapes are pores (P)).
5b.	Guan-1 body's microstructure in SEM image.
6a.	Dayao-1 body's microstructure in SEM image.
6b.	Dayao-9 body's microstructure in SEM image.
7.	The cross-section of Dayao-6 sample displays white-edge on exterior of body (red arrow).
8a.	Mullite crystallization phase (M) in Dayao-1 body in SEM image.
8b.	Anorthite crystallization phase (A) in Aotou-1 glaze close to the interface between glaze and body.

CHAPTER 3

1.	Ceramic hoards were arranged in a space-saving manner (After CICRA and SMM 2012, 8).
2a.	Pie chart of Suining ceramic hoards.
2b.	Pie chart of Dongxi ceramic hoards.
2c.	Pie chart of Lüeyang ceramic hoards.
2d.	Pie chart of Langzhon ceramic hoards.
3a.	Histogram of ceramic hoard items in Suining.
3b.	Histogram of ceramic hoard items in Dongxi.
4a and 4b.	Bowl with lotus petals design, and cup with cover and lotus petals design. Suining City Museum (After Asahi Shimbun 1998, Pls. 50 and 60).
5a.	Longquan celadon *li*-shaped incense burner. Suining City Museum (After Asahi Shimbun 1998, Pl. 22).
5b.	A contemporary archaic bronze (After CICRA and Pengzhou Municipal Musem 2009, 61).
6a.	Archaic bronze *cong* (After CICRA and Pengzhou Municipal Musem 2009, 61).
6b.	Archaic stone *cong*. Suining City Museum (After Asahi Shimbun 1998, Pl. 135).
6c.	Longquan celadon *cong*-shaped vase. Suining City Museum (After Asahi Shimbun 1998, Pl. 7).

x | List of Illustrations

7a. Mallet-shaped vase with phoenix décor, Songyang County Museum (After Zhu 1998, Pl. 115)
7b. Mallet-shaped vase with fish décor, found in Sinan wreck. National Museum of Korea (After Shen 2012, 144).
8. Bottle-shaped Longquan vase. Suining City Museum (After Asahi Shimbun 1998, Pl. 5).

CHAPTER 4

1a and 1b. Five tube barn jar with dragon or tiger décor, the first-generation SSG-style Longquan celadon products, found in Suichang, Longquan, height of 24 cm, and 25.3 cm, respectively, middle-late SS (After Zhu 1998, Pls. 100 and 101).
2a and 2b. *Fen-qing* and *meizi-qing* SSG-style Longquan celadon vase with five spouts (tubes), height of 12.3 cm, and 12.4 cm, respectively, the second-generation products, late SS. Suining City Museum (After Asahi Shimbun 1998, Pls. 18 and 20).
3a and 3b. Third-generation elite Longquan celadon products, *li*-shaped incense burner, height of 8.2 cm; melon-shaped ewer, height of 6.3 cm, early Yuan. National Museum of Korea (After Shen 2012, 77 and 107).
4a and 4b. Longquan celadon products excavated from Jininglu hoard site, Inner Mongolia, height of 9.4 cm, and 25.5 cm, respectively, Yuan (After IMICRA 2004, Pls. 60 and 61).
5a and 5b. Biscuit plates and testers (After HPICRA 2008, color Pls. 46 and 48).
6a. A waste U-shaped saggar loaded around five or more vases unearthed from Xikou kiln site, Longquan (After Jin 1962, Pl. 9–10).
6b. A triple-adjoined mallet-shaped vase with fish décor was collected by H. M. King Gustaf VI Adolf of Sweden, height of 16.5 cm. Őstasiatiska Museet, Stockholm, OM-1974-0994 (image courtesy of Őstasiatiska Museet).

CHAPTER 5

1a. Early SS dish with flower design and combing pattern.
1b. Middle SS bowl with design on interior only.
1c. Late SS bowl with engraved lotus petals on exterior (After Zhu 1989, 51–53).
2a and 2b. A *meizi-qing* (or *fen-qing*) SSG-style elite Longquan celadon bowl found in Dayao kiln site, same to the bowl from Suining hoard site, late SS. Longquan Celadon Museum, Suining City Museum (After Zhu 1998, Pl. 134; Asahi Shimbun 1998, Pl. 49).
3a and 3b. Incense burner and bowl fragments unearthed from the eastern area, SS (After ZPICRA 2005, color Pls. 48–6 and 8–5).
4a and 4b. Stamping design and mold forming dish fragments unearthed from the eastern area, Yuan (After ZPICRA 2005, color Pls. 36–5 and 37–1).
5a and 5b. Signatures on the exterior bottom center of a bowl and cup (After Sun and Zhen 1986, 126).

List of Illustrations | xi

5c.	Phags-pa script on a large-sized dish fragment (After Sun and Zhen 1986, 129).
6.	Longquan celadon production volume variations per year in SS and Yuan.
7a and 7b.	Elite Longquan celadon fragments in the early Yuan style unearthed from Fengdongyan kiln site. Longquan Celadon Museum (After Mori et al. 2012, Pls. 125 and 128).

CHAPTER 6

1.	SSG-style vases. Suining City Museum (After Asahi Shimbun 1998, Pl. 3); Kuboso Memorial Museum of Arts, Izumi (After Curatorial Division, Nezu Museum 2010, Pl. 18).
2.	Early Yuan-style jar and vase. National Museum of Korea (After Shen 2012, 243 and 138).
3.	Early Ming-style jar and vase. Longquan Celadon Museum (After Mori et al. 2012, Pl. 170); Tokyo National Museum (TNM Image Archives).
4a and 4b.	An early Yuan-style Longquan celadon vase, height: 33.3 cm, and an early Yuan-style Jingdezhen Qingbai porcelain vase, height: 22 cm, unearthed from Sinan wreck. National Museum of Korea (After Shen 2012, 95 and 94).
5a and 5b.	Early Yuan-style Longquan celadon vase and incense burner found in Xian Yushu tomb. Hangzhou Museum (After Zhejiang Provincial Museum 2000, Pls. 221 and 222).
6a and 6b.	Alleged Ge ware. National Palace Museum, Taipei; Palace Museum (After Palace Museum 1998, Pl. 11).

CHAPTER 7

1a and 1b.	SSG-style Longquan celadon fragments unearthed from Ningpo dock site. Zhejiang Provincial Institute of Cultural Relics and Archaeology (After Lin 1981, Pls.11–5 and 11–8).
2a, 2b and 2c.	SSG-style bottle vase, early Yuan-style incense burner and wine jar found in Sinan wreck. National Museum of Korea (After Shen 2012, 150, 77 and 219).
3a and 3b.	One of three SSG-style Longquan celadon bowls with carved lotus petal design and with writing in ink on the interior of this bowl, dated 1265, unearthed from Hakata harbor site. Fukuoka City Archaeological Center (After Curatorial Division, Nezu Museum 2010, Pl. 67).
4a and 4b.	Imported elite Longquan celadon products unearthed from Hakata harbor city site. Fukuoka City Archaeological Center (After Tanaka and Satō 2008, 120; Curatorial Division, Nezu Museum 2010, Pl. 66).
5a and 5b.	Imported elite Longquan celadon teaware and tableware unearthed from samurai homes site in Kamakura town. Kamakura City Board of Education (After Curatorial Division, Nezu Museum 2010, Pls. 77 and 79).

CHAPTER 8

1, 1a and 1b.	Several elite Longquan celadon objects used in Zashiki living room and kitchen. Hongan-ji temple (After Shibudō and Kokuritsu Bunkazai Kikō 1981).
2.	Two flower pots placed on outside wooden shelf. Hongan-ji temple (After Shibudō and Kokuritsu Bunkazai Kikō 1981).
3a and 3b.	Two flower pots (or tripod censers) similar to Figure 2 pots unearthed from Sinan wreck, early Yuan-style Longquan celadon products. National Museum of Korea (After Shen 2012, 84 and 156).
4 and 4a.	Zen room scene, a set of Mitsugusoku: a celadon incense burner, celadon flower vase and bronze candle stand. Hongan-ji temple (After Shibudō and Kokuritsu Bunkazai Kikō 1981).
5 and 5a.	Zen room scene, a set of Mitsugusoku: a celadon incense burner, celadon flower vase and bronze candle stand. Hongan-ji temple (After Shibudō and Kokuritsu Bunkazai Kikō 1981).
6.	A drawing of mallet-shaped flower vase in *Okazarisho* (After Yano 2000, 108).
7.	Elite Longquan celadon tea bowls with carved lotus petals design painted in '*Kanpūzu Byōbu (觀楓図屏風)* Maple-viewing painting' (red circles). Tokyo National Museum (TNM Image Archives).
8a.	Longquan celadon incense burners unearthed from Ichijōdani Asakura family's castle. Ichijōdani Asakura Family Site Museum (photograph courtesy of Ichijōdani Asakura Family Site Museum).
8b.	Some early Ming-style Longquan celadon objects unearthed from a medical house site. Ichijōdani Asakura Family Site Museum (After Fukuiken [et al.] 2017).
8c and 8d.	A flower vase and incense burner unearthed from Nishiyam Kōshōji temple site. Ichijōdani Asakura Family Site Museum (After Fukuiken [et al.] 2017).
8e.	A restored SSG-style elite Longquan celadon mallet-shaped vase with fish décor. Ichijōdani Asakura Family Site Museum (After Fukuiken [et al.] 2017).
9 and 9a.	A batch of Longquan celadon fragments unearthed from Kusado Sengen-chō ruins. SS fragments are displayed on upper row, with several Yuan-style fragments in middle section, and a considerable amount of Ming-style fragments on the bottom of the exhibit panel. Hiroshima Prefectural Museum of History (photographs courtesy of Hiroshima Prefectural Museum of History).
9b.	A couple of fragments, belonging to a Yuan-style Longquan celadon flower vase, unearthed from Kusado Sengen-chō ruins, identical to Figure 10 vase.
10.	An intact flower vase found in Sinan wreck. National Museum of Korea (After Shen 2012, 140).
11.	Two fragments of mallet-shaped vase with phoenix décor found in Ryōsen-ji ruins. Saga Prefecture Board of Education (After Nishida 2010, 16).
12.	A batch of SSG-style elite Longquan celadon objects and fragments

List of Illustrations | xiii

	unearthed from downtown Kyoto. Kyoto City Archaeological Museum (After Curatorial Division, Nezu Museum 2010, Pl. 80).
13.	A batch of SSG-style elite Longquan celadon fragments unearthed from Toyama, Kaga and Daishōji Domains prefecture sites in Tokyo. Archaeological Research Unit, The University of Tokyo (After Curatorial Division, Nezu Museum 2010, Pl. 81).
14.	At least five types of flower vases mentioned in this drawing with notes, all SSG-style elite Longquan celadon branded products, 1554 (After Nishida 2010, 15).

CHAPTER 9

1.	Elite class members' collections during Edo period.
1a.	Yomei Bunko (After Curatorial Division, Nezu Museum 2010, Pl. 17).
1b and 1c.	The Tokugawa Art Museum (The Tokugawa Art Museum © The Tokugawa Art Museum Image Archives / DNPartcom).
2.	Zaibatsus and tea ceremony performers' collections.
2a and 2c.	Mitsui Memorial Museum, Fujita Museum (After Curatorial Division, Nezu Museum 2010, Pls. 6 and 53).
2b.	Seikado Bunko Art Museum (Image courtesy of Seikado Bunko Art Museum).
3.	Unknown provenances collections.
3a, 3b and 3c.	Rokuon-ji, Fujita Museum, Nezu Museum (After Curatorial Division, Nezu Museum 2010, Pls. 9, 5 and 50).
4.	Pre- and post-war entrepreneurs' collections.
4a.	Tokiwayama Bunko Foundation (After Curatorial Division, Nezu Museum 2010, Pl. 47).
4b and 4c.	Idemitsu Museum of Arts, Hagi Uragami Museum (After Mori et al. 2012, Pls. 62 and 76).
5.	A mallet-shaped vase with phoenix décor, height of 25.5 cm, Yuan. Daikōmyō-ji temple, Kyoto (After Arima 1991, Pl.125).
6.	A mallet-shaped vase with *Xi(犧)*-shaped décor, height of 20.9 cm, Ming or later imitation. National Palace Museum, Taipei.

CHAPTER 10

1.	A mallet-shaped vase with phoenix décor, height around 18 cm, unearthed from Dayao kiln site, Longquan (After Zhu 1989, Pl. 23–4).
2.	A fagment of mallet-shaped vase with phoenix décor, height around 17 cm, unearthed from Xikou kiln site, Longquan (After Jin 1962, 537).
3.	A small-sized mallet-shaped vase with phoenix décor, height of 15.7 cm, found in Sinan wreck. National Museum of Korea (After Shen 2012, 143).
4.	A mallet-shaped vase with rooster décor, height of 16.7 cm, unearthed from Emeishan site, Sichuan (After Chen 1990, 41).
5.	The SSG mallet-shaped vase, height of 11.8 cm. National Palace Museum, Taipei.
6.	SSG-style mallet-shaped vase with fish décor, unearthed from Dongxi

	hoard site, Sichuan, height (a) 31 cm, diameter of dish-shaped mouth (d) 11.6 cm, diameter of bottom (e) 10.5 cm (After Sichuan Shen Wen Wu Guan Li Wei Yuan Hui 1987, 71).
7a and 7b.	Two fragments of SSG-style elite Longquan celadon vase with phoenix (or fish) décor, and two fragments of bottle-shaped vase with bamboo nodes design, unearthed from mansion site of SS Gongshengrenlie Empress, Hangzhou (After HMICRA 2008, color Pls. 69–2, 69–3, 42–3).
8.	A small-sized Longquan celadon vase, height of 15.3 cm, unearthed from a late SS tomb. Deqing County Museum (After Zhejiang Provincial Museum 2000, Pl. 215).
9.	A golden cup with a pair of fish décor, unearhed from a SS tomb. Dongyang City Museum (After Lü 2011, 5).
10a and 10b.	A pair of *long-hu-pin* vases (or jars) manufactured during middle or late SS, unearthed from Longquan. Longquan Celadon Museum (After Zhu 1998, Pls. 104 and 103).
11a.	The SSG-style elite Longquan celadon mallet-shaped vase with phoenix décor. Kuboso Memorial Museum of Arts, Izumi (After Curatorial Division, Nezu Museum 2010, Pl. 18).
11b.	The SSG-style elite Longquan celadon mallet-shaped vase with fish décor. The Tokugawa Art Museum (The Tokugawa Art Museum © The Tokugawa Art Museum Image Archives / DNPartcom).

Acknowledgments

The author and publisher gratefully acknowledge the following for permission to reproduce copyright material; specific source detail is provided in the List of Illustrations and in the text:

Archaeological Research Unit, The University of Tokyo (東京大学埋蔵文化財調査室)
Artist Press, Taipei (藝術家出版社)
Culture Relics Press, Beijing (文物出版社)
Daikomyo-ji Temple, Kyoto (大光明寺)
Deqing County Museum (德清縣博物館)
Dongyang City Museum (東陽市博物館)
Fujita Museum (藤田美術館)
Fukuoka City Archaeological Center (福岡市埋蔵文化財センター)
Gwangju National Museum (國立光州博物館)
Hagi Uragami Museum, Yamakuchi (山口縣立萩美術館・浦上記念館)
Hangzhou Municipal Institute of Cultural Relics and Archaeology (杭州市考古研究所)
Hangzhou Museum (杭州博物館)
Henan Provincial Institute of Cultural Relics and Archaeology (河南省文物考古研究院)
Hiroshima Prefectural Museum of History, Kusado Sengen Museum (廣島縣立歷史博物館 ふくやま草戸千軒ミュージアム)
Hunan Provincial Institute of Archaeology and Cultural Relics (湖南省文物考古研究所)
Ichijodani Asakura Family Site Museum (福井県立一乗谷朝倉氏遺跡資料館)
Idemitsu Museum of Arts (出光美術館)
Inner Mongolia Museum (內蒙古博物院)
Kamakura City Board of Education (鎌倉市教育委員会)
Kuboso Memorial Museum of Arts, Izumi (和泉市久保惣記念美術館)
Kyoto City Archaeological Museum (京都市考古資料館)
Kyoto National Museum (京都國立博物館)
Lishui City Museum (麗水市博物館)
Longquan Celadon Museum (龍泉青瓷博物館)
Mitsui Memorial Museum (三井記念美術館)
Nanfang Wen Wu Press, Jiangxi (南方文物出版社)
National Museum of Korea (國立中央博物館 韓國)
National Palace Museum, Taipei (國立故宮博物院)

Nezu Museum（根津美術館）
Östasiatiska Museet, Stockholm
Palace Museum (故宮博物院)
Rokuon-ji Temple (Deer Garden Temple (Temple of the Golden Pavilion))（鹿苑寺（金閣寺））
Saga Prefecture Archaeological Center (佐賀県埋蔵文化財センター)
Seikado Bunko Art Museum（靜嘉堂文庫美術館）
Songyang County Museum (松陽縣博物館)
Suining City Museum (遂寧市博物館)
The Tokugawa Art Museum（德川美術館）
Tokiwayama Bunko Foundation (常盤山文庫)
Tokyo National Museum (東京國立博物館)
Victoria and Albert Museum, London
Wuyi County Museum (武義縣博物館)
Yomei Library（陽明文庫）
Zhejiang Provincial Institute of Cultural Relics and Archaeology (浙江省文物考古研究所)

The publishers apologize for any errors or omissions in the above list and would be grateful to be notified of any corrections that should be incorporated in the next edition or reprint of this book.

Preface

Chinese Longquan (龍泉) celadon is one of the most famous branded products and trade ceramics, particularly during the 13th and 14th centuries. Its archaeological materials come from various attributes' sites, including kilns, tombs, hoards, harbors and shipwreck, as well as overseas transactions or consumption cities. Such massive and complicated research resources actually had attracted many modern researchers' attention and accumulated considerable literature in the past century. However, most studies focused on archaeological investigations or excavations, products' chronology, or scattered scientific analytical data. It lacked a virtual connection with contemporary art, commerce, society and culture.

In fact, the multiple attributes with plentiful cultural information about Longquan celadon's historical and archaeological materials provide researchers a great deal of food for thought. As Arnold stated (1993, 4), "Ceramics can be approached by several methodologies at several levels of analysis." The present book, *The Circulation of Elite Longquan Celadon from China to Japan: An Interdisciplinary and Cross-Cultural Study*, clearly proclaims the author's intention, employing interdisciplinary approach with broader perspective to explore some creative and interesting issues, closely associated with contemporary art, technology, commerce, religion, politics, society and culture.

The first part of this book focuses on elite Longquan celadon in China's Southern Song (SS 1127–1278) and Yuan (1271–1368) periods. The issues include how Longquan potters elevated their products' artistic quality from a regional and popular to elite art during middle and late SS (see also Chapter 1 and 2). And, how such a commercial ceramic played a crucial role in conveying the elite art to the populace, functioning as art education in SS society? In addition, why did elite Longquan celadon style change after the end of SS? And, what was the contemporaneous society's reaction to this change—support or resistance—during political environment of transferring era (see also Chapter 6)?

What is more, in terms of modern ceramic science and analytical techniques, another issue is how to understand the manufacturing technology and technological particularity of SSG-style (Southern Song Guan style) Longquan celadon—the most elegant Longquan product. Its technological particularity achieved its uniqueness, differentiating it from SSG ware—the SS imperial ware—creating its commercial brand (see also Chapter 2). However, passing such highly-developed and delicate technology on to the next generation of potters was difficult in traditional potter training system. It also probably addresses a long-standing question: why several cutting-edge ceramic technologies were quickly lost, resulting in some elegant and unique ceramics becoming a single-generation product in pre-industrial China (see also Chapter 4).

Further, Longquan celadon's successful marketing was largely owed to Song advanced commercial mechanism and system. Many SS elite ceramic archaeological hoards have been found that provide crucial information for exploring elite Longquan celadon products' marketing strategy and domestic elite ceramics markets' circulation and consumption pattern during SS (see also Chapter 3). However, a continual and neglected problem is the destruction of ceramic production locations' ecological environment, particularly after a mass and intensive production. Actually, Longquan production center's shift from southern to eastern area after the end of SS probably concealed serious ecological environmental destruction (see also Chapter 5).

The second part of this book focuses on elite Longquan celadon products as a trade ceramic to export to Japan. Beginning with late Kamakura (1192–1333) via Muromachi (1392–1573) to Edo (1603–1868) periods, an extensive span of time, those imported elite Longquan celadon objects always circulated within elite class communities and Zen temples. They played a crucial role in shaping medieval Japanese culture (see also Chapters 7 and 8). Several interesting issues, in terms of the present case, explore Japanese manner of adopting Chinese Song and Yuan culture, a cross-cultural transmission study from China to Japan.

For instance, one of the most fascinating issues is why SSG-style elite Longquan celadon was chosen and cherished by medieval Japanese Zen monks and elite class members (see also Chapter 7). Beyond a trade ceramic, this style of elite celadon carried rich SS cultural information, which should be learned and accepted; otherwise, it should have disappeared from Japanese society after brief usage. However, in spite of experiencing several brutal wars and frequent fires, SSG-style elite Longquan celadon survived throughout medieval history in Japan. Thus, why did it survive, and why was it always cherished by Japanese (see also Chapter 8 and 9)?

As a cultural transmitter, SSG-style elite Longquan celadon was the best endorsement of SS art and culture. Then, although its products were distributed to many corners of the world at that time, the most significant and profound influence was obviously in Japan. It not only shaped medieval Japanese culture, but was also rooted in Japanese thought and tradition (see also Chapter 10). As a trade ceramic, elite Longquan celadon really created an incredible magic in the cross-cultural transmission from China to Japan.

Following my first English book, published in 2016, *Art Archaeology & Science: An Interdisciplinary Approach to Chinese Archaeological and Artistic Materials*, this, my second English book, is dedicated to interdisciplinary and further cross-cultural study. The author sincerely hopes this book vivifies existent Longquan celadon archaeological and historical materials, and provides readers and researchers a broader perspective and additional methodologies to review and gain a new understanding of ancient Longquan celadon.

Here, I greatly appreciate the use of shards from Nils Palmgren's collection in the Museum of Far Eastern Antiquities (Östasiatiska Museet), Stockholm, for scientific analyses in Chapter 2 and Appendix. Moreover, I also deeply thank Prof. Jennifer K. Barton in Department of Biomedical Engineering, University of Arizona in the United States, for providing OCT instrument and relevant aids and information, and Dr. Yoshiyuki Iizuka and his laboratory assistants at the Institute of Earth Sciences, Academia Sinica, Taiwan, for providing SEM with EDS instrument use and assistance.

MEILI YANG

Taipei, March, 2018.

PART 1

Elite Longquan Celadon in China's Song and Yuan

Chapter 1
From Popular to Elite Art: Worshiping Objects' Evolution

The Longquan kilns began by producing some popular living necessities for the local population, primary tableware, kitchenware and worshiping utensils. Their style was similar to the adjacent Yue (越) kilns' celadon products. However, by middle Southern Song (SS 1127–1278), a few Longquan potters pursued the Southern Song Guan (imperial) (SSG) ware style, and created a sort of high-quality SSG-style elite celadon. Among its elite products, those worshiping objects are the most conspicuous, including various types of vases, jars and incense burners.

Worshiping utensils are closely associated with local belief, religion and custom, with very strong grassroots and regional affiliations. Theoretically, their style and usage are more inertial, particularly those artifacts used in birth, marriage or funeral rites. Moreover, a regional worshiping utensil was usually produced in local kilns. Thus, when local kilns begin to manufacture some different styles of worshiping products, it implies two possible causes: (1) the local social culture has a large shift; or, (2) those kilns are changing or expanding their market.

When Northern Song (NS 960–1127), Longquan celadon worshiping products primarily served Longquan local market, its style, to a considerable degree, reflected local custom and culture. However, during the final decades of NS, frequent brutal wars in the North of China enforced mass northern Han immigration to the South that resulted in the southern population and society structural changes. New consumers and new market demand boosted southern ceramic industry prosperity, and required far more products' variety. The wave of impact lasted until early SS. Confusion and floundering in regard to the new market trend were especially clearly expressed in contemporaneous Longquan worshiping products.

Beginning with middle SS and maturing in late SS, successful SSG-style Longquan celadon manufacturing not only created a new style, but also elevated its artistic quality from previously popular to elite art. At the same time, Longquan celadon market was also largely expanded, in spatial distribution from Longquan region to the entire country and even overseas, and in consumers' communities from populace to rich middle class, elite class and even the royal family.

However, in the entire evolution process, socioeconomic environment's support is certainly a significant dynamic. Particularly, commerce itself is operated within a cultural

realm. In addition to highly specialized technology, as a commercial ceramic, sensitively controlling the market trend and timely regulating the product's design and style to powerfully connect its business with contemporary economy and society should be the most critical. The better connection the better development its commerce has.

The present study focuses on Longquan celadon worshiping product to view how it evolved from popular ceramic to contemporary famous elite celadon, and how it popularized its elite art in terms of successful marketing to the general populace in SS society.

WORSHIPING ARTIFACTS IN SONG AND ELITE ART IN SS

Worshiping Artifacts and Popular Rites in Song

The present archaeological materials mostly come from Song tombs, which primarily included some artifacts used in funerary or worshiping rites and grave goods. The former had a set of fixed utensils based on local custom, usually some jar, vase and bowl or dish. And, the latter was associated with the tomb host's social rank, such as in intellectual's tombs some utensils for writing were buried, and in most women's tombs a few cosmetic accessories. Moreover, tombstones commonly placed in officers' tombs stated the host's career.

A tomb's artifacts or grave goods are considered to be important materials for reconstructing local funerary custom or worshiping rites (Morris 1992, 108; Halsall 2010, 205). Moreover, they are actually conducted by local belief or religion, which guides people's thinking about the afterlife and determines worshiping utensils genres and usage. Thus, in terms of these worshiping utensils, to a considerable degree, we could understand local belief or religion, and view local craft style and art.

However, when ritual or worship had become seriously tedious and wasteful, mixing Buddhism, Taoism, local belief and superstition in Song (960–1278), some intellectuals began aggressively to promote a set of simple and respectful rites based on Confucian tradition (Yu 1981, 55–57). The *Zhu Zi Jia Li* (朱子家禮) written by Zhu Xi (朱熹 1130–1200), one of the most outstanding SS thinkers, is the best paradigm (Zhu 1997; Matsumoto 2006, 20–21). In fact, behind the rites reformation, the new ideology—Neo-Confucianism, emphasizing rational thinking and life—provided the most crucial support.

Although this reform process was impeded by several barriers, mostly from the previous rites' followers or conservatives who criticized the simplified funerary rites to be disrespectful to the dead, simplification of worshiping activity and artifacts usage was seemingly a trend in SS society (Yu 1981, 59–60). It was also clearly reflected by SS Longquan celadon worshiping product's style.

SS Elite Ceramics Art

'Elite art' refers to a sort of cultural art which was popularized within elite class in ancient society. The ruling class always possessed the highest quality objects, including daily living necessities and luxury goods, which circulated within elite class community and formed a special artistic taste and aesthetic. They are usually isolated at the top of social structure from mass populace at the bottom. However, in a somewhat open society, elite art is probably relayed down to middle or even lower classes by means of commercial avenues, and creates a wave of fashion influencing contemporary popular art.

Although modern Western definition of art, particularly elite art, is without any commercial behavior intervention, when this sort of art is inevitably intervened by commercial culture, balancing between art quality and commercial benefit should be the largest challenge to creators and businessmen. As Trodd (2000, 58–59) argued: "… which suggest the alignment of the aesthetic and the social at the level of the density of human experience …," thus, to look for the largest common divisor between art and commerce, and elite class and mass populace cultures is probably the best balance.

The Song had a relatively open and freer society than other dynasties in ancient China, regardless of craft innovation, commercial activity, economic exploitation, social structure or even politics and thought. Song court instituted craft workshops and conscripted the most masterful craftsmen throughout the country who manufactured elegant craftworks, based on the emperor's favor, for court and royal family usage (Tuo 1977, 3864 and 3917; Xu and Chen 1964, 2988). These crafts formed a sort of unique style, particularly when the emperor was interested in arts and crafts with unique taste, such as the Emperor Huizhong (徽宗 1100–1126).

During SS, the court constructed a kiln to manufacture the imperial ware—SSG ware—for court and official use. SSG ware's form followed traditional ritual objects with simple decoration. Its style shaped SS unique elite art—a sort of simple and dignified art. Thus, when Longquan potters introduced SSG ware technology and style, the resultant product—SSG-style elite Longquan celadon—should possess contemporary elite art essence.

However, SSG-style elite Longquan celadon product is, after all, a commercial ceramic, unlike SSG ware, a noncommercial imperial ceramic. Market demand was its first concern. Thus, SSG-style elite Longquan celadon certainly required a certain degree of commodification rather than simply duplication of SSG ware characteristics that created the elite art of SSG-style Longquan celadon to be somewhat different from SSG ware.

LONGQUAN WORSHIPING PRODUCTS FOR LOCAL MARKET IN NS

Five Tube Jars' Styles

An intact hole tomb was excavated at Longquan in 1976, and three Longquan celadon artifacts were found: a five tube jar, long-neck vase, and pot with handle, which were considered to be a set of worshiping artifacts used in local funeral during early NS (Figures 1a, 1b and 1c; Pls. 1, 2 and 3) (Zhejiang Longquan Xian Tu Shu Guan Wen Wu Guan Li Xiao Zu 1979, 95). The special five tube jar with a cover was called 'ying (罌)' by local people, meaning barn jar to symbolize a full crop (Li 1999, 130).

Figure 1a jar, height of 39.5 cm, has an ovoid body and five tubes modeled on its shoulder equidistantly. The cup-shaped cover, describing a lotus pool scene with four ducks, has a knob on the center top. This jar is in pale brownish glaze with carved relief lotus petals. Figures 1b and 1c, the vase and pot, probably constitute a set of wine ware. Ceramic pot was not always found or sometimes replaced by metal in Song tombs. However, the vase, height of 40.5 cm, has also an ovoid body with a long tubular neck and dish-shaped mouth above.

In fact, this set of worshiping artifacts has identical craftsmanship, surmising to be the same Longquan workshop's products. Viewing those decorative motifs, in addition to Buddhist symbols, such as lotus petal and knob, traditional popular belief, such as five tube symbolizing five major bumper crops, and rural life scenes, ducks in a pool, completely presented the popular art unique richness and vividness.

The prototype of five tube barn jar could be traced back to funerary urn used during late Han (202 BC–AD 220) or Three Kingdoms (220–280) (Shen 2009; Tong 2004). According to current archaeological materials, most five tube barn jars were unearthed from Longquan region, belonging to Longquan kilns' products (Yang 1999, 113). Figure 2 is a seven tube barn jar, height of 24.7 cm, with a missing cover, unearthed from Wang Zhijin's (王 志金) tomb in Chatian (查田), Longquan (Zhu 1998, 82). The body was sculpted in pagoda shape with a short neck. Although each single tube opening into a flower-like mouth is similar to Figure 1a, Figure 2 jar and Figure 3a barn jar are identical in size and form.

Figures 3a and 3b, a barn jar and vase, dated to 1078, unearthed from a tomb in Longquan (Zhejiang Provincial Museum 2000, Pls. 201 and 202). The barn jar, height of 27.9 cm, with ovoid body was sculpted in pagoda shape with chrysanthemum petals design and five tubes on the upper portion, and lotus petals design on the lower portion. An umbrella-shaped cover is topped with a flower bud knob. In addition, Figure 3b vase is somewhat short and stout, height of 22.4 cm.

Figure 4, a barn jar, height of 29.1 cm, was dated to 1070, based on twelve words written in ink on the interior of its cover (Zhejiang Provincial Museum 2000, Pl. 200). This jar's form, design, décor and even glaze hue are completely identical to Figure 3a jar, surmising both to be the same Longquan workshop's products during middle or late NS.

Usage and Significance of Five Tube Jar

The five tube barn jar is a unique funerary artifact in Longquan region. Figure 5 jar, height of 30 cm, with twenty-four words written in ink on the interior of its cover states that Ms. Zhang used this jar to worship all gods, asking her surviving family to be long-lived, lucky and rich (張氏五娘五穀倉柜 上應天宮下應地中 蔭子益孫長命富貴) (Zhu 1998, 95). To worship gods not only asserts the dead family's role in the other world, but also requests fertility for his or her surviving family in a traditional belief (Rakita 2009, 156–157; Matsumoto 2006, 21).

In fact, Figure 4 jar also clearly revealed the same worshiping significance although only the worshipper's name and date were written. It is seemingly not difficult to understand that such contemporary barn jars accompanied by a vase or pot and bowl or dish for wine or tea and food organized a set of worshiping utensils used in funerary rites to express the living family's secular desires. Unfortunately, most NS tombs in Longquan region were destroyed. As a result, further knowledge related to those worshiping artifacts' usage is difficult to attain.

However, an intact tomb, located at Liujialing (劉家嶺), Guiyang (桂陽), Hunan province today, provided more complete information related to China's southern funerals during NS (HPIACR 2013). An incense burner and bowl were prepared on the worshiping platform, at the front end of the tomb chamber close to tomb door. In addition, two jars were placed in a wall shrine at the rear end of tomb chamber in the proximity of tomb host's head (Figure 6).

The two jars' form and design are, to a considerable degree, similar to Longquan's five tube barn jar or following *long-hu-pin* (dragon-tiger vase) jar, surmising their attributes and function to be the same (Figures 6a and 6b). Moreover, according to two jars' position in the tomb, it implies a direct connection with the afterlife. In contrast, the incense burner and

bowl were located close to the tomb door, indicating both for surviving family's use in worshiping activity (Figures 6c and 6d). Although Liujialing's worshiping artifacts had a somewhat different assemblage and decorative style from Longquan's, representing various regional religions and customs, they all shared the same attributes and function, and transmitted common secular wish.

Throughout NS, although the size of Longquan worshiping products was seemingly gradually reduced from a height of around 40 cm to less than 30 cm, and the body's shape was transformed from wide upper-belly to wide middle-belly ovoid, as well as the glaze's hue changed from pale brownish to brown-greenish, the major decorative motifs were seemingly unchanged, combining Buddhist symbols and local beliefs. It implies, until the final decades of NS, Longquan worshiping products' style had no significant change, and primarily supplied the local market.

LONGQUAN WORSHIPING PRODUCTS BETWEEN LATE NS AND EARLY SS

New Decorative Motifs

A vase found at Chatian, Longquan (Figure 7), called by local people '*long-hu-pin*' vase, height of 30.7 cm, had a somewhat short ovoid body with a tiger modeled on the vase neck, and a roof-shaped cover topped with a bird knob. The glaze was in blue-greenish hue, somewhat different from previous Longquan celadon barn jar's brownish hue. It was said that Chatian once unearthed several similar vases (or jars) called '*long-hu-pin*' during pre-war period (Chen 1946, 66).

As a funerary or worshiping product, *long-hu-pin* vase (or jar) was usually paired in manufacturing with fixed animal motifs assemblage. When a bird was on the top of the cover, a tiger decorated the vase neck and shoulder, whereas if a dog was on the top, there was a dragon on neck and shoulder. Dragon and tiger were regarded as Taoist symbols in Song and became popular decorative motifs in the South of China, particularly after the Taoist high priest established his shrine at the mountain, called Longhushan (龍虎山) located in Guixi (貴溪), southeast corner of Jiangxi province today (Bi 1957, 2284).

Moreover, because of the Emperor Huizhong's religiousness, Taoism prevailed during late NS. However, Taoism and popular belief are always mixed and confused by most Chinese. Chicken (or bird) and dog are two of the most familiar decorative motifs in popular belief and art. And, because both were thought to be friendly to human beings, their figures were commonly used to accompany the tomb dead in various ways, such as decorated on buried artifacts or tomb wall paintings. In a late NS tomb, located at Youxi (尤溪), Fujian province today, a dog and chicken figures were painted on the rear wall, indicating an intimate relationship with the tomb host (Figure 8) (Fujian Provincial Museum and Youxi County Museum 1991, 347).

In fact, *long-hu-pin* vase (or jar) or resembling artifact was extensively used in the South of China, covering Longquan and its peripheral areas during late NS and early SS. In addition to the previously mentioned Lieujialing in Hunan (see also Figures 6a and 6b), in eastern Jiangxi, local populations were accustomed to using a kind of jar, similar to *long-hu-pin* vase (or jar), as a funerary artifact (Figure 9) (Yang 1992). In addition, for instance in Wuyi (武義), around 100 kilometers away from the north of Longquan, a jar resembling *long-hu-pin*, dated to 1083, manufactured by a local kiln, was found (Figure 10) (Zhejiang Provincial Museum 2000, Pl. 203).

8 | Worshiping Objects' Evolution

Figures 1a, 1b and 1c. Five tube barn jar, wine vase and pot. Longquan Celadon Museum (After Zhu 1998, Pls. 36, 37 and 38).

Figure 2. Seven tube barn jar unearthed from Wang Zhijin's tomb in Chatian, Longquan. Longquan Celadon Museum (After Zhu 1998, Pl. 41).

Figures 3a and 3b. Five tube barn jar and vase, 1078, unearthed from Tashi, Longquan. Longquan Celadon Museum (After Zhejiang Provincial Museum 2000, Pls. 201 and 202).

Figure 4. Five tube barn jar with writing in ink on the interior of cover, 1070, unearthed from a tomb at Lanju, Longquan. Longquan Celadon Museum (After Zhejiang Provincial Museum 2000, Pl. 200).

10 | Worshiping Objects' Evolution

Figure 5. Five tube barn jar with writing in ink on the interior of cover. Longquan Celadon Museum (After Zhu 1998, Pl. 56).

Figure 6. #4 and 5 are two jars (Figures 6a and 6b) placed close to the tomb host's head; #1 and 2 are an incense burner and bowl, prepared on worshiping platform close to the tomb door (Figures 6c and 6d) (After HPIACR 2013, 9).

Figures 6a and 6b (left). Two jars (After HPIACR 2013, Pls. 120 and 112).

Figures 6c and 6d (right). An incense burner and bowl (After HPIACR 2013, Pls. 124 and 126).

Figure 7 (left). *Long-hu-pin* vase unearthed from Chatian. Longquan Celadon Museum (After Zhu 1998, Pl. 99).

Figure 8 (right). Song tomb wall painting on the rear wall, Youxi, Fujian province today, a dog and chicken figures accompanied the tomb host (After Fujian Provincial Museum and Youxi County Museum 1991, 347).

12 | Worshiping Objects' Evolution

Figure 9 (left). A pair of Jingdezhen Qingbai porcelain *long-hu-pin* jars, 1118 (After Yang 1992, Pl. 4–3).

Figure 10 (right). A *long-hu-pin* jar unearthed from Wuyi, 1083. Wuyi County Musuem (After Zhejiang Provincial Museum 2000, Pl. 203).

Figure 11 (left). A *meipin* vase unearthed from Cheng Daya's tomb in Songyang, 1195. Songyang County Museum (After Zhejiang Provincial Museum 2000, Pl. 210).

Figure 12 (right). A Song tomb wall painting found in Anyang, Henan, 1077 (After Su 1957, 20).

Worshiping Objects' Evolution | 13

Figure 13a (left). A vase collected by Longquan Celadon Museum with writing in ink on the bottom exterior, stating this vase was Mr. Wu Sange's worshiping object (After Zhu 1998, Pl. 70).

Figure 13b (right). A vase with same design and form unearthed from Dayao kiln site, Longquan (After Zhu 1989, 52).

Figure 14 (left). A SSG vase unearthed from Laohudong kiln site, Hangzhou, one of SS imperial kilns, early SS (After Tang 2004, 179).

Figure 15a (middle). A vase unearthed from Dayao kiln site, Longquan, dated early SS (After Zhu 1989, 52).

Figure 15b (right). A vase with same form unearthed from Suichang, Longquan (After Zhu 1998, Pl. 86).

14 | Worshiping Objects' Evolution

Figure 16a (left). A *long-hu-pin* vase collected by Shanghai Museum, middle or late SS (After Zhu 1998, Pl. 102).

Figure 16b (right). A *long-hu-pin* vase collected by Longquna Celadon Museum, middle or late SS (After Zhu 1998, Pl. 105).

Figure 17 (left). A SSG-style elite Longquan celadon *long-hu-pin* vase collected by V&A Museum, late SS. V&A Museum, C.28–1935.

Figure 18a (middle). A SSG-style Longquan celadon *long-hu-pin* vase with tiger and bird décor unearthed from Longquan, middle or late SS. Longquan Celadon Museum (After Zhu 1998, Pl. 104).

Figure 18b (right). An identical *long-hu-pin* vase with dragon and dog décor unearthed from Longquan. Longquan Celadon Museum (After Zhu 1998, Pl. 103).

Figure 19a (left). A SSG-style elite Longquan celadon mallet-shaped vase with a pair of phoenix décor unearthed from Songyang. Songyang County Museum (After Zhu 1998, Pl. 115).

Figure 19b (right). A SSG-style elite Longquan celadon mallet-shaped vase with a pair of fish décor unearthed from Songyang. Songyang County Museum (After Zhu 1998, Pl. 116).

Figures 20a and 20b. A *meipin* vase and jar unearthed from Hu Hong and his wife's tomb, 1203 (After ZPICRA and Commission for Preservation of Ancient Monuments, Qingquan County 2015, cover photos).

16 | Worshiping Objects' Evolution

Figure 21 (upper). A SSG-style Longquan celadon incense burner unearthed from Wu Ao's tomb, 1268. Deqing County Museum (After Zhu 1998, Pl. 122).

Figures 22a and 22b (lower). A SSG-style Longquan celadon jar and box. unearthed from Li Hou wife's tomb in Longquan, 1222. Lishui City Musuem (After Zhang 2008, Pls. 183 and 184).

Therefore, Chatian's *long-hu-pin* vase's presence not only reflected that Longquan kilns had a new worshiping product, but also implied Longquan potters were probably exploiting their new markets in this period. In fact, *long-hu-pin* vase's creation should be merely one of several changes, and more innovation was being promoted by Longquan potters at that time.

Initiating New Products and New Style

As previously mentioned, massive northern immigration to the South in the final decades of NS was changing the southern economy, society and culture. Six *meipin* vases, height of 28.2 cm, were unearthed from Cheng Daya's (程 大雅 1134–1195) tomb, located at Songyang, Longquan (Figure 11) (Song and Liu 2015, 88). These Longquan celadon vases had a wide upper-belly and elongated lower-belly body decorated in neat horizontal ridges with beautiful green-bluish hue glaze, considerably uniform in quality and style.

This form of *meipin* vase was commonly used as wine ware in worshiping rites or daily lives in the North of China during Song. Figure 12, a wall painting on a northern tomb, located at Anyang (安陽), Henan province today, depicted worshiping activity scene and artifacts usage during NS (Su 1957, 20). A pair of *meipin* vases flanked a flower vase and a couple of bowls or dishes with food on the worshiping table. And, a man was by the side of the table. When compared with Figure 6, an illustration of simultaneous southern worshiping custom, the differences between northern and southern worshiping culture are evident.

However, it is also noticeable that Cheng tomb's *meipin* vases exhibited a sort of new hue, green-bluish glaze with shallow crazing, thoroughly different from previous Longquan celadon in pale brownish or brown-greenish hue. The new glaze color probably followed Ru ware's style, the NS imperial ware. It is seemingly understandable that to supply the new market demand, coming from mass northern immigrants, some Longquan potters probably began producing northern style celadon products during early SS.

Nevertheless, with the gradually growth and domination of SS imperial ware, SSG ware's influence was quickly increasing following early SS. A vase, height of 17.2 cm, was collected by the Longquan Celadon Museum. On its bottom exterior, seven words were written in ink, stating: Mr. Wu Sange worshiping in front of Buddha (吳三哥佛前供養) (Figure 13a) (Zhu 1998, 109). This vase has a brown-greenish glaze, a depressed-globe body with a somewhat long and slender tubular neck and engraved flower design and combing patterns.

It and another vase, excavated from Dayao (大窯) kiln site in Longquan, dated to early SS, are completely identical (Figure 13b) (Zhu 1989, 49). This sort of wide lower-belly body vase, at times described as bottle shape vase, was extensively adopted by SSG ware users, representing southern style vase as wine vase or flower vase during SS (Figure 14) (Tang 2004, 178–179). Its form is strongly opposite to the previous *meipin* vase's wide upper-belly body, a typical northern style vase.

Moreover, Figures 15a and 15b, two Longquan celadon vases, belonging to such southern style form without any design and décor, are completely identical. The former was unearthed from Dayao kiln site, height of 25.5 cm, and the latter found in Suichang (遂昌), Longquan (Zhu 1998, 121; Zhu 1989, 49). Dayao is one of the most crucial Longquan celadon manufactories to produce elite products, particularly SSG-style during middle and late SS (Chen 1946, 60; Zhu 1989, 64). Here once nucleated the most masterful Longquan potters who were actually familiar with both Longquan celadon and SSG ware's technologies (see also Chapter 2).

However, although these bottle shape vases were similar to SSG vase's form, their glaze's hue was still in traditional Longquan celadon's brownish scheme, unlike SSG ware's beautiful *fen-qing* hue—green-bluish with somewhat pink-white. It is understandable that in the initial stage, Longquan potters probably first introduced SSG ware's form and decorative style rather than glaze technology, because the latter is more difficult than the former to imitate.

In fact, according to archaeological materials, Longquan celadon products displayed a considerably wide variety in style and quality during early SS, implying Longquan potters were vacillating between northern and southern consumers, local and peripheral markets, old tradition and new fashion, and even elite and popular buyers. A sort of stumbling in regard to the new trend and attempting to expand its market were clearly exhibited. However, it is also clear Longquan celadon possessed considerable future commercial potential.

ELITE WORSHIPING OBJECTS IN MIDDLE AND LATE SS

SSG-style Elite Longquan Celadon Creation

A series of similarly-styled Longquan celadon *long-hu-pin* vases (or jars) were found during pre-war period, and dated to middle or late SS (Figures 16a and 16b; Pl. 4) (Chen 1946, 66). These objects not only verified that SSG ware's technology was gradually controlled by Longquan potters, but also anticipated the SSG-style elite Longquan celadon creation, speedily transitioning Longquan celadon from previous popular art to elite art.

One of the most elegant SSG-style Longquan celadon *long-hu-pin* vases (or jars), currently collected in the Victoria and Albert (V&A) Museum, London, height of 25.4 cm, has somewhat thick and beautiful *fen-qing* hue glaze, completely craze-free, surmising to be from late SS (Figure 17; Pl. 5) (Kerr 2004, 95). A dragon is dynamically tied the upper half of this jar with such natural fluency that it is reminiscent of Chinese calligraphy *xing-cao* (行草). And, a bird (phoenix) elegantly sits on the top of the domed cover. Doubtless, the jar's artistic attribute completely transcended its religious or custom's connotations, even though it was still framed in traditional *long-hu-pin* vase's model.

Figures 18a and 18b are two *long-hu-pin* vases without or missing covers, height of 25.3 cm and 24.2 cm, respectively. Each had a cylindrical body with a slack and clean shoulder, in which miniature dragon and dog, or tiger and bird décor were modeled. It is conspicuous to miniaturize decorative motifs and leave a wider space free of any décor or design to create a form in clean and simple style to directly guide viewers' attention to the glaze hue's beauty, without any designs' or décor's interference.

Moreover, to skillfully transform those religious motifs or to moderately dilute those religious elements and intensify the artistic not only gradually shifted worshiping objects' attributes from religious to artistic, but also accorded it a more powerful crossing the commercial territory's boundaries, built based on different religions or beliefs. At the same time, it also opened up a more largely creative space for those masterful Longquan potters.

For instance, Figures 19a and 19b, two SSG-style elite Longquan celadon vases, could be the derived products of *long-hu-pin* vase during late SS. The mallet-shaped vases with a pair of phoenix or fish décor (handles) were unearthed from Songyang, Longquan (Zhu 1998, 148–149). With cylindrical body and recessed circle-foot, each displays a clean form with beautiful *fen-qing* or *meizi-qing* hue. The form's prototype should come from SSG

vase (see Figure 5 in Chapter 10), but its design should be following *long-hu-pin* vase, with various animal motifs décor (see also Chapter 10).

It is apparent that Longquan potters didn't discard their grassroots culture, as a regional and popular ceramic, in transforming it to a countrywide and even worldwide famous elite ceramic process, particularly presenting those worshiping products. With highly specialized technology and considerably flexible creativity, SSG-style elite Longquan celadon products were bringing their unique commercial nature into full play. Both possessing popular art vividness and SS elite art simplicity and elegance, SSG-style elite Longquan celadon products' market potential was unlimited.

SSG-style Elite Longquan Celadon Popularization

SSG-style elite Longquan celadon actually played a very crucial role to popularize elite art in SS society. Nine jars and two *meipin* vases were found in the wall shrines of Hu Hong (胡紘) and his wife's tomb (Figures 20a and 20b) (ZPICRA and Commission for Preservation of Ancient Monuments, Qingyuan County, 2015). Hu (1137–1203) was born in Longquan, a high-ranking officer in SS government. All jars and vases apparently belonged to the same Longquan workshop's products, craze-free in *meizi-qing* hue. Other than an elephant knob on the top of the cover, no decoration was employed on these objects.

Elephant motif symbolizes Samantabhadra (普賢菩薩) in Buddhism. The Buddha represents so-called '*lide* (理德),' which seemingly met contemporary Neo-Confucianism ideology and earned SS intellectuals' favor. Moreover, Samantabhadra's Bodhimanda (*Daochang* 道場) was located at Emei (峨眉) mountain, eastern Sichuan, where this belief was flourishing. And, eastern Sichuan was also the largest market of SSG-style elite Longquan celadon products during late SS (see also Chapter 3).

In addition to highly uniform quality, these jars and *meipin* vases are commonly smaller, less than 12 cm and less than 19 cm in height, respectively. Such miniature worshiping products were probably custom made to accommodate the tomb's structure, in which several small wall shrines were built by chiseling into the tomb walls' average 30x30x16 cm3 spaces. Only miniature artifacts could be placed in these wall shrines. In fact, to prevent thriving tomb robbery, SS tomb was commonly simplified and miniaturized (Zhang 2009, 436–437).

An SSG-style Longquan celadon incense burner was unearthed from Wu Ao's (吳奧) tomb in Deqing (德清), Zhejiang province today (Figure 21) (Zhu 1998, 154). Wu died in 1268. In addition, Figures 22a and 22b, a SSG-style Longquan celadon jar and box were unearthed from the tomb of Li Hou's (李垕) wife, dated to 1222 (Wu and Guan 2007, 38). Wu Ao and Li Hou were not the high-ranking officers in SS, based on their tombstones. Then, they were apparently a group of contemporary SSG-style Longquan celadon consumers, whose social status swung between elite class and middle class, depending on individual economic power.

All these miniature objects are apparently in SSG-style, sharing the common and essential characteristics of SSG-style elite Longquan celadon, such as blue-greenish hue and simple form free of any décor or design, but seemingly in somewhat inferior quality, such as decreased glaze thickness resulting in the glaze texture unfastened or color unsaturated. Thus, a reasonable surmise is that to use SSG-style Longquan celadon products among elite or middle class had been a sort of enjoyment, however depending on use situations and individual economics, users probably chose somewhat different quality and prices of products in SS society.

A series of SSG-style Longquan celadon products, priced accordingly from the most elegant to somewhat inferior quality, supplied contemporary consumers' multiple choices. Longquan celadon successfully created its elite ceramic brand, and expanded its consumption communities, from elite class to rich middle class and even mass populace. It actually played a crucial role in relaying elite art to the public.

CONCLUSION

Ritual is not static, and worshiping activity and artifacts usage should shift over time (Halsall 2010, 212). A commercial ceramic could survive in an intensely competitive market relying on sensitivity to market trend, flexibility and nimbleness in varying or regulating products' style and quality. It is a sort of commercial gift. It is apparent that SS Longquan potters were given such a great gift.

In general, when a product is elevated to elite and artistic commodity, it is usually isolated from mass population and only circulated within elite class, formed usually by political and economic elite members. However, SSG-style elite Longquan celadon products' consumers were not only these elite class members, but also a considerable amount of newly-emerging rich middle class, particularly rich merchants, who actually possessed considerable purchasing power in SS society. Then, they also had their special artistic taste, which was not completely similar to elite class members', but more or less with some flavor of popular or vulgar life.

Longquan celadon had the predominance of bridging elite and popular arts, and of earning these rich middle class consumers' favor, because its development was rooted in local popular art and culture. Once middle class consumers began to purchase the elite product, their purchasing power is the most powerful dynamic to relay elite art to the mass populace (Wilson 2000, 178). SSG-style Longquan celadon exhibited a successful commercial ceramic story, raising from popular art to elite art. Moreover, it accidentally also contributed a mode of art education to contemporary society that changed the populace's aesthetic and elevated popular art.

Chapter 2

Technological Particularity: As an Elite Commercial Ceramic

As the previous chapter argued, Longquan potters should first introduce the form and decorative style of Southern Song Guan (imperial) (SSG) ware, rather than firing technology, to create its first elite product—SSG-style Longquan celadon—because the latter is more complicated and difficult (see also Chapter 1). At the same time, it is also emphasized that SSG-style elite Longquan celadon was absolutely not a copy of SSG ware, but an innovative elite ceramic because of its strong commercial attribute, unlike SSG ware, a noncommercial imperial ware.

In addition to maintaining uniform and high quality, an elite ceramic commodity's solid and pleasant visual impression is also crucial to earning consumers' favor. Therefore, although SSG ware technology was introduced and shared by Longquan potters who thoroughly had the ability to produce the same SSG ware product, specific technological details would require adjustment to create a product that is both exquisite and marketable.

Thus, compared with SSG ware, SSG-style elite Longquan celadon should possess some technological divergences and convergences that created its technological particularity and product's uniqueness. The objective of the present study is, by means of modern analytical techniques and scientific knowledge, to understand SSG-style elite Longquan celadon's technological particularity. And, how did it achieve its distinctiveness to become one of the most successful elite commercial ceramics in pre-industrial China?

SSG-STYLE LONGQUAN CELADON AND SSG WARE

Longquan kilns, beginning with Five Dynasties (907–979) and for a long period following, primarily produced celadon similar to Yue (越) ware to supply local and surroundings residents' usage, priced accordingly for general consumers. However, in its most prosperous period, the middle and late Southern Song (SS 1127–1278), some Longquan potters introduced SSG ware technology to manufacture a relatively high-quality and high-priced SSG-style elite Longquan celadon for elite class consumers. Two varieties of Longquan celadon products, elite and popular, varying in quality and style,

were simultaneously produced and circulated in SS society and sequent Yuan (1271–1368) and Ming (1368–1644).

In contrast, production of SSG ware came later and lasted for a shorter period, primarily during SS. However, beginning with early SS, the court sequentially constructed two imperial kilns, Xiuneisi (修內司) and Jiaotanxia (郊壇下) in the capital, Linan (臨安 Hangzhou today), Zhejiang. The initial purpose was to produce a product resembling Ru ware, the predecessor imperial ware during late Northern Song (960–1127), for court and official usage, particularly in ritual or ceremonial situations. However, due to a lack of Ru ware raw materials and technology, SS imperial potters actually manufactured their own unique style of celadon product.

With *fen-qing* (粉青) hue, SSG ware was ranked as one of the most elegant Song porcelain products by ancient Chinese connoisseurs and modern ceramic collectors (Gao 1996, 404–406; Gu 1968, vol. 2: 4; H. 1952, Foreword; W. 1944, 1). SSG ware's characteristics can be briefly described as: (1) simple form, displaying a dignified, soft and dull visual impression; (2) crazing lines throughout the whole object's surface, presenting a certain fixed pattern, deep-brownish parallel lines sometimes combining in a chicken wire pattern; (3) dark gray or black body with *fen-qing* hue glaze, a green-bluish with noticeably opaque pink-white; and, (4) thin body, usually less than 2.0 mm, and thick glaze, usually more than 0.8 mm (Figure 1; Pl. 6).

SSG-style elite Longquan celadon and SSG ware actually have a certain degree of similarity, particularly the form and glaze's hue. However, some subtle nuance is also articulated, such as: (1) beyond simple form, displaying a sort of solid and pleasant visual impression; (2) the whole object free of crazing; (3) white or gray-white body with *fen-qing* or *meizi-qing* (梅子青) hue glaze, a bluish-green analogous to immature plum; and, (4) regular thickness in body, around 3 mm, and relatively thick glaze, around 0.8 mm (Figures 2a and 2b; Pls. 7 and 8).

Compared with SSG ware, the most noticeable differences should be craze-free and solid texture, which characterized SSG-style elite Longquan celadon as an elite commercial ceramic, and reversed a stereotypical impression as an imitation SSG ware. However, after all, SSG-style Longquan celadon and SSG ware still belong to the same color scheme, as highly-homogeneous elite celadon products.

THE SAMPLES AND ANALYTICAL TECHNIQUES

The Samples

According to Chinese archaeological investigations and excavations of Longquan kiln sites, Dayao (大窑), located just south of today's Longquan county, was the most representative kiln, producing elite celadon during SS (Chen 1946, 97; Zhu 1989, 64–65; Palmgren 1963, 97). Beginning with the pre-war period, several Western shard seekers visited this kiln site to gather fragments and shards. Therefore, Dayao shards were known earlier, and became the first choice for scientific analyses to understand SSG-style elite Longquan celadon manufacturing technology in the past century (Wu et al. 2009, 207).

The present samples come from Nils Palmgren's shards collections (see also Table 1 in Appendix). Palmgren, a Swedish archaeologist, investigated Chinese Song kiln sites, including Ding, Cizhou, Jun, SSG and Longquan in 1935–36, gathering numerous shards

at that time, housed in the Museum of Far Eastern Antiquities (MFEA) (Östasiatiska Museet), Stockholm today. Several Western ceramic scientists have benefitted from Palmgren's shards collections (Sundius 1963; Steger 1963; Hall et al. 1973; Vandiver and Kingery 1984).

In 2014, I visited the MFEA to study Palmgren's collections, and received a batch of shards, including the present Longquan celadon samples. Eight samples (Dayao 1–3 and 5–9) coming from Dayao kiln site and one (Aotou-1) from Aotou (坳頭) kiln site, located very close to Dayao kiln and producing few SSG-style elite Longquan celadon products, are analyzed in the present study (Palmgren 1963, 111). In addition, a SSG shard (Guan-1) gathered at Hangzhou by Palmgren is regarded as the control. Compared with previous studies, the Guan-1 sample is considerably representative, regardless of its compositions and microstructure features (see also Appendix) (Yang 2016, 91–105; Yang et al. 2012).

Analytical Techniques

Optical coherence tomography (OCT) is a technique similar to ultrasound, in which an acoustic wave is reflected from impedance mismatches in a sample. Similarly, OCT signals arise as the result of time-gated, near-infrared light backscattered from index of refraction mismatches in a sample. Cross-sectional images of a material's microstructure are obtained, particularly helpful for analyzing transparent and translucent materials, such as glass or ceramic glazes. OCT is a fast, convenient and completely nondestructive technique to acquire microstructure images and does not require any sample preparation.

A commercial device OCT system equipped with a handheld probe, the Thorlabs Spectral Radar system (Thorlabs, Inc., Newton, New Jersey, USA), is used in the present study. This system uses a central wavelength of 930 nm and a spectrum bandwidth of almost 100 nm as its light source, resulting in an image resolution of approximately 6.0 μm axial and approximately 9.0 μm lateral. It can present the cross-sectional microstructure from the surface of glaze to the interface between glaze and body.

Traditional Chinese Song porcelain glaze usually consists of three essential phases: homogeneous glass phase, liquid-liquid phase separation phase and crystallization phase, presented and distinguished in the OCT image, based on the individual refractive index (n). According to our previous studies, in OCT images, the homogeneous glass phase (n=1.5) is presented in black, liquid-liquid phase separation phase (n=~1.52) in even gray, and the crystallization phase, depending on the crystal's species, in varying grayscale (Yang et al. 2009, 813–816; Yang et al. 2015, 838–840). In addition, some residuals or undissolved additives and inevitable bubbles are also presented. Each single bubble is displayed in two bright parallel short lines (or dots) at the top and bottom.

In addition, scanning electron microscopy (SEM) with energy dispersive spectroscopy (EDS) is also used in the present study to provide highly-precise microstructure images of glaze and body, with a qualitative and quantitative analysis of the components and compositions. The present SEM instrument, the W-SEM JSM-6360LV with Oxford EDS (INCA-350), is devised in the low vacuum (LV-SEM) environment to detect the signals coming from the target sample. This device allows us, without conductive coating of the sample, to acquire the composition data and microstructure images from the polished sample face (Iizuka et al. 2005, 84).

24 | As an Elite Commercial Ceramic

Figure 1 (left). *Fen-qing* SSG vase. National Palace Museum, Taipei.

Figures 2a and 2b (middle and right). *Fen-qing* and *meizi-qing* SSG-style Longquan celadon vase and incense burner. Suining City Museum, Kyoto National Museum (After Asahi Shimbun 1998, Pl. 5; Mori et al. 2012, Pl. 39).

Figure 3a (upper). Type I glaze's phase structure in OCT image, Dayao-6. (The upper arrow points to the interface between two layers of glaze, and below the lower arrow no signal is acquired.)

Figure 3b (lower). Guan-1 glaze's phase structure in OCT image.

As an Elite Commercial Ceramic | 25

Figure 4a (upper). Type II glaze's phase structure in OCT image, Dayao-1. (The upper arrow points to the interface between two layers of glaze, and below the lower arrow nearly no signal is acquired.)

Figure 4b (lower). Aotou-1 glaze's phase structure in OCT image.

Figure 5a (left). Dayao-6 body's microstructure in SEM image. (Light gray particles are quartz (Q), and dark gray or black in various shapes are pores (P)).

Figure 5b (right). Guan-1 body's microstructure in SEM image.

Figure 6a (left). Dayao-1 body's microstructure in SEM image.

Figure 6b (right). Dayao-9 body's microstructure in SEM image.

Figure 7. The cross-section of Dayao-6 sample displays white-edge on exterior of body (red arrow).

Figure 8a (left). Mullite crystallization phase (M) in Dayao-1 body in SEM image.

Figure 8b (right). Anorthite crystallization phase (A) in Aotou-1 glaze close to the interface between glaze and body.

TWO TYPES OF SSG-STYLE ELITE LONGQUAN CELADON

Previous descriptions of SSG-style elite Longquan celadon glaze's hue reveal two major types, *fen-qing* and *meizi-qing*; the former has more similarity to SSG ware, whereas the latter is divergent from SSG ware, presenting SSG-style elite Longquan celadon's unique hue (see also Figures 1, 2a and 2b). However, according to glaze's OCT images, the two types of samples have somewhat different phase structure.

Type I, *fen-qing* hue glaze's phase structure is dominated by rich flocculated substance (in gray-white) with a small proportion of homogeneous glass phase (in black), and bubbles (paired bright short lines on top and bottom of a bubble) are mostly small- and middle-sized (Figure 3a) (Yang et al. 2012, 69). This type of phase structure is apparently similar to SSG ware glaze's (Figure 3b). Among the present samples, *fen-qing* hue Dayao-6 and -7 belonged to this type of phase structure (see also Appendix).

In contrast, type II, *meizi-qing* hue glaze's phase structure is dominated by a homogeneous glass phase with a small amount of flocculated substance (Figures 4a and 4b). Moreover, based on the bubbles' distribution, a well-developed fluidity with mostly clear direction is displayed. Among the present samples, Dayao-1, -2, -3, -8, -9 and Aotou-1 glazes belonged to this type of phase structure (see also Appendix). In addition, both type I and II samples at least two-layer glaze structure is presented and characterized in OCT images.

DIVERGENCES IN MATERIALS PREPARATION TECHNOLOGY

Ceramic glaze's phase structure is characterized by its components and microstructure. Furthermore, the former is determined primarily by raw materials and recipe, whereas for the latter firing technology is critical. To understand the raw materials and recipe employed by ancient potters, modern scientific analysis of compositions is useful. Table 1 presents four major elements' oxide content in each single sample's body and glaze, including silica (SiO_2), alumina (Al_2O_3), calcite (CaO) and potassium oxide (K_2O).

Table 1. A brief compositions data of body and glaze in the present samples (All contents are in wt %.) (The detailed analytic data are attached in Appendix of the present book).

type/sample		SiO_2 B/G	Al_2O_3 B/G	K_2O B/G	CaO B/G
	Guan-1	67.4/66.02	25.24/15.8	4.68/3.94	0/14.23
I	Dayao-6	72.16/69.69	23.29/14.34	4.55/5.93	0/10.03
	Dayao-7	74.22/69.61	21.04/14.81	4.7/6.35	0/7.6
II	Dayao-9	69.25/69.95	24.76/14.27	5.4/5.81	0/9.07
	Dayao-1	72.34/68.35	20.64/15.65	5.05/5.68	0/8.84
	Dayao-2	72.5/68.5	20.13/14.44	4.73/5.96	0/10.08
	Dayao-8	72.59/69.57	22.17/15.72	5.24/5.75	0/8.47
	Dayao-3	73.53/68.2	20.54/15.63	5.03/5.33	0.9/10.84
	Aotou-1	73.12/70.8	18.71/13.66	5.64/6.77	0/7.25

Silica, Alumina and Calcite Content in SSG-style Longquan Celadon

Compared with SSG ware sample (Guan-1), nearly all SSG-style Longquan celadon samples, regardless of type I or II, unanimously had a higher silica content in body and glaze. Silica has an immediate relationship with matrix's viscosity of body or glaze. To increase silica content will increase the viscosity of body or glaze. In contrast, alumina content was largely lower in all samples, particularly for the body. In addition, calcite content in glaze was also significantly decreased.

If SSG ware's compositions are advantageous for the development of a heavily-crazed product, did such disparities in compositions cause SSG-style elite Longquan celadon's glaze to be craze-free and have a solid texture? At times, solid texture and craze-free are two sides of the same coin in ceramic manufacturing. Crazing occurs in a porcelain product due to thermal shock, caused by the existent difference of coefficient of thermal expansion (CTE) between body and glaze or among different phases within glaze. Thermal expansion of a glass ceramic is related to its composition, thermal history and internal structure, and involves a number of complicated variables (Darwish et al. 2001, 129).

The CTE's variation in terms of changing the content of calcite and alumina in a glass ceramic material was tested by some scientists. It reveals that increasing calcite will increase the CTE, whereas increasing alumina will decrease it (Salman and Salama 1985, 261). Therefore, to distinctly lower alumina in body and decrease calcite content in glaze correctly balances the CTE between body and glaze, and contributes to a craze-free SSG-style Longquan celadon product.

Potassium Content in SSG-style Longquan Celadon

However, potassium oxide content in SSG-style Longquan celadon samples is commonly higher, 5-6 wt %, than in SSG ware, in body and glaze. This was actually noted by several ceramic scientists (Tite et al. 2012, 43; Zhuo et al. 2005, 225–227; Li and Ye 1989, 148–149; Tichane 1978, 58; Hall et al. 1973, 66). Potassium ion is a crucial lubricant in a clay-like substance, such as muscovite [$Al_4K_2(Si_6Al_2)O_{20}(OH)_4$] in the ceramic body. As Norton (1952, 13) stated: "The bonding of the potassium ions is weak … but the bonds are strong enough to cause each layer to be accurately aligned with the next and to prevent water molecules from going between the layers."

Muscovite is a good accessory for developing the body's integrity and preventing water from entering. Potassium oxide in Longquan body primarily came from orthoclase ($KAlSi_3O_8$) and muscovite (Tite et al. 2012, 43). The former is a form of feldspar, and the latter is a clay-like mineral, both usually utilized by traditional Chinese potters. Therefore, theoretically, increasing potassium content is useful for solidifying the body and preventing craze from occurring.

In addition, potassium is also the primary deflocculant in glass ceramic materials, particularly in glaze. It results in better fluidity, decreasing aggregation of excess substance in the matrix of glaze, such as excess of calcite or clay (Li et al. 1989, 337). Furthermore, it not only aided with releasing thermal stress, caused by the interior structure of glaze and body in heat treatment process, decreasing thermal expansion, but also removed bubbles in glaze and created a relatively clean matrix, such as seen in more translucent and less opaque type II glazes (Askeland and Phulé 2006, 794).

DIVERGENCES IN FIRING TECHNOLOGY

As SEM images reveal, the additive quartz particles in SSG-style Longquan celadon bodies are commonly small-sized with rounded rims, whereas in SSG ware they are larger and slightly sharp (Figures 5a and 5b) (see also Appendix). In addition, most pores in the former are smaller and in isolated round shapes, whereas in the latter they are larger and connected. It not only implies the raw materials or additives were prepared more delicately, but also a more sufficient heat treatment process was employed in SSG-style Longquan celadon products than in SSG ware (Tite et al. 2012, 51; Sundius 1963, 437).

Firing Technology of SSG-style Longquan Celadon

In addition to the above-mentioned quartz particles' and pores' size and shape, the fine and even body matrix in SEM image also verifies SSG-style elite Longquan celadon had a more sufficient heat treatment process (Figures 6a and 6b). Ceramic's heat treatment technology not only requires controlling the top temperature, but also the rate of heating and cooling, and, moreover, the draft of the kiln chamber in the entire heat treatment process.

Previous researchers proved SSG ware to be an underfired product, with a top firing temperature below 1100°C (Tichane 1978, 56; Vandiver and Kingery 1985, 199; Tite et al. 2012, 51). It is apparently disadvantageous for solidifying the product. However, the top temperature range of SSG-style elite Longquan celadon was estimated at 1250–1280°C, a considerably high temperature (Zhou et al. 1989, 127; Vandiver and Kingery 1985, 199). This provided a more developed temperature and more complete heat treatment process.

Underfiring not only does not completely dry the body, but also results in a looser body structure. It could cause the body to reabsorb water after the product was drawn from the kiln. Particularly, if some cracks appeared on the final product's surface, it would cause crazing to be more severe. In fact, underfiring technology characterized SSG ware's craze morphology, moisture-crazing, displaying distinct parallel lines at times combining in a chicken wire pattern (Schurecht and Polk 1932, 636; Schurecht and Fuller 1931, 565).

However, perhaps underfiring technology was utilized by SSG ware's potters to prevent flooding of thick and heavy glaze. Then, if the thick glaze was still required and underfiring was not adopted, a new and feasible heat treatment technology should be necessary. Longquan potters first employed biscuit technology to dry and integrate the body. Several Chinese researchers recognized that, to a considerable degree, biscuit technology was commonly utilized by Song potters, based on archaeological materials, however, Longquan potters probably further intensified biscuit technology (IACASS et al. 1996, 14; Zhu 1989, 65).

A magnification of Dayao-6 sample's cross-section displays the body's two sides, particularly the exterior close to the boundary of body and glaze, vitrified to translucent white, rather than coated with a layer of white slip, indicating intensified biscuit technology (Figure 7). In fact, Longquan biscuit technology not only helped with drying the body, but also solidifying the body.

Heat treatment process determines the final ceramic product's style and quality. Glaze hue is the most critical trademark of all Song elite celadon products. *Fen-qing* or *meizi-qing* hue glaze was SSG-style elite Longquan celadon products' trademark. In order to create the hue, a stronger reductive atmosphere within the kiln was required in the entire firing process (Li et al. 1989, 343; Zhou et al. 1989, 127–128). In fact, SSG-style elite Longquan celadon products maintained more uniform hue and quality than SSG ware or even other Song elite celadon products.

TECHNOLOGICAL CONVERGENCES

Although in the entire manufacturing process, SSG-style elite Longquan celadon technology distinctly has some variations from SSG ware; after all, it was still intentionally following SSG ware style to create its elite commercial celadon. Therefore, theoretically, it still had to maintain, to a considerable degree, SSG ware technological characteristics. As previously viewed composition data, although there are some specific divergences, few convergences are also apparent.

For instance, some inclusions, titanium oxide or zircon grains in body and calcium phosphate grains in glaze, commonly appeared in SSG-style elite Longquan celadon and SSG ware (see also Appendix). It asserted that both potters shared some common technological information, particularly related to raw materials, additives and recipe.

In addition, according to microstructure images, mullite and anorthite commonly appeared in SSG-style elite Longquan celadon and SSG ware's body and glaze. Mullite ($3Al_2O_3 \cdot 2SiO_2$), needle-shaped crystals are formed in body, and anorthite ($CaO \cdot Al_2O_3 \cdot 2SiO_2$), needle- or column-shaped crystals are formed in glaze close to the interface between glaze and body (Figures 8a and 8b) (see also Appendix). Whether both were formed or unformed or even remained in a specific crystal-developing stage in the final product depends on individual thermal conditions and history that involves time, temperature and transformation variables controlled in heat treatment process (Uhlmann 1972, 339).

Crystallization in a glass ceramic material could be separated into two sequentially physical processes: (1) nucleation of crystallites; and, (2) growth of crystallites (Chiang et al. 1997, 432). However, viewing the microstructure images of both SSG-style Longquan celadon and SSG ware, mullite in body and anorthite in glaze remained in identical crystallization stage, proceeding crystallites growth. If this situation is the most ideal, it is apparent that both potters should have a considerable degree of identical heat treatment technology, particularly in controlling the heating and cooling rate.

However, although it is difficult to establish an equivalent relationship, which technological variations created the various characteristics in SSG-style elite Longquan celadon that differentiated it from SSG ware, or which convergences created the common characteristics of both, without those technological divergences the uniqueness of SSG-style elite Longquan celadon could not have been achieved, and without those convergences Longquan potters could not create a SSG ware style product—SSG-style elite Longquan celadon. Thus, regardless of divergence or convergence, they all created the technological particularity of SSG-style elite Longquan celadon.

CONCLUSION

According to glazes' phase structure, type I, the *fen-qing* hue glaze apparently has more characteristics common to SSG ware, such as rich flocculated substance, which caused Dayao-6 to display as relatively opaque appearance. It indirectly proved that some Longquan potters actually possessed SSG ware technology and the capability to manufacture a product similar to SSG ware. However, some technological adjustments had been accomplished in Dayao-6.

In fact, according to Longquan kiln sites' excavations, such as Dayao and Xikou, identical SSG ware's fragments, in thin black body with thick *fen-qing* glaze, were found (Zhu

1989, 66; Zhu 1998, 18–19; Tokudome 2012, 33–34). It implied Longquan potters could manufacture SSG-style elite Longquan celadon product and SSG ware simultaneously. Therefore, although the technological accommodation between both is still a debated issue, the fact that is Longquan potters had SSG ware technology (Chen and Zhou 1995, 185; Li 2004, 118–119; Tokudome 2012, 36; Zhou 2013, 17).

With type II, the *meizi-qing* hue glaze's phase structure distinctly displays considerably difference from SSG ware, as the minimal flocculated substance causing the glaze to be more translucent and less opaque. Moreover, to create such unique greenish hue, although previous researchers had various explanations, such as stronger reductive atmosphere, or titania additive function, the glaze's phases characteristic should play a critical role (Li et al. 1989, 343; Kingery and Vandiver 1983, 1273).

Regardless of subtly nuanced hues of type I and II glazes, they all commonly display solid texture and craze-free appearance. In addition to raw materials and recipe controls, firing technology employed should be crucial, with a higher top temperature and more complete heat treatment process than SSG ware. With both divergences and convergences in SSG ware technology, Longquan potters created the technological particularity that achieved their SSG-style products' uniqueness. It seems to be apparent that, when cross-technological exchange or application had become a trend in the thriving development of Song ceramic industry, Longquan potters exhibited the greatest potentiality and flexibility for technological innovation (Yang 2016, 141–155).

Chapter 3

Marketing and Market Value: Hoards in Eastern Sichuan

As a worldwide famous trade ceramic, Longquan celadon products' archaeological materials could come from kilns, tombs, hoards, houses, docks, shipwrecks and overseas transaction sites. It is a massive research resource. Although kiln sites' material is crucial for understanding ceramic production and contemporary market demand, it is somewhat difficult for viewing products' distribution and consumption, and particularly for providing the information related to products' marketing.

Focusing on domestic market, the archaeological materials coming from tomb, hoard and house sites probably directly indicate products' distribution, consumption and market value, the present concern. In general, tomb artifacts are associated with local funerary custom, fixed in some specific genres (see also Chapter 1). In addition, house sites completely preserved or found are too sparse to provide useful information related to the present study.

Hoard site creation is usually explained to be a consequential relic of local riot or brutal war (Zhang 2007, 106; Li 1994, 30–31). People used to hide some valuable items in a secret site, temporarily, in order to prevent them from being destroyed or stolen when the society was in a very unstable situation. However, those hoards were sometimes never retrieved. Therefore, hoards usually possess an essential nature—valuableness. The 'valuableness' is a considerably complicated concept, immediately associated with contemporary value system, always changing with economic and societal shifting.

During the final decades of Southern Song (SS 1127–1278), many hoard sites were created that usually contained a considerable amount of elite Longquan celadon products. Does this phenomenon imply elite Longquan celadon to be valuable at that time? Archaeological hoards actually provide crucial information for exploring the circulation of elite commodities under contemporary market mechanisms and consumers' free will. The objective of the present study is, in terms of archaeological hoards in eastern Sichuan, to explore elite Longquan celadon products' marketing and market value, and to further understand contemporary elite ceramics consumption pattern.

HOARDS' ATTRIBUTES AND ELITE COMMODITIES' NATURE

Hoarding in different periods of Chinese history possesses various social and cultural significances. Archaeological workers usually unearthed a batch of intact artifacts from some pits or spaces, neither waste pits nor tombs or house sites, but hoard sites. Current archaeological materials reveal that the final decades of Western Zhou (WZ 1046–771 BC) and SS are two peak periods for hoard sites' creation in ancient China (Zhang 2007, 105; Cai 2010, 46).

Hoards' Attributes

As previously mentioned, hoards are valuable, and, the valuableness is a complicated concept rather than simply signifying a high price. Value and price are not completely equivalent, depending considerably on a given circumstance (Simmel 1978, 95). Bronze object with owner's family inscription, such as an heirloom, is one-of-a-kind hoard in WZ (Zhang 2007, 105–106). Bronze was monopolized by the king and nobles, and represented the owner's status and social class in that period. It is pointless to deny that bronze hoard was valuable and a symbol of elite class in WZ society.

However, in a completely different cultural context, in addition to gold, silver or bronze objects, a considerable amount of elite ceramic objects was hoarded, implying few specific kilns' products were valuable in SS society. Different periods with varying social value systems determine the hoards' species and attributes. To distinguish WZ hoards' attributes from SS hoards is similar to distinguishing gift from commodity. According to Appadurai's (1986, 11–12) definition of both, it is "… gifts link things to persons and embed the flow of things in the flow of social relations, commodities are held to represent the drive—largely free of moral or cultural constrains—of goods for one another, a drive mediated by money and not by sociality."

Bronze hoard in WZ is a sort of gift, whereas elite ceramic hoard in SS is elite commodity. The former was formally sent by Zhou king, symbolizing high glory to those owners and their families, and usually used in some formal ceremonies (Ihuel 2008, 99). Theoretically, gift is unable to be freely exchanged. In contrast, the latter is freely exchangeable in the market, possessing elite commodity or luxury market value.

Nature of an Elite Ceramic Commodity

As Kopytoff (1986, 64) stated, 'commodity' is "an item with use value that also has exchange value." Moreover, the exchangeability of a commodity determines its market value. However, commodity is usually distinguished by two classes, 'luxury' and 'necessity,' or 'elite' and 'utilitarian,' or other similar dichotomous terms, based on their function, quality or market price (Simmel 1978, 90-91; Rice 1981, 222; Kopytoff 1986, 68–70).

The latter is of ordinary quality for daily usage and fair-priced or even low-priced. In contrast, the former is usually high-quality, high-priced and even valuable, with an emphasis on satisfying the consumer's enjoyment. However, in traditional value system, valuables are referring to those highly value-preserved items, such as gold, silver or bronze objects, because raw materials themselves are durable, rare and precious. Moreover, according to SS government's ban on luxury goods, the above three metal objects were enumerated (Shiba 1968, 469).

Unlike durable and tough metal, ceramics are fragile, usually regarded as consumables. However, beginning with Song Dynasty (960–1278), ceramic manufacturing technology was energetically developed, greatly raising products' quality and transcending traditional stereotypical impression as consumables. Particularly, the court's adoption of specific kilns' products as formal ritual objects to partly replace bronze usage further stimulated and encouraged elite ceramics creation and production. At the same time, it also gradually changed people's value system of a ceramic commodity.

Elite ceramic became one of the value-preserved commodities, a luxury free of government's ban in SS society. In addition to royal family and government officers, it was actually also attracting rapidly-rising wealthy middle class members, particularly rich merchants who were rushing to demand elite ceramic commodities to acquire social identification of their new status (Tregear 1982, 14; Atago 1977, 151–152). A sizeable market demand for elite Longquan celadon was reflected by the considerable number of archaeological hoards in Sichuan during late SS.

SICHUAN'S ELITE CERAMIC HOARDS

Current archaeological materials reveal that eastern Sichuan, a prosperous place during SS, is one of the most concentrated areas of hoard sites, because here suffered from brutal destruction in the final decades of SS due to Mongolian invasions, when some rich people hid their valuables in a pit or underground chamber before fleeing (Bi 1957, 4639–4640; Li 1994, 30). The number of hoards varied considerably, a few sites held around one thousand pieces, or several hundred, and most a couple of dozens (CICRA and SMM 2012, Appendix 1; Tokudome and Yokoyama 2012, 165). However, all hoards were arranged in a neat and space-saving manner.

Elite Ceramic Hoard Sites in Eastern Sichuan

In addition to a few sites hiding gold, silver or bronze objects, most SS hoard sites hid elite ceramic, primarily contemporary Longquan celadon and Jingdezhen Qingbai porcelain products with a few other kilns' wares in eastern Sichuan. Sichuan, in the southwest of China, is nearly two thousand kilometers from Longquan, Zhejiang province today, and at least one thousand kilometers from Jingdezhen, Jiangxi province. In general, the distance is also a criterion to determine the commodity's market price, the more distance between the commodity produced and location exchanged, the higher the market price.

Although distance is not completely referring to physical distance, and sometimes there are some intermediate stages to acquire that desired commodity, the actual distance still has a concrete influence on the commodity's price (Simmel 1978, 91). Sichuan, a somewhat remote place from Longquan or Jingdezhen, two of the largest and most famous elite ceramic production centers in SS, primarily relied on transportable waterway system to acquire both elite products.

Waterway is always the fastest and cheapest transportation system in ancient China. Particularly, the Yangtze River and her many branches form a very convenient waterway network, which connects the prosperous eastern coast with inland areas in the South of China. Most hoard sites were located along branches of Yangtze River in eastern Sichuan. For instance, sites in Suining (遂寧) and Santai (三台) were alongside Fujiang river (涪江),

Jianyuan (簡陽), Chengdu (成都), Pengzhou (彭州) and Shifang (什邡) alongside Tuojiang river (沱江), Qingshen (青神) and Emeishan (峨眉山) alongside Minjiang river (岷江), and Jiange (劍閣), Langzhong (閬中), Yingshan (營山), Wusheng (武勝) and others alongside Jualingjiang river (嘉陵江) (CICRA and SMM 2012, Appendix 1; Tokudome and Yokoyama 2012, 165).

It means that these hoards' owners mostly lived along transportation-convenient cities or towns, where local elite class members and rich merchants were also congregating (Xu 1976, 5). Thus, it is seemingly a reasonable supposition that current archaeological hoards in eastern Sichuan belonged to local elite classes' or rich merchants' treasure or stocks.

In fact, eastern Sichuan is southwest China's most crucial goods' concentration center, particularly for those high-value economic goods, such as medicine, silk, cloth and others. Periodically, boats brought Sichuan's goods downstream to eastern coastal cities, including Hangzhou, the capital and largest goods' concentration center in SS. However, on the return journey, those boats traveled against the stream, usually carrying only high-profit goods (Shiba 1988, 323). It is surmised that elite Longquan celadon and Jingdezhen Qingbai products should be the major cargo on the return journey.

Two Paradigmatic Elite Ceramic Hoard Sites

Elite ceramic hoards were usually deliberately arranged in a large-sized pottery or iron jar, in a space-saving manner, with majority of identically shaped bowls or dishes together centered around the minority of variously shaped objects, such as vases, pots or incense burners (Figure 1). Then, filling in a large amount of sand prevented them from crashing into one another. After covering with a stone plate or other container as lid, the hoard jar was deposited in a secret pit or site (CICRA and SMM 2012).

In addition, building an underground chamber or using a discarded tomb chamber was also usual (Zhang 1984, 85; Huang 2013, 80). At times, the owner separated his hoards into two or more batches to hide in various sites. For instance, the second hoard site found at Jinyucun (金魚村), Suining, is not far away from the first site (CICRA and SMM 2012, Appendix 1). And, the second hoard site found in Emeishan is only seven meters away from the first site (SPCRARI and Emeishan Shi Wen Wu Guan Li Suo 2003). To separately hide at different sites is to lower risk of losing them.

Unfortunately, many ancient hoard sites were casually destroyed in the past. Two completely preserved elite ceramic hoard sites in eastern Sichuan are Jinyucun in Suining and Yuanyichang (園藝場) in Dongxi (東溪), providing crucial materials for the present study (CICRA and SMM 2012; Sichuan Sheng Wen Wu Guan Li Wei Yuan Hui 1987). Although the latter attribute and date are still somewhat debated, as an early Yuan tomb or late SS hoard site, its elite Longquan celadon products' style, quality and genres are similar to the former, asserting its attribute to be identical to the former.

Moreover, such an unusually large amount of homogeneous elite ceramic hoards found in the two sites, Suining site more than 900 and Dongxi site around 500 pieces, implied that both were probably local traders' stock, rather than family's store (Fontijn 2008, 5). However, a few hoard sites are probably local elite class members' stores because of a small quantity. For instance, at Baduhe (八渡河) site in Lüeyang (略陽), Shaanxi, close to the boundary of eastern Sichuan, only 33 pieces were hoarded (Hanzhong Di Qu Wen Hua Quan and Lüeyang Xian Wen Hua Quan 1976).

DISTRIBUTION OF ELITE LONGQUAN CELADON PRODUCTS

The quantitative distribution of elite Longquan celadon and Jingdezhen Qingbai porcelain products in Suining and Dongxi sites is presented in the following pie charts (Figures 2a and 2b). Thirty-five percent of total ceramic hoards in Suining and 44% in Dongxi belonged to elite Longquan celadon, whereas 62% in Suining and 38% in Dongxi to Jingdezhen Qingbai porcelain. Moreover, summing up both elite ceramics, the sum is 97% in Suining and 82% in Dongxi, respectively. It means that other kilns' products constitute a very small percentage (CICRA and SMM 2012; Sichuan Sheng Wen Wu Quan Li Wei Yuan Hui 1987).

In fact, this percentage of elite Longquan celadon, 35–45%, was common in eastern Sichuan and surroundings ceramic hoard sites. At Baduhe site in Lüeyang, among 33 pieces of ceramic hoards found in 1968, there were 15 pieces of elite Longquan celadon, 46%; whereas Jingdezhen Qingbai amounted to 11 pieces, 33% (Figure 2c) (Hanzhong Di Qu Wen Hua Quan and Lüeyang Xian Wen Hua Quan 1976).

At Langzhon site in eastern Sichuan, among 77 pieces of ceramic hoards, there were 22 pieces of elite Longquan celadon, 28%, somewhat low, whereas Jingdezhen Qingbai amounted to 43 pieces, 56% (Figure 2d) (Zhang 1984). Obviously, elite Longquan celadon and Jingdezhen Qingbai porcelain were two keenly competitive rivals, and monopolized contemporary elite ceramic market. Such evenly matched adversaries provide the best commercial competitive model that effectively promotes product's quality and balances market price.

However, did the above distribution really reflect the two elite ceramic brands' market share and competitiveness? In fact, in a few sites, either Longquan celadon or Jingdezhen Qingbai were the only ceramic hoards' products. For instance, at Zhongba (中坝) site in Zhongxian, 21 pieces of elite Longquan celadon ware were found with some local kilns' products, without Jingdezhen Qingbai (SPCRARI et al. 2001). In contrast, at Emeishan site, 56 pieces of Jingdezhen Qingbai ware were found without Longquan celadon (SPCRARI and Emeishan Shi Wen Wu Guan Li Suo 2003, 20).

Behind such explicit elite ceramics market shares, a certain degree of free will with limited options—either Longquan or Jingdezhen, or both—is actually also reflected. Then, what factors caused both to possess absolute predominance in contemporary elite ceramic market? And what kind of marketing strategies were employed by Longquan potters to successfully exploit their product during SS?

MARKETING OF ELITE LONGQUAN CELADON

Statistics for Best-selling Items

An inventory of archaeological elite ceramic hoards in eastern Sichuan reveals a majority of tableware and teaware, including bowl, dish, cup and basin, whereas worshiping utensils or decorative objects, such as flower (or wine) vase, incense burner, box and others were in the minority. Furthermore, it is also apparent that bowl and dish dominated Jingdezhen Qingbai porcelain, whereas flower (or wine) vase and incense burner dominated Longquan celadon (Figures 3a and 3b).

Figure 1. Ceramic hoards were arranged in a space-saving manner (After CICRA and SMM 2012, 8).

Site\items	1. Longquan	2. Jingdezhen	3. other kilns	Total
Suining	338	598	28	964
Dongxi	231	198	96	525

Figure 2a (left). Pie chart of Suining ceramic hoards.
Figure 2b (right). Pie chart of Dongxi ceramic hoards.

Lüeyang

■ 1 ■ 2 ■ 3

- 46%
- 21%
- 33%

Langzhon

■ 1 ■ 2 ■ 3

- 16%
- 28%
- 56%

Site\items	1. Longquan	2. Jingdezhen	3. other kilns	Total
Lüeyang	15	11	7	33
Langzhon	22	43	12	77

Figure 2c (left). Pie chart of Lüeyang ceramic hoards.

Figure 2d (right). Pie chart of Langzhon ceramic hoards.

Suining

kiln/genre	bowl	dish	basin	cup	vase	burner
Longquan	51	51	54	67	35	9
Jingdezhen	220	402	0	33	25	6

Figure 3a. Histogram of ceramic hoard items in Suining.

Dongxi

kiln/genre	bowl	dish	basin	cup	vase	burner
Longquan	45	103	18	21	22	17
Jingdezhen	61	125	0	8	2	0

Figure 3b. Histogram of ceramic hoard items in Dongxi.

Figures 4a and 4b. Bowl with lotus petals design, and cup with cover and lotus petals design. Suining City Museum (After Asahi Shimbun 1998, Pls. 50 and 60).

Figure 5a (left). Longquan celadon *li*-shaped incense burner. Suining City Museum (After Asahi Shimbun 1998, Pl. 22).

Figure 5b (right). A contemporary archaic bronze (After CICRA and Pengzhou Municipal Musem 2009, 61).

Hoards in Eastern Sichuan | 41

Figure 6a (left). Archaic bronze *cong* (After CICRA and Pengzhou Municipal Musem 2009, 61).

Figure 6b (middle). Archaic stone *cong*. Suining City Museum (After Asahi Shimbun 1998, Pl. 135).

Figure 6c (right). Longquan celadon *cong*-shaped vase. Suining City Museum (After Asahi Shimbun 1998, Pl. 7).

Figure 7a (left). Mallet-shaped vase with phoenix décor. Songyang County Museum (After Zhu 1998, Pl. 115).

Figure 7b (middle). Mallet-shaped vase with fish décor, found in Sinan wreck. National Museum of Korea (After Shen 2012, 144).

Figure 8 (right). Bottle-shaped Longquan vase. Suining City Museum (After Asahi Shimbun 1998, Pl. 5).

Tableware or teaware is immediately associated with food customs, which have strong regionalism. For instance, China's southern and northern food customs are distinctly different, also reflected in individual tableware and teaware choice. Jingdezhen Qingbai tableware, following northern white porcelain style, dominated the eastern Sichuan elite ceramic market that implied a larger proportion of wealthy population coming from the northern immigration, still keeping northern food customs during SS.

According to demographic data, Sichuan's population experienced at least three massive migration waves between late Tang (618–907) and late Northern Song (NS 960–1127) (Wu 2006, 281–285; Cai 2010, 46). An extensive migration occurred during late NS due to brutal wars between NS and northern Liao (916–1125) and Jin (1115–1234) that brought northern Han to the South in massive numbers. Sichuan was one of the most ideal places for northern immigrants. It partly explains Jingdezhen Qingbai tableware's dominance in eastern Sichuan during SS.

In contrast, Longquan celadon represents southern ceramic style. Elite Longquan celadon bowl or cup with carved lotus petal design, a Buddhist symbol, was particularly welcome by local Sichuan residents due to Buddhism flourishing there. At Suining site, among 51 elite Longqaun celadon bowls, 43 pieces are in such design, and among 67 cups with lid, there are 58 pieces, nearly 85%. Similarly, at Dongxi site, there are 42 pieces among 45 elite Longquan celadon bowls.

In fact, lotus petal design bowl was commonly known as elite Longquan celadon branded product at that time. Outside of Sichuan, at Xiao Xian (筱縣), Hunan province today, 38 elite Longquan celadon products were found in a ceramic hoard site. And, among 11 bowls, 8 pieces are in this style (Zhuzhou Shi Wen Wu Quan Li Chu 1999, 150). A specially-designed product to create individual branded commodity is the most efficient marketing strategy seemingly known by Longquan potters during SS.

Creation of Branded Products

As Pamela Robertson (1998, 24) argued: "Any successful business is generally good at new brand development …" However, the creation of branded products requires skill and innovative ideas. The former includes glaze technology, forming, decorative and other practical techniques. The latter requires sufficient creative resources. Viewing SS elite Longquan celadon branded products, three resources are primary: (1) local tradition, referring to popular art; (2) contemporary archaic objects, particularly ritual bronze; and, (3) Southern Song Guan (imperial) (SSG) ware.

Then, how did Longquan potters apply those resources to create their new branded products and sublimate them to elite commodities? As previously mentioned, elite Longquan celadon bowl or cup with carved lotus petals derives its uniqueness from its lotus petal design. The design's idea came from earlier Longquan worshiping products, particularly five tube vase (or jar) (see also Chapter 1). A single row of long and overlapping lotus petals was carved in relief on a bowl's or cup's exterior, creating the appearance of a lotus flower in full bloom in beautiful *fen-qing* or *meizi-qing* hue (Figures 4a and 4b; Pls. 9 and 10).

However, the most conspicuous elite Longquan celadon branded products should be several specially-designed flower vases and incense burners. Their designs were mostly based on contemporaneous archaic bronze objects, such as *ding* (鼎), *gui* (簋), *li* (鬲) and other ritual objects. For instance, the type of *li*-shaped incense burner was commonly welcome, casting off ritual bronze object's rigidness to create a sort of unique celadon smoothness (Figures 5a and 5b).

In addition, *cong* (琮)-shaped flower vase's prototype is archaic bronze or jade (or stone) *cong* object (Figures 6a, 6b and 6c; Pl. 11) (CICRA and Pengzhou Municipal Museum 2009, 55; CICRA and SMM 2012, 15). However, unlike bronze *cong* sealed at both top and bottom, or jade *cong* open at both top and bottom, an elite Longquan *cong*-shaped vase had a bottom that functioned as a workable flower vase. Furthermore, to simplify designs and intensify those precise horizontal ridges, Longquan artisans not only created the unique style of *cong*-shaped celadon vase, but also a functional worshiping or decorative object.

Others, such as mallet-shaped vase with phoenix or fish décor (handles) (Figures 7a and 7b; Pls. 12 and 13), should derive its creative idea from identical shape of SSG ware (see Figure 5 in Chapter 10). In addition, the elite Longquan celadon bottle-shaped vase, unlike SSG ware's over-emphasized dignity and decorum, has a sort of easy and pleasant impression (Figure 8).

However, in addition to form, design and special décor, the most enchanting trademark of elite Longquan celadon would be its beautiful *meizi-qing* or *fen-qing* hue glaze and craze-free appearance, giving a sort of faultless commodity impression. This subtle celadon hue successfully followed SSG ware color style to become the most conspicuous trademark and powerful marketing tool. All elite Longquan celadon hoards found in eastern Sichuan are in such beautiful hue.

Marketing Branded Products to SS Society

Creating branded product concept should have begun before this term acquired its modern usage in China. However, whether a branded product can achieve successful marketing depends on contemporary market mechanisms in pre-industrial period. Moreover, to judge a branded product's marketing, a crucial criterion is whether or not it possesses considerable degree consumers' collective perceptions (Holt 2004, 3).

Modern business by means of various media advertisements, via magazine, newspaper, post, broadcast or television and others, transmit commodity's information to attract potential buyers. However, in pre-industrial SS society, a couple of avenues were available to transmit commodity's information. First, people enjoyed sharing some commodity's information, particularly those intellectuals who recommended some skillful crafts or branded products in their conversation or writings (Meng 1962, 29–30; Wu 1962, 310–311).

Secondly, because the court paid attention to craftsmanship, SS government systematically established contemporary craftsman archive (Bao 1986, 51). Thus, much information related to those masterful potters' craftsmanship and artworks was acquirable at that time. Thirdly, to most buyers or investors of elite ceramics, the most immediate information should come from transaction agents, called 'yaren 牙人,' who provided useful information and relevant service, particularly with those high-profit branded commodities, for simple and fluent transactions (Shiba 1968, 391–400). Elite Longquan celadon marketing benefited greatly from energetic commercial environment during SS.

CONSUMPTION PATTERN AND MARKET VALUE

Consumption Pattern of SS Elite Ceramics

The consumption pattern of elite ceramics in late SS—choosing either Longquan celadon or Jingdezhen Qingbai or both—projected the two ceramic brands' monopolization of

contemporary market. Then, what factors created their predominance? And what driving force guided consumers' choice? Purchasing itself is a complicated human social behavior. Consumers value an elite brand product not only to satisfy their enjoyment in life, but also to construct their identities of social status or economic power (Holt 2004, 4; Simmel 1978, 65). These motivations powerfully drive buyers pursuing some specific branded products.

As previously mentioned, several innovative ideas of elite Longquan celadon branded products came from archaic bronze objects or SSG ware during SS. The former represented contemporary elite class members' ideological trend. And, the latter was SS imperial ware, leading contemporary mainstream art and fashion. Fashion usually guided people to cohere with the largest common taste. Elite Longquan celadon not only closely followed elite classes' ideological trend (see also Chapter 1), but also intelligently embraced SSG ware's unique art and aesthetic that benefited its brand's marketing.

Similarly, Jingdezhen potters began by following the NS imperial ware—Ding white ware style—and later developed Ding-like white porcelain with somewhat bluish hue, the elite Qingbai porcelain (Kerr 2004, 102–103). It means elite Jingdezhen Qingbai porcelain actually also benefited from NS imperial ware (Yang 2016, 148). However, although Longquan celadon and Jingdezhen Qingbai commonly had imperial ware corona shadow, in branded products' creation, the former distinctly had larger innovative potentiality than the latter.

Integrally viewing the elite ceramics consumption patterns in late SS society, Jingdezhen Qingbai tableware was dominant, and Longquan celadon worshiping or decorative objects, particularly those branded flower vases and incense burners, owned the largest market share.

Market Value of Elite Longquan Celadon

Once individual reputation is established, those elite branded products probably controlled their market price and determined their market value in various ways, such as in terms of supply and demand ratio. In a normal commercial environment, market value had a relative relationship with market price. And, market price of each single commodity determined involves all costs and services in entire production line and marketing chain. They covered materials supply, human power employment, technology application, transportation system, commodity circulation and other services.

In addition, the political, economic and social environments must be also considered, such as central government and district taxes, and transaction risk in an unstable economic or social situation. During SS, ceramic production line had been organized into very detailed division of labor. A high market-priced commodity, theoretically, should be made of the best raw materials with the most sophisticated skill and unique and elaborate design. It requires a great deal of time to perfect. Such a set of evaluation mechanisms assured elite commodities' availability at a more reasonable market price.

Thus, for instance, tableware dominated by Jingdezhen Qingbai porcelain was able to be massively produced. Therefore, even those bowls or dishes that were Jingdezhen Qingbai porcelain branded products could be offered at a lower market price, relatively lowering their market value. In contrast, to produce flower vase or incense burner that dominated Longquan celadon, each single flower vase or incense burner required special design, technology and additional time that certainly limited production amount. Thus, they had a higher market price, relatively raising their market value.

Therefore, although the integral market share of elite Longquan celadon is somewhat lower than Jingdezhen Qingbai porcelain, it is actually reasonable to estimate the former should have a higher market value and profit than the latter.

CONCLUSION

A lack of copper resources and coin casting system disorder resulted in coins' loss of actual value. The SS government was forced to produce paper money to replace copper coin circulation (Inoue 2006, 218–19). However, it caused serious inflation, particularly during late SS. A large amount of paper money didn't signify a real substance to contemporary people who bought and stored some valuable items as treasure rather than keep a large amount of paper money. The socioeconomic crisis largely benefitted elite goods' market.

Moreover, the ban on luxury goods, limiting gold, silver and bronze object's transaction, drove wealthy people to choose elite ceramics, such as elite Longquan celadon or Jingdezhen Qingbai porcelain branded products. The present hoard sites' materials reveal that ceramic product was elevated to value-preserved commodity for the first time in Chinese ceramics history. At the same time, it also reflects a value system change and a new elite ceramic consumption pattern in SS society.

Elite Longquan celadon and Jingdezhen Qingbai porcelain became two keenly competitive commercial rivals in contemporary elite ceramic market, possessing individual characteristics and predominance in production and marketing. However, Longquan potters were seemingly more sensitively following SS elite class ideological trend and art mainstream. Particularly, various designs of flower vase and incense burner became the successfully-marketed branded products, nearly monopolized both domestic and overseas elite ceramics markets at that time.

Chapter 4

Single-Generation Technology: SSG-style Elite Products

Transferring ceramic technology in traditional potter training system has a very long history in ancient China that assures technological continuity. However, when ceramic manufacture developed into a considerably complicated high-temperature firing technology, usually over 1200°C, was this training system still viable? A certain degree of unpredictability, uncontrollability and inarticulateness not only characterized Song elite ceramic technology, but also likely projected contemporary potters' dilemma of continuing those specifically delicate technologies.

For the past century, ceramic scientists have usually been surprised by those incredible technologies practiced in ancient China, completely undertaken without any modern scientific aid. Spontaneous reactions and multiple variables in a high-temperature heat treatment process make technology itself difficult to completely control and articulate; that actually also becomes a potential crisis to maintain or continue the technology for more than one generation.

Beginning with middle Southern Song (SS 1127–1278), a few Longquan potters introduced Southern Song Guan (imperial) (SSG) ware technology to create their unique SSG-style elite Longquan celadon during late SS. However, after the end of SS, the everglorious SSG-style elite Longquan celadon was no longer produced, and the replacement was a somewhat varied and inferior sequent celadon product during early Yuan (1271–1368). Was the SSG-style elite Longquan celadon technology lost or changed?

Although ceramic technological change is usually discussed by Western archaeologists or anthropologists, they primarily focus on low-temperature firing technology and humanitarian concerns (Dunnell 1978; Basalla 1988; Schiffer and Skibo 1997; Loney 2000). Low-temperature firing technology, usually lower than 900°C, doesn't sensitively or critically influence pottery quality or style, whereas high temperature would subtly influence the final product quality and artistry.

Moreover, with high-temperature pyric technology it is difficult to establish an equivalent connection between the technological details and the final product's nuances in quality or style. This difficulty should cause ancient empirical potters considerable stress. In fact, even for modern ceramic scientists, who probably appeal to scientific aid to more efficiently and precisely record and control each single procedure and detail in firing process, determining the connection is still an enormous challenge.

Archaeological evidence revealed Song potters made a considerable effort to determine some critical connections. However, it was very limited. This sort of technological powerlessness eventually resulted in specific critical technologies surviving for only a single generation. The present study, in terms of SSG-style elite Longquan celadon case, explores which technologies survived for only a single generation? And, why were in traditional potter training system those technologies unable to be continued?

TECHNOLOGICAL GENERATION IN ELITE LONGQUAN CELADON

'Generation' Concept in Traditional Ceramic Technology

'Generation' is usually defined under the framework of an axis of lineage family and society system (Biggs and Lowenstein 2013, 160–161). Particularly in ancient China, crafts inheritance strictly followed this axis. Therefore, single-generation technology not only means one-generation potters' skill, but also reflects the same generation's common social experience, value system, cognition and even aesthetics (Biggs and Lowenstein 2013, 165).

To create a new ceramic technology and perfect a novel product style, from familiarity with new materials to improving form for more stable, streamlined and smoother fabric and appearance, requires around 50 years (Loney 2000, 651). One or two generations of potters' efforts are required, around 30–50 years. Although Song potters had the most advanced and sophisticated skill at that time worldwide, to perfect a new technology for new product style was still a time-consuming task. Moreover, it also depends on the contemporary society's support.

As previously mentioned, SS government was enthusiastically encouraging ceramic production, and energetically supporting market mechanisms for products' circulation and consumption (see also Chapter 3). In addition to maintaining the waterway transportation system and vivifying commercial activities, several preferential strategies were released, including replacing the official forced labor by paying crafts business tax, and others (Bao 1986, 53–54). It is apparent that contemporary society provided considerable support to accelerate developing some novel ceramic technologies and products.

Three Generations of SSG-style Elite Longquan Celadon Technology

Scheme 1 illustrates three generations of SSG-style elite Longquan celadon technological development, from middle SS to late Yuan. And, some archaeological materials, such as Suining (遂寧) hoards and Sinan (新安) wreck salvages and others, also provide indicative products for determining each single generation's technological characteristics.

Following the Five Dynasties (907–979), for several generations products resembling Yue ware style Longquan celadon, in thin glaze with brown-yellowish or gray-greenish hue, primarily supplied local populace. However, beginning with middle SS, a few Longquan potters tried a new product style—SSG-style celadon—of high quality for contemporary elite class consumers. They were the first generation of potters, creating the first-generation SSG-style Longquan celadon technology, targeted at imitating SSG ware style.

However, the first-generation technological uncertainty and immaturity were completely presented on two pieces of Suichang (遂昌) jars (Figures 1a and 1b). Although the glaze's thickness and hue are similar to SSG ware, the integral expression looks dull. It is apparent that the new technology still required further refining and perfecting. Then, around the

beginning of late SS, a greater quantities of perfect SSG-style elite Longquan celadon products began circulating in domestic ceramic market and even overseas.

This indicates the second generation of technological achievement. The typical products are in somewhat thick glaze with *fen-qing* or *meizi-qing* hue and solid texture, as well as craze-free. Nevertheless, as previously emphasized, they are not SSG ware's duplicate, but unique elite celadon product with SSG ware's essence (see also Chapters 1 and 2). The Suining hoards are the representative products (Figures 2a and 2b; Pls. 14 and 15) (see also Chapter 3) (CICRA and SMM 2012). Thus, it is surmised that around the 1220s–1260s was the peak of second-generation technology.

The most elegant SSG-style Longquan celadon branded products were mostly second-generation technological achievements, such as *cong*-shaped vase, mallet-shaped vase with phoenix or fish décor, *li*-shaped incense burner and others. However, in the final decade of SS, this technology was seemingly quickly disappearing. Following the third generation, technology clearly had a distinct divergence from its predecessor. Sinan wreck preserved a specific amount of early Yuan-style elite Longquan celadon products, representing this generation's technology (Figures 3a and 3b; Pls. 16 and 17) (Cho 2012, 21; Mori 2013, 152).

In fact, after early Yuan, SSG-style elite Longquan celadon products seemed to completely disappear. Some good-quality Longquan celadon hoards excavated from Yuan old city sites in Jininglu (集寧路) and Yanjialiang (燕家梁), Inner Mongolia today, represented the middle and late Yuan style (Figures 4a and 4b) (IMICRA 2004, 22; IMICRA and Baotou Shi Wen Wu Guan Li Chu 2010, 492–511 and 646). When early Ming (1368–1644), SSG-style elite Longquan celadon products were intentionally recovered by a few Longquan potters, however, actually found to be in various styles (see also Chapter 6). It verified SSG-style elite Longquan celadon technology had been completely lost after early Yuan.

Briefly reviewing SSG-style elite Longquan celadon technological development for three generations, first-generation technology presents the initial-stage immaturity and uncertainty; the second generation exhibits maturity and perfection; and, the third generation unveils a sort of technological divergence and degradation or powerlessness. Three generations portray a complete SSG-style elite Longquan celadon technology life story.

SUMMARY OF SSG-STYLE LONGQUAN CELADON TECHNOLOGY

As previously discussed (see also Chapter 2), a few Longquan potters introduced SSG ware technology to create a new product style—SSG-style elite Longquan celadon—during middle SS. They originally received traditional potter training to manufacture popular Longquan celadon products. However, although possessing such a technological foundation, to recognize and familiarize themselves with the new materials and firing technology should still be a significant challenge.

Materials and Recipes

Table 1 takes referable information from Chinese ceramic analyzers' publications from various periods of Longquan celadon samples' composition data (Zhou et al. 1989, 104–109; Yap and Hua 1989, 167). In addition to the last two samples, SSG-1 and SSG-2 belonged to SSG ware, coming from the kiln site, located at Jiaotanxia (郊壇下), Wuguishan Hill, Hangzhou, Zhejiang province today, all elite Longquan celadon samples came from archaeological kiln site, Dayao (大窯) in Longquan (IACASS et al. 1996, 78).

50 | SSG-style Elite Products

```
1st generation    2nd generation    3rd generation
M-SS         L-SS          E-Yuan        M-Yuan      L-Yuan

Suichang jars    1236-42           1323 Sinan wreck
                 Suining hoards    salvages
                                   1327 Ren's tomb    1351-58 Inner
                                   artifacts          Mongolian hoards
```

Scheme 1. Three generations of SSG-style elite Longquan celadon technology and relevant archaeological materials.

Figures 1a and 1b. Five tube barn jar with dragon or tiger décor, the first-generation SSG-style Longquan celadon products, found in Suichang, Longquan, height of 24 cm, and 25.3 cm, respectively, middle-late SS (After Zhu 1998, Pls. 100 and 101).

Figures 2a and 2b. *Fen-qing* and *meizi-qing* SSG-style Longquan celadon vase with five spouts (tubes), height of 12.3 cm, and 12.4 cm, respectively, the second-generation products, late SS. Suining City Museum (After Asahi Shimbun 1998, Pls. 18 and 20).

Figures 3a and 3b. Third-generation elite Longquan celadon products, *li*-shaped incense burner, height of 8.2 cm; melon-shaped ewer, height of 6.3 cm, early Yuan. National Museum of Korea (After Shen 2012, 77 and 107).

52 | SSG-style Elite Products

Figures 4a and 4b. Longquan celadon products excavated from Jininglu hoard site, Inner Mongolia, height of 9.4 cm, and 25.5 cm, respectively, Yuan (After IMICRA 2004, Pls. 60 and 61).

Figures 5a and 5b. Some referable testers with biscuit plates unearthed from Ru kiln site at Qingliangsi, Henan (After HPICRA 2008, color Pls. 46 and 48).

Figure 6a (left). A waste U-shaped saggar loaded around five or more vases unearthed from Xikou kiln site, Longquan (After Jin 1962, Pl. 9–10).

Figure 6b (right). A triple-adjoined mallet-shaped vase with fish décor was collected by H.M. King Gustaf VI Adolf of Sweden, height of 16.5 cm. Östasiatiska Museet, Stockholm, OM-1974-0994 (image courtesy of Östasiatiska Museet).

According to Table 1, it is apparent that SSG-style elite Longquan celadon products' (samples SSL-1 and S3-1) composition differed greatly from precedent NS and early SS products (samples FDL-1 and NSL-1), whereas there is a small divergence from SSG ware (samples SSG-1 and SSG-2). Moreover, it is also noticeable that Yuan and Ming products (samples YL-1 and ML-1) actually had very similar composition data to SSG-style elite Longquan celadon.

Ceramic's raw materials and recipe preparation was usually regarded as the most basic training for a new or young potter, and its technology was mostly known, particularly for those popular products. However, few elite products or special branded products' recipe should be termed 'trade secret' to circulate only to the chief potter's family. According to Table 1, it is apparent that SSG-style elite Longquan celadon potters had finished a large-range regulation in raw materials and recipe preparation from the previous. It is a complete new materials technology.

Table 1. Glaze and body composition data from various periods of Longquan celadon samples (All contents are in wt %.)

*sample	B/G	SiO_2	Al_2O_3	CaO	K_2O	MgO	Na_2O	Fe_2O_3	TiO_2
FDL-1 (M-NS)	Body	76.47	17.51	0.6	3.08	0.34	0.27	1.28	0.42
	Glaze	59.37	15.96	16.04	3.43	2.04	0.32	1.8	0.39
NSL-1 (E-SS)	Body	74.23	18.68	0.54	2.77	0.59	0.48	2.27	0.42
	Glaze	63.25	16.82	13.0	3.26	1.09	0.57	1.42	0.23
SSL-1 (L-SS)	Body	67.82	23.93	-	5.32	0.26	0.32	2.10	0.22
	Glaze	69.16	15.4	8.39	4.87	0.61	0.32	0.95	-
S3-1 (L-SS)	Body	70.95	21.54	-	4.54	0.06	0.43	2.39	-
	Glaze	65.63	15.92	9.94	5.06	0.86	1.12	1.10	-
YL-1 (Yuan)	Body	70.77	20.13	0.17	5.50	0.74	0.82	1.63	0.16
	Glaze	67.41	16.74	6.83	5.49	0.63	1.16	1.51	0.18
ML-1 (Ming)	Body	70.18	20.47	0.16	6.02	0.29	0.97	1.71	0.19
	Glaze	67.57	15.0	6.28	6.48	1.72	1.14	1.44	-
SSG-1 (SS)	Body	64.60	25.90	0.30	4.00	0.40	0.20	2.50	1.50
	Glaze	66.58	14.37	12.72	3.04	0.75	0.48	0.87	0.12
SSG-2 (SS)	Body	65.70	25.00	0.30	4.00	0.40	0.10	2.50	1.40
	Glaze	62.21	15.95	14.69	3.33	0.91	0.47	1.14	0.17

* All sample labels and date ranges are based on original publications. Dating is indicated below each single sample label in parentheses. (M-NS): middle Northern Song, sample in yellow-greenish glaze; (E-SS): early Southern Song, sample in light-greenish glaze; (L-SS): late Southern Song, samples in *fen-qing* glaze; (Yuan): Yuan, sample in light *fen-qing* with somewhat yellow-greenish glaze; (Ming): Ming, sample in light yellowish glaze (Zhou et al. 1989, 104-109; Yap and Hua 1989, 167).

Furthermore, although Yuan or Ming potters probably followed SSG-style raw materials and recipe, their products' style was distinctly different from SSG-style elite Longquan celadon. Specific technologies such as firing technology—the most critical to determine the final product's quality and style—seemed to have been changed or lost after late SS.

Firing Technology

New materials and recipes certainly require a new firing technology. According to previous study, SSG-style elite Longquan celadon was fired at a considerably high temperature, with the top temperature estimated to be 1250–1280°C, and the process was controlled in a stronger reductive atmosphere (see also Chapter 2). Moreover, viewing the body's and glaze's microstructure, mullite in body, and anorthite in glaze close to the interface between glaze and body, are mostly in crystallites growing stage (see also Chapter 2 and Appendix).

It means that SSG-style elite Longquan celadon potters had to skillfully and perfectly control the entire heat treatment process in the most optimal situation, including heating temperatures and rate, as well as cooling rate, to achieve their desired products. However, by the beginning of late SS, second-generation technology had been perfected, and actually employed in the production line.

In fact, compared with other Song elite ceramics, such as the imperial Ru, Jun, or SSG wares, SSG-style Longquan celadon had the largest volume of uniform style and quality elite products in individual production history. It implies that although specific critical heat treatment technologies were difficult to completely control, second-generation firing technology was stable and smoothly employed for one generation of production during late SS. Then, how was this achieved by second-generation potters?

ARCHAEOLOGICAL EVIDENCE IN KILN SITES

Archaeological evidence revealed that a special device and auxiliary apparatus for the firing process were employed during late SS. At Dayao kiln site, one of the most crucial Longquan kilns to produce SSG-style elite Longquan celadon products, a few kilns' structure was specially devised. A dragon kiln was built along a natural hillside around 50 m long, with a sharp increase in this kiln's incline between middle and rear sections, and in a direction turned dramatically from the original (Zhu 1989, 46).

Moreover, in the middle section, the kiln chamber's width was enlarged, with its wall built in saggers rather than general bricks. In fact, middle section of a long dragon kiln is the most ideal location for firing high-priced elite products because its moderate temperature and atmosphere create the most optimal thermal environment. In contrast, the front section, close to the fire boxes, has an overly high temperature, and the rear section, close to the chimney or air vents, overly weak.

Two types of saggar were used: 'M' and 'U' shapes. The former is for stacking bowls or dishes, and the latter for loading individual object, such as a pot, vase, or incense burner, respectively. In general, saggar was made of general refractory clay, a sort of consumptive kiln furniture. However, a few saggars were apparently made of good-quality clay, similar to elite products' body materials, for loading those high-priced elite products.

In addition, a sort of auxiliary tool—tester—was used in firing process. Testers were usually found in some Song elite ceramics' kiln sites, such as the imperial Ru ware, Jun

ware, SSG ware, SSG-style Longquan celadon and Jingdezhen Qingbai porcelain (Li 1981, 40; ZPICRA et al. 2015, 539; JPICRA and Jingdezhen Museum of Civilian Kiln 2007, 407–408). They were made of the same materials as those simultaneously fired elite products in this kiln, in platelet with a circular hole in the center (Figures 5a and 5b).

Ten to twelve testers were inserted into each individual slot on a biscuit plate and placed in a very small cell located at the front of kiln chamber when the firing began (Feng et al. 1997, 285-286). During the heat treatment process, to understand kiln chamber and product conditions, the most experienced potter will check those testers by drawing them out one by one at specific intervals. By observing each single drawn out tester for glaze hue, texture, fluidity and others, he could timely regulate fuel or draught or other conditions to optimally control the entire heat treatment process.

Such elaborate auxiliary apparatus employed actually reflects that Longquan potters made a considerable effort to control the high-temperature pyric technology. However, it still did not guarantee each single batch of products to be ideal. For instance, a large-sized U-shaped saggar with failed elite product relics was found in Xikou (溪口) kiln site, one of manufacturing SSG-style elite Longquan celadon kilns in Longquan. It revealed around 5 pieces of vases were loaded in this saggar (Figure 6a) (Jin 1962, 535).

As previously mentioned, a U-shaped saggar usually loaded a single object. Then, why would the potter load more than one object in a U-shaped saggar? Theoretically, a saggar is a somewhat isolatable and fixed space in which potters could set or regulate for a more ideal atmosphere and temperature. Although controllable conditions were still limited, saggar's delicate device at least provided a more efficient control in firing process.

Then, more than one object loaded in a U-shaped saggar implied that once the firing was determined to be successful, more than one product in same quality and style will be acquirable. But, there was also a risk—all products within this saggar will be unusable due to collision or sticking to one another. A piece of triple-adjoined mallet-shaped vase with fish décor was collected by H.M. King Gustaf VI Adolf of Sweden during pre-war period (Figure 6b) (Asahi Shimbun 1971, pl. 70). Although it is probably the lucky survival, it is still unusable because the three vases stuck together in firing process.

However, to choose such potential risk also reflects that to successfully control each single firing process was a larger challenge to SSG-style elite Longquan celadon potters. As archaeological materials revealed, many late SS kilns and kiln tools or furniture were continuously used by early Yuan potters. It means that the second-generation hardware mostly was used by third-generation potters. Unfortunately, the latter still couldn't manufacture the same style products. Although the cause is probably complicated, loss of critical firing technology should be the most significant, resulting in third-generation technology malfunctioning in SSG-style elite Longquan celadon manufacture. It actually projected traditional potter training system was really incapable of transferring some specially delicate and complicated firing technologies.

TRANSFER OF TECHNOLOGY IN POTTER TRAINING SYSTEM

The ceramic workshop model was common in Song ceramic industry, usually with around 5–10 potters organized in a work team, in which the division of labor was adopted and each single potter had his (or her) specialization and respective work item (Atago 1977, 154–155). Such a model largely supported the large-scale ceramic manufactories for mass production.

Popular Ceramic Production and Potter Training

According to Chinese archaeologists' rough estimate, a dragon kiln in Longquan, around 50 m length, could produce around 20,000 pieces in a single firing during late SS (Zhang 1989, 71; Li 1981, 42). And, if there were twenty identically-sized kilns simultaneously working, a seasonal production volume should be considerably spectacular, even after deducting a portion of failed products (see also Chapter 5). However, the mass production of Longquan celadon products was mostly of popular quality and style.

Popular products primarily served as daily living and routine consumptive artifacts, in specific fixed forms, sizes and designs, such as tableware bowl or dish, produced in batches. Moreover, because the price was fair or even low, it also meant consumers required little in terms of products' quality or style variety. Thus, those manufacturing technologies are easily standardized. As Rice (1981, 220) stated, the standardization of ceramic manufacture: "Standardization may emphasize reduced variety in behavior and in the product."

Technological standardization not only supported mass production, but also was convenient for teaching a new or young potter, and prevented the technology from being lost (Rice 1981, 221). Longquan kilns sites in Dayao and Jincun (金村) revealed that several adjacent kilns' owners probably commonly shared a workshop, with setting clay pools, studio or other equipment. And, a formal house was built and probably housed a full-time potter's family for a long period of time, whereas some lodging rooms offered those part-time workers housing for a short stay.

The full-time chief potter was responsible for the whole production management, with several part-time workers responsible for various work-related tasks. Ceramic manufacture was separated into several procedures or tasks, such as preparing materials, forming, decorating, glazing, firing and others, to be completed by an individual potter or team. However, most potters were part-time workers who worked at their task during agricultural slack time (Ren 1981, 145; Mou 1981, 171). Or, they also probably worked for a couple of workshops alternately.

This working morphology is more flexible with human resources, and feasible to pass on each single technological procedure and train a functioning potter in a short time. However, its consequence should be that most potters became incapable of independently finishing a perfect product, exclusive of those few chief potters. Moreover, division of labor potters are basically inclined to reject new variations, evading complicated technology that resulted in most technologies gradually rigidifying (Leeuw 1994, 141, note 7).

Elite Ceramic Production and Potter Training

An elite product or commodity is more or less to satisfy specific elite consumers demand. As Costin and Hagstrum (1995, 622) stated: "… elite patrons may sponsor specialists to produce unique goods, where uniqueness confers value to the product." The second-generation SSG-style elite Longquan celadon products are doubtless the most elegant and unique. They were manufactured by the most masterful Longquan potters at that time, usually the chief potter in a ceramic workshop, supervising the entire manufacturing process utilizing the most critical firing technology.

Moreover, those critical technologies were usually referred to as 'trade secrets' by the elite ceramic producers. It means their circulation or knowledge was limited, and only passed on to the right potter, who was chosen as the direct descendant of the chief potter's family. In general, the junior potters always followed the experienced senior potters

practice, and timely obtained verbal instruction, as with apprenticeship training in ancient traditional Chinese craft communities.

The junior potters required considerable patience because it probably took a very long time to become a fully-trained potter, familiar with the whole manufacturing process and technology. In addition, they should be somewhat gifted because some technologies were really difficult and inarticulate. Therefore, some of them were not guaranteed to be successful inheritors. It further projected the dilemma of technology transference.

For those easily standardized popular ceramic technologies, staffing of new potters, by means of recruiting voluntarily through wage contract or other means and providing training, allowed for a smooth technology transition (Costin and Hagstrum 1995, 620). Nevertheless, elite ceramic technological transfer was confronted with a large risk—the technology could be lost, once the critical technology was not smoothly passed on to the next generation, or the right potter might suddenly die (Forster 1965, 58).

CONCLUSION

High-temperature pyric technology manifests a certain degree of uncontrollability and inarticulacy to ancient potters that makes it essentially difficult to be completely maintained and handed down, even when employing auxiliary apparatus in Song elite ceramic industry. Moreover, transferring craft skills and craftsman training system were strictly limited in by the family inheritance framework in ancient Chinese society that further increased the risk of losing specific delicate or cutting-edge technologies in the transfer process.

Nowadays scientists, aided by modern ceramic knowledge and scientific analytical techniques, probably more clearly view ancient potters' dilemma in technological continuity, particularly those considerably complicated firing technologies. In fact, it is probably an inevitable reality that when a strong imbalance between potters' knowledge and practical technology occurred, potters became confused with about what happened to their products. For second-generation potters, the perfect SSG-style elite Longquan celadon technology probably always left them with many unrealizable and inarticulate questions.

Science would be the best aid, but its advent was not timely in Chinese Song. Thus, such an imbalance between highly-developed pyric technology and undeveloped science should be the most fatal defect, resulting in several contemporary cutting-edge technologies being lost. The most critical technology of SSG-style elite Longquan celadon being lost in the transfer process is absolutely not the only case in ancient Chinese crafts history. Several Song elite kilns wares' technologies also suffered from the same fate, such as the imperial Ru and Jun ware.

However, behind each single elegant ceramic product, several elaborate technological stories were created by those industrious potters, from the first-generation potters' restless trial and error, the second-generation potters' technological zenith to the third-generation potters' powerlessness. And, behind those stories, it actually hid serious dilemma when those zenithal and highly complicated technologies were going to hand down.

Chapter 5

Production Center Shift: Local Ecological Environment

According to archaeological investigations, Longquan celadon kilns were concentrated in two separate areas: the southern area, located in the south about 40 kilometers from Longquan county hall today; and the eastern area, in the east around 20 kilometers away (Map 1) (Zhu and Wang 1963; Jin 2005; ZPICRA et al. 2015, ii–iii). The former was intensively used in Southern Song (SS 1127-1278), including Dayao (大窯), Jincun (金村), and Xikou (溪口) and other scattered adjacent villages. And, the latter was primarily used during Yuan Dynasty (1271–1368), including Shantouyao (山頭窯), Dabaian (大白岸), Yuankou (源口), Anfu (安福), Anrenlkou (安仁口), Shanyaner (上嚴兒) and others.

Moreover, based on kiln numbers and size, the southern area developed a large-scale production center during late SS, and the eastern area during middle and late Yuan, both creating Longquan celadon production two zeniths, respectively, in Longquan ceramic industry history. Thus, the production center shifted from the southern to eastern area after the end of SS raised some thought-provoking issues, such as why it was necessary to shift, and what was probably the most critical cause?

Traditional ceramic production requires three essential conditions: (1) an adequate natural resources supply, including raw materials, such as clay, glaze stone and tempers, and wood or coal for fuel; (2) a convenient transportation system, particularly waterway in pre-industrial period; and, (3) vast human power support, including potter population and an attendant workforce. Once any condition malfunctioned, it should directly result in production interruption, particularly in a large-scale production manufactory.

Dean E. Arnold (1993, 3) emphasized: "Since ceramics are one kind of material culture and are part of the "exploitative technology," the study of ceramic fits well within the paradigm of culture ecology." The ecological concept was introduced to ancient ceramic production study beginning in the 1960s (Arnold 1993, 4; Matson 1965). It gradually becomes a researchers' concern—behind those production activities how the local ecological context, including physical, biological and cultural environments, was impacted and influenced (Matson 1965, 213). This concept provides a good guidance for the present study.

Occurring between SS and Yuan, although ceramic production center shift more or less had a relationship with contemporary political and socioeconomic change, production conditions' malfunction and local ecological environment's change are probably the most

critical causes. Then, this shift from the southern to eastern area seemingly fit smoothly and quickly into the production system and pace to uninterruptedly supply that huge market demand at that time. The objective of the present study is to understand why the shift was necessary, and how it was accomplished.

HISTORY, GEOGRAPHY AND ARCHAEOLOGY OF LONGQUAN

History and Geography of Longquan

'Longquan,' a county name for a long time, had become a synonym for 'Longquan celadon', whose fame was established beginning with Five Dynasties (907–979), via Northern Song (NS 960–1127), reaching its zenith in SS. According to chorography or ancient literati writings, a village called 'Liutian (琉田),' located at the foot of the hill Liuhuashan (琉華山) where local people manufactured ceramics for their living, should be SS Longquan celadon kiln site (Lu 1968, vol. 14: 10; Gu 1975, 106 and 154).

Moreover, regarding the Liutian location, Chen Wangli (1946, 53) thought it was the current Dayao village, located in the south, around 85-*li* (42.5 kilometers) from Longquan county hall. However, Ozaki (1932, 4–5) surmised that it should be located in Yanqing (延慶), in the southwest, about 70-80-*li* (35-40 kilometers) from Longquan county hall. Chen's assumption, in addition to being based on his investigation in the 1930s, primary followed Lu Rong's (陸 容 1436-1494) writing.

Lu stated that contemporary celadon primarily came from Liutian, Jincun, Baiyan, … Anren, Anfu and others. Further, he emphasized Liutian had the best clay and glaze materials (Lu 1968, vol. 14: 10). The above-mentioned place names are mostly still used in Longquan county today. In the past century, Chinese archaeological workers followed Lu's writing to investigate and excavate, and basically organized two Longquan celadon production centers, as previously mentioned, the southern and eastern areas, respectively (Zhu and Wang 1963; Jin 2005).

Longquan is a mountainous district with several small rivulets, rich clay and glaze stone mines, as well as dense woods. Natural resources apparently established its predominance as a ceramic production center. Moreover, the large river—Oujiang (歐江)—provided a convenient waterway transportation system to connect with Wenzhou (溫州) or other southern harbors and large cities. Longquan is an ideal district for developing ceramic industry.

Spring and summer is rainy, particularly the summer's monsoons with heavy rain usually causing floods or mudslides (Lin et al. 1994, 28). However, autumn is dry and cool and should be the most appropriate season for ceramic manufacture. Change in the physical environment is relatively rarer than in biological or cultural environments (Matson 1965, 213). Therefore, the current local physical information should be still referable. Moreover, the distance between the southern and eastern areas is not far, around 60 kilometers, revealing both to be in same geographic and ecological region.

Archaeology of Longquan Kiln Sites

Archaeological investigation of Longquan kiln sites began with the 1930s (Chen 1946). Many Longquan celadon shard gatherers or ancient kiln site seekers visited those villages in the two areas, and numerous shards, fragments and artifacts were unearthed during the pre-war period. Moreover, dig robbing rampancy also had caused serious destruction to

Longquan kiln sites before the end of World War II (Chen 1946, 49 and 65; Palmgren 1963, 98).

Beginning in 1959, the formal archaeological investigation and excavation began with the southern area, then, in the 1980s, concentrated in the eastern area. In terms of these archaeological records and materials, although to reconstruct both production activities is somewhat difficult, it is still possible to understand individual production scale and characteristics, and furthermore, explore the cause of production center shift.

Production scale has an immediate relationship with production volume when the products' style and technology are inclined to uniformity and standardization. Thus, one could estimate a manufactory production scale based on kiln size and numbers, or even relevant deposits. However, when the product varies widely and utilizes considerably delicate technology, the estimate is somewhat complicated, not simply depending on production volume. For instance, previously discussed SSG-style elite Longquan celadon product not only involves technological capability, but also potter intelligence and additional time (see also Chapters 2, 3 and 4).

As Philip J. Arnold III (1991, 91) stated: "Production scale refers to the size and complexity of the production system, including determinations of workforce size, input/output quantities, and technological capabilities." In fact, since middle SS, at least two styles of Longquan celadon were simultaneously produced in the southern area: elite and popular products (see also Chapter 1). The latter production system was easily simplified and standardized for mass production. In contrast, the former was complicated with limited production.

SOUTHERN AREA PRODUCTION SYSTEM IN SS

Kilns in Dayao and Jincun

In Dayao, a small village, at least 53 kiln sites were found, including 7 used in early and middle SS, 49 during late SS, 1 in Yuan and 2 in Ming (1368-1644) (Zhu 1989, 65). It reveals that Dayao reached its production zenith during late SS, then after the end of SS, nearly all production activities were discontinued. Dayao is an indicative kiln site to understand the southern area production system and reason for abandonment after late SS intensive production.

Most kilns in dragon kiln form were built along the natural hillside and in nearly the same direction, from south to west (Zhu 1989, 45). Two kiln sites, DY3 and DY2, better preserved, were excavated in 1960. DY2 is a typical late SS kiln, with a residual length of 46.5 m. A small portion of the front and rear sections had been destroyed, surmising the original kiln's length to be over 50 m. The widest portion lies in the middle section of kiln chamber, 2.5–2.58 m, with height of 1.7 m interior wall, and nine kiln doors separately open on two sides for loading or unloading products.

The middle section was elaborately designed, two side walls layered with discarded saggars in lower portion, and brick in upper portion. Moreover, following the middle section, kiln's direction distinctly faced north rather than originally westward, and incline also increased sharply. Saggars were paved on kiln bed with sand filling in saggar gaps. However, all large-sized saggars were placed in the middle section, whereas small-sized were arranged in the front and rear sections. In addition, the section close to kiln tail was used for biscuit.

Saggar is crucial kiln furniture when loading products for firing. Two types of saggar were used: 'M' and 'U' shapes; the former for stacking objects with the same form and fixed-sized bowls or dishes, and the latter for loading a single object, such as a pot, vase, incense burner or others. Saggar's size and quality varied to meet different products' demand (Zhu 1989, 57). In addition, various kiln tools, such as rest cake, rest circle, support pillar and others, were flexibly used.

Jincun is located 2.5 kilometers to the south of Dayao. A preliminary investigation, in 1960, unveiled 15 kiln sites, including 14 kilns used in SS and 1 in NS. However, only two kilns were excavated, JY1 and JY2. JY1, with a residual length of 50.35 m, was used during early and middle SS. And, JY2 was used during late SS, with a residual length of 28.85 m. However, the original length of JY2 should be 50 m or more, based on its deposits' scattering range around 70 m (Zhang 1989, 87). JY1 and JY2 kiln's structure, furniture and tools were completely identical to the previous DY2.

In addition, according to a simple investigative report, some kiln sites found in Xikou were similar to DY2 in structure, surmised to be contemporaneous. It is apparent that the southern area's kilns, to a considerable degree, shared common structure, furniture and tools, particularly with those used during late SS. It not only implies kiln's devise and construct had been considerably unified, but also production system standardized. However, for small quantity production of elite products, a special devise was separately required.

A rough estimation of the production volume of previously mentioned JY1, around 50 m in length, in a single firing is around 20,000 pieces of product (Zhang 1989, 71). If thirty such scale kilns were working simultaneously in the southern area, there would be around 600,000 pieces of output. Furthermore, if a season had three batches of output from each single kiln, the production volume could reach 1800,000. Deducting some failed products, however, it is still a considerably spectacular quantity of production per year.

Shards in the Southern Area

Of the considerable number of shards unearthed from the southern area, the majority is popular products, dominated by a few simple genres, such as bowl and dish in thin glaze with brown-yellowish or gray-greenish hue engraved in a flower and leaves design. However, the design was gradually simplified over time, from early to late SS. For instance, the detailed combing pattern within each single petal or leaf design gradually disappeared, or simple design was decorated only on the exterior of a bowl or dish rather than both interior and exterior, or eventually plain entirely (Figures 1a, 1b and 1c) (Kamei 2014, 457–459).

To simplify and standardize forming, decorating or glazing procedures decreased time spent on a single product and created large production quantities. It is the most direct avenue to achieve mass production. However, a few kilns, such as DY2, simultaneously produced a limited amount of elite products during late SS. Some elite product's fragments, high-quality SSG-style celadon bowl, vase and incense burner in thick *fen-qing* hue glaze, were found at this kiln site (Zhu 1989, 53–56). A piece of intact bowl unearthed, in beautiful *fen-qing* hue, is identical to the bowl from Suining hoard site (Figures 2a and 2b) (see also Chapter 3).

Creating an elite product required special and delicate technologies and procedures that were unable to be easily standardized and simplified. As previously discussed, its technologies and working procedures are considerably complicated (see also Chapters 2 and 4). Moreover, elite Longquan celadon product genres had more variety, particularly incense

The Colour Plate Section

Pls. 1, 2 and 3. Five tube barn jar, wine vase and pot, early NS, 10th–11th century. Longquan Celadon Museum.

Pl. 4. Longquan celadon *long-hu-pin* vase, middle or late SS, 12th–13th century. Longquan Celadon Museum.

Pl. 5. SSG-style elite Longquan celadon *long-hu-pin* vase, late SS, 13th century. V&A Museum.

Pl. 6. *Fen-qing* SSG vase, SS, 12th–13th century. National Palace Museum, Taipei.

Pls. 7 and 8. *Fen-qing* and *meizi-qing* SSG-style Longquan celadon vase and incense burner, late SS, 13th century. Suining City Museum; Kyoto National Museum.

Pls. 9 and 10. SSG-style Longquan celadon bowl and cup, late SS, 13th century. Suining City Museum.

Pl. 11. SSG-style Longquan celadon *cong*-shaped vase, late SS, 13th century. Suining City Museum.

Pls. 12 and 13. Mallet-shaped vase with phoenix décor. Songyang County Museum. Mallet-shaped vase with fish décor, late SS, 13th century. National Museum of Korea.

Pls. 14 and 15. *Fen-qing* and *meizi-qing* SSG-style Longquan celadon vase with five spouts (tubes), late SS, 13th century. Suining City Museum.

Pls. 16 and 17. Longquan celadon *li*-shaped incense burner and melon-shaped ewer, early Yuan, 13th–14th century. National Museum of Korea.

Pls. 18 and 19. Stamping design and mold forming Longquan dish fragments, Yuan, 13th–14th century. Zhejiang Provincial Institute of Cultural Relics and Archaeology.

Style	Elite Longquan celadon vase or jar	Description
SSG Figure 1		Glaze hue: *fen-qing* or *meizi-qing* Glaze thickness: ~0.8 mm Vase size: most 20–30 cm in height Form and decoration: most wide lower-bellied body without design
Early Yuan Figure 2		Glaze hue: light pale blue or green Glaze thickness: 0.2–0.4 mm Vase size: most 40–60 cm in height Form and decoration: wide upper-bellied body with denser design
Early Ming Figure 3		Glaze hue: *bi-lu* (jasper color) Glaze thickness: over 0.8 mm Vase size: most 40–70 cm in height Form and decoration: wide upper-bellied body with denser design

Pl. 20. SSG-style, early Yuan-style and early Ming-style elite Longquan celadon products

Pls. 21 and 22. Early Yuan-style Longquan celadon vase and Jingdezhen Qingbai porcelain vase, 13th–14th century. National Museum of Korea.

Pl. 23. SSG-style Longquan celadon bowl with writing in ink on the interior of this bowl, 13th century. Fukuoka City Archaeological Center.

Pl. 24. Imported elite Longquan celadon products, 13th–14th century. Fukuoka City Archaeological Center.

Pl. 25. Imported elite Longquan celadon teaware, 13th century. Kamakura City Board of Education.

Pl. 26. Detail of *Boki Ekotoba* scroll, a celadon incense burner used in Zashiki living room, 14th century. Hongan-ji temple.

Pl. 27. Detail of *Boki Ekotoba* scroll, several celadon products used in kitchen. Hongan-ji temple.

Pls. 28 and 29. Longquan celadon flower pots, 13th–14th century. National Museum of Korea.

Pl. 30. Detail of *Boki Ekotoba* scroll, a celadon incense burner and flower vase and bronze candle stand in Zen room. Hongan-ji temple.

Pl. 31. Detail of *Boki Ekotoba* scroll, a celadon incense burner, flower vase and bronze candle stand. Hongan-ji temple.

Pl. 32. '*Kanpūzu Byōbu* (觀楓図屏風) Maple-viewing painting', 16th century. Tokyo National Museum.

Pl. 33. Longquan celadon products unearthed from Kusado Sengen-chō ruins, 13th–15th century. Hiroshima Prefectural Museum of History.

Pls. 34 and 35. Kusado Sengen-chō ruins' flower vase and Sinan wreck's, 13th–14th century.

Pl. 36. SSG-style elite Longquan celadon objects and fragments unearthed from downtown Kyoto, 13th century. Kyoto City Archaeological Museum.

Figure 1a (left), 1b (mid.), 1c (right)			
Provenance	Tokugawa-Emperor *(Sensei)* H: 26.0 cm	Tokugawa Family H: 25.4 cm	Tokugawa Family H: 6.4 cm
Figure 2a (left), 2b (mid.), 2c (right)			
Provenance	Mitsui M. M. H: 16.8 cm	Konoike family Seikado M. D: 24.6 cm	Hirooka family Fujita M. H: 25.4 cm
Figure 3a (left), 3b (mid.), 3c (right)			
Provenance	Rokuon-ji H: 32.0 cm	Fujita Denzaburō H: 16.3 cm	Nezu Kaichirō H: 15.8 cm
Figure 4a (left), 4b (mid.), 4c (right)			
Provenance	Tokiwayama B. F. H: 10.5 cm	Idemitsu M. D: 33.5 cm	Uragami M. M D: 15.2 cm

Pl. 37. Elite Longquan celadon collections in modern Japan.

Pls. 38 and 39. Two mallet-shaped vases with décor, Yuan or Ming or later imitations. Daikōmyō-ji, Kyoto; National Palace Museum, Taipei.

Pl. 40. SSG mallet-shaped vase, 12th–13th century. National Palace Museum, Taipei.

Pls. 41 and 42. A pair of Longquan celadon *long-hu-pin* vases, middle or late SS, 12th–13th century. Longquan Celadon Museum.

Pls. 43 and 44. A pair of mallet-shaped vases with phoenix and fish décor, late SS, 13th century. Kuboso Memorial Museum of Arts, Izumi; The Tokugawa Art Museum.

Dayao-1		Dayao-2		Dayao-3		Aotou-1		Dayao-5		
glaze	body	glaze	body	glaze	body	glaze	body	glaze	body	
Thickness/mm										
~0.9	4.2	~0.9	2.5	1.0	2.0	0.8	2.7	~0.9	2.2	
Dayao-6		Dayao-7		Dayao-8		Dayao-9		Guan-1		
glaze	body	glaze	body	glaze	body	glaze	body	glaze	body	
Thickness/mm										
~0.9	3.0	~0.8	4.5	1.0	2.8	~0.9	2.7	~1.1	1.4	

Pl. 45. SSG-style Longquan celadon samples. Palmgren's shard collections, Östasiatiska Museet, Stockholm.

burner, incense box, flower vase, wine vase, or teaware, which possessed the attributes of ritual and luxury, seriously requiring individual uniqueness and variation in form or décor, based on their specific consumers' demand (see also Chapter 1).

Consumers were mostly contemporary elite class members or rich middle class who sometimes sought to establish a good connection with those masterful craftsmen. It means a few producers or potters were closely associated with their elite clients, and gradually formed a special potters' core group. They not only monopolized access to some specific or high-quality raw materials, but also probably controlled an area's production activities (Arnold 2008, 153; Charlton et al. 2007, 243).

Dayao probably played just such a core role during late SS in the southern area. According to unearthed shards, Dayao had the most complete SSG-style elite Longquan celadon genres and the highest quality products. In contrast, in adjacent Jincun or Xikou, the elite products were scattered. It actually reflects that the entire southern area's production was anchored by Dayao, responding to the whole complicated production system of both popular product mass production and elite celadon limited manufacture, even further determining contemporary Longquan products' market price.

One Consequence of Intensive Production in the Southern Area

However, such a large-scale production model not only required considerable amount of raw materials and fuel supply, but also a huge potter population and attendant workforce. For instance, raw materials procurement needed to be mined from quarries, and fuel gatherers were required to chop down masses of trees, as well as waterway transportation system maintaining, raw materials and the final products loading or unloading, all tasks that required considerable human resources. Thus, the southern area should become a dense population place, particularly peak production season during late SS.

It is understandable that after maintaining such extensive productivity more than 50–60 years, from middle to late SS, clay mines were probably exhausted, woods cleared and water resources misused. Moreover, the large population concentration in this area caused anthropogenic destruction. The overexploitation would result in local ecological environmental disaster. Thus, frequent floods or mudslides during the summer monsoons would be common.

Eventually, local physical environment's destruction seriously threatened potters' livelihood and ceramic production activity. To seek a new resource for continuing their business should be necessary. However, confronting enlarged market demand, how could Longquan potters quickly and smoothly shift their manufactories to a new location without interrupting mass production? And, is the eastern area the best choice for this shift?

EASTERN AREA PRODUCTION SYSTEM IN YUAN

Eastern Area Longquan Celadon Production before Yuan

Before a large reservoir was built in this area, archaeological investigation was hurriedly initiated. Since 1979, several Chinese archaeological institutes separately undertook various kiln sites excavations. Many kiln sites were found scattered along the middle reaches of the Oujiang river and several rivulets in the eastern area, estimating its production scale was probably larger during Yuan than in the southern area during SS.

64 | Local Ecological Environment

Map 1. Kiln sites in the southern and eastern areas of Longquan (After Zhu and Wang 1963, 28).

Figure 1a (left). Early SS dish with flower design and combing pattern.

Figure 1b (middle). Middle SS bowl with design on interior only.

Figure 1c (right). Late SS bowl with engraved lotus petals on exterior only (After Zhu 1989, 51-53).

Figures 2a and 2b. A *fen-qing* SSG-style elite Longquan celadon bowl found in Dayao kiln site, identical to the bowl from Suining hoard site, late SS. Longquan Celadon Museum, Suining City Museum (After Zhu 1998, Pl. 134; Asahi Shimbun 1998, Pl. 49).

Figures 3a and 3b. Incense burner and bowl fragments unearthed from the eastern area, SS (After ZPICRA 2005, color Pls. 48-6 and 8-5).

Figures 4a and 4b. Stamping design and mold forming dish fragments unearthed from the eastern area, Yuan (After ZPICRA 2005, color Pls. 36-5 and 37-1).

66 | Local Ecological Environment

Figures 5a and 5b (left and middle). Signatures on the exterior bottom center of a bowl and cup (After Sun and Zhen 1986, 126).

Figure 5c (right). Phags-pa script on a large-sized dish fragment (After Sun and Zhen 1986, 129).

Figure 6. Longquan celadon production volume variations per year in SS and Yuan.

Figures 7a and 7b. Elite Longquan celadon fragments in the early Yuan style unearthed from Fengdongyan kiln site. Longquan Celadon Museum (After Mori et al. 2012, Pls. 125 and 128).

According to an integral archaeological report, 218 kiln sites were found, including 173 used in Yuan, a considerably high rate of 79% (ZPICRA 2005, 47–57). However, a few kilns were used earlier during late NS, SS, and later in Ming. It is apparent the eastern area production activity was concentrated in Yuan, particularly middle and late Yuan.

A couple of kilns were used to produce popular products during late SS in Shantouyao. In addition to kiln structure and equipment similar to the contemporaneous southern area's kilns, the products' style was also highly homogeneous. As Ren Shilong's and Kamei Akinori's chronology of Shantouyao products from NS to SS based on design techniques and patterns revealed, the eastern and southern areas kilns actually produced nearly same style and quality popular celadon products before Yuan (Kamei 2014, 465–466; Ren 1981).

Similar ceramic production conditions, such as physical environment and natural resources, particularly raw materials, will develop same potters' training and technology. In addition, the eastern and southern areas were actually located along the same waterway system—Oujiang river—in the same geographic region convenient for human power movement and adaption. Thus, the eastern area should be the best choice to replace the southern area as a new production center, required for quickly continuing business.

Kilns in Eastern Area

During early Yuan, kiln size was usually small. Three kilns excavated in Yuankou, EY16y1, EY16y2 and EY16y3, are 33.5 m, 20 m and 28.3 m in length, respectively (ZPICRA 2005, 406–407). However, during middle and late Yuan, kiln size was apparently enlarged. A kiln found in Anrenkou is 48.5 m in length, and other contemporaneous kilns were also 40–50 m long.

Compared with the southern area kilns used during late SS, the eastern area kilns' size is somewhat shorter, and structure simpler, lacking special device. Moreover, kiln furniture and tools decreased in variety. For instance, although two types of saggar were found, 'M' and 'U' shapes, the former is in overwhelming majority. This means the same form and size of bowls and dishes are the staple genre in the eastern area production center.

A kiln site found at Anfu, is 49.6 m in length and 2 m in height. According to same-sized M-shaped saggars commonly found at this kiln site, each single saggar is 10 cm in height, and, within the 2 m high kiln chamber, 16 saggars could be stacked (Jiang 1981, 508). Thus, a rough estimation of the production volume was over 20,000 pieces in each single firing. It implies the eastern area production volume was not at all inferior to the southern area, and at times surpassed the latter. However, nearly all products are bowls or dishes.

Shards in Eastern Area

Simplification of product genre is actually an efficient method to increase production quantity. The bowl was always the primary genre in the eastern area beginning with late NS. Then, during SS, around 84–91% of products were bowls, based on unearthed shards and fragments from Shanyaner (Li and Li 1986, 49–50). Furthermore, the percentage rapidly increased after early Yuan. It means other genres were nearly absent in the eastern area production center. For instance, in some kilns used during late SS, in addition to a large amount of bowl and dish shards, a few incense burner, box, pot and vase fragments were still able to be found (Figures 3a and 3b). However, by middle and late Yuan, only bowl and dish shards could be found in this area (Li and Li 1986, 70).

Moreover, decorative techniques were also gradually simplified. The molded relief or stamping design technique, a faster method to create a uniform design on each single product, replaced the previous engraving design with combing pattern (Figures 4a and 4b; Pls. 18 and 19). Most bowls or dishes were plain on their surface exclusive of some fixed small designs, such as double-fish, dragon or a single flower, stamped on the interior bottom center. In fact, forming technique was also simplified to massively employ molds, rather than potter's wheel.

Simplification and standardization of production activity decreased time spent on a single object, creating spectacular productivity. However, due to the products' great similarity, it became difficult to distinguish a commodity's provenances or brands in the contemporary ceramic market when consumers thought it to be crucial and necessary. Thus, some marks, logos or signatures were used on the exterior bottom center of a bowl or dish, such as '仲夫 (zhongfu),' '富 (fu),' '玉 (yu),' '後(hou),' '月(yue),' or others (Figures 5a and 5b) (Sun and Zheng 1986, 109; Li and Li 1986, 58; ZPICRA 2005, 241 and 348).

Concentrating on thin glaze with pale brow-greenish or brown-yellowish hue popular celadon production, simplifying genre and decorative techniques, as well as standardizing manufacturing process, all characterized the eastern area production system and products' style, and achieved spectacular production volume during Yuan. However, in addition to mass production, demand for large-sized objects was also rapidly increasing. Large-sized bowl over 35 cm in diameter and 18–43 cm M-shaped saggars are commonly found in the eastern area's kiln sites (Sun and Zheng 1986, 109 and 105).

In fact, among Sinan wreck salvages, a certain amount of bowls and dishes were over 35 cm in diameter (Mu-byŏng Yun, Korea (South), Munhwajae Kwalliguk 1981, 282–285). It implies that large-sized Longquan celadon products not only had a domestic market demand, but also an overseas market. This rapidly growing trend of ceramic product's size enlargement was attribute to new Longquan celadon consumers—Mongolian inhabitants in China, who were accustomed to a large-sized bowl or dish for their food culture. The Phags-pa script (八思巴文Mongolian character) stamped on some large-sized products should be the evidence (Figure 5c) (Sun and Zheng 1986, 109).

Product's size enlargement, such as bowl and dish size from around 20 cm diameter in SS to around 40 cm during Yuan, also implies raw materials' requirement to be more tensional. Large-quantity production and increase in large-sized products should result in raw materials supply hard-pressed, particularly after around 60-year intensive production during middle and late Yuan. It is imaginable local natural resources exhaustion and serious ecological environmental destruction would cause the eastern area to confront the same consequence as previously experienced in southern area.

DISCUSSION OF THE CAUSES OF PRODUCTION CENTER SHIFT

A rough estimate of gross production volume variety over time from middle SS to early Ming, particularly popular products based on previous estimations and archaeological investigations, indicates two production zeniths separately appeared in late SS and middle-late Yuan. However, the latter should exceed the former (Figure 6). The southern area's kiln size was typically longer, 50–70 m in length, than the eastern area's 40–50 m; however, the latter's kiln numbers nearly doubled the former.

According to Figure 6, two curves crossed between late SS and early Yuan. And, after late SS, the southern area was rapid decline; however, after late Yuan, it seemed to partly revive. It not only implies that the time of shift was between late SS and early Yuan, but also that the southern area local raw materials were not completely exhausted during late SS. Therefore, lack of raw materials supply should not be the most critical cause resulting in the southern area being abandoned, but local ecological environmental destruction, particularly woods cleared or water resources misused, is probably the primary cause.

However, after nearly one hundred years of vegetation recovery and water resources returning, the southern area reestablished its ecological equilibrium during early Ming. Some potters returned to work there. In fact, according to chorography, to maintain local waterways system was always local governmental and population's largest challenge (Su and Shen 1984, 623–27). Therefore, once the ecological environment was destroyed, it would not only seriously threaten the local population's lives and ceramic production activity, but also influence the connection with the outside.

As previously mentioned, the great similarity in geographical and ecological environments provided the eastern area with considerable predominance to replace southern area production in Yuan. However, the replacement was seemingly not complete. Only popular celadon production was shifted. In contrast, manufacture of previous elite products, particularly SSG-style elite Longquan celadon did not shift. Then, why didn't it shift from the southern area?

One of several explanations is that the eastern area lacked critical high-quality materials for elite celadon manufacture. As Lu (1968, 10) had written, Liutian (Dayao) in the southern area had the best raw material for Longquan celadon manufacture that also indirectly denied the eastern area good conditions for producing elite celadon. Without appropriate materials, those elite products' potters and technologies should not come.

In addition, it is also a possible explanation that there was no longer market demand and value for SSG-style elite Longquan celadon products after the end of SS. It forced those few masterful Longquan potters to yield elite products manufacture. However, as other chapters in this book mentioned, there was still a certain market demand for elite Longquan celadon products during Yuan (see also Chapter 6 and 7). Thus, when the eastern area didn't supply elite products, could another area supply them?

Two provenances are surmised: (1) Fengdongyan (枫洞岩) kiln in Dayao, the original southern area; and, (2) a few kilns in Jingdezhen, Jiangxi province today. In fact, after Longquan celadon production center shifted to the eastern area, a few masterful potters in the southern area, particularly at Fengdongyan kiln, continued to make very limited elite products with somewhat different style from SSG-style during early Yuan (Figures 7a and 7b) (ZPICRA et al. 2009; Shen 2009, 9; ZPICRA et al. 2015, 307 and 548). It means that a few masterful potters, after the production center shift to the eastern area, probably remained and continued their business in the southern area.

However, a few of them also probably moved to the adjacent Jingdezhen, where the country's largest ceramic production center was energetically developing during early Yuan. They kept the previous technology, and used Jingdezhen local materials to create a somewhat various style of elite Longquan celadon with Jingdezhen Qingbai porcelain flavor. And, they were perhaps the first-generation potters in Jingdezhen produced Longquan celadon imitations during Yuan and even early Ming (Yang 1991; Degawa 2011, 124).

CONCLUSION

Natural resources are limited, and would be exhausted over a long period of intensive exploitation. Moreover, anthropogenic destruction is inevitable to local ecological environment. When the area is no longer able to supply all conditions for a large-scale ceramic production, it should be discarded. One choice is to look for new resources if its business hoped to continue. Thus, the shift of a ceramic production center is analogous to nomadic people moving in search of pasture.

However, each single shift has its individual consideration that determines the new location. For the present Longquan celadon production center shift, occurring after the end of SS, it apparently was targeted at continuing its mass production of the same style popular products to uninterruptedly provide contemporary market's tremendous demand. With such a goal, the southern area is the best choice, possessing natural resources and human labor similar to the southern area.

Then, it is also apparent that the shift was not complete, particularly in technological transference. A potter is the technological carrier. When the elite products, particularly SSG-style elite celadon, didn't appear in the new area, it implied most masterful potters probably never arrived there. Although the cause is somewhat complicated, the eastern area lacked high-quality and appropriate raw materials or other critical resources required for elite product manufacture that should be the most critical.

However, Fengdongyan kiln in the southern area could continue to supply the very small amount of elite Longquan celadon products for contemporary market demand, after the production center had moved to the eastern area. It also indirectly verified that the critical cause of shift after the end of SS should be local ecological environmental destruction, rather than exhaustion of raw materials.

Chapter 6

Behind Style Change: A Contemporary Social Atmosphere

As previously mentioned, beginning with middle Southern Song (SS 1127–1278), Longquan potters actually manufactured products in two styles: popular style, following Yue ware style, and elite style, following Southern Song Guan (imperial) (SSG) ware style. However, with Longquan celadon production and marketing environments shifting, closely associated with contemporary political, economic and societal conditions, the latter evidenced a distinct and sensitive change, whereas with the former, there were fewer changes.

Style change implies some specific critical technologies are intentionally or accidentally changed or modified. Technology achieves an artifact or artwork's style, and style exhibits technological practice. However, when a technology is no longer continued, the original style should disappear. Similarly, when a product style is no longer welcome, its relevant technologies should be discarded. Thus, for cultural products, style and technology are in both the forefront and background.

Then, to achieve or establish a new style, in addition to technology's support, it requires a social driving force, which not only pushes new technology to be perfected and continued, but also endorses a value system to strength the style's attributes for practicing its social function. Each single style's attributes are determined by contemporary society and culture. Thus, technology, style and society encompass all ancient ceramic procurement and manufacture activities (Loney 2000, 647; Carr and Neitzel 1995, 389; Schiffer and Skibo 1997, 27).

Therefore, when a new style is created, it not only implies employing some new technologies, but also generating a new social driving force to support or discourage it. At the same time that the old style's attributes are probably withering as the new style's establishing. However, in the transition, at times there is some degree of struggle between the new and old social driving forces (Annis 1985, 240).

Elite Longquan celadon development experienced three styles, from middle SS via Yuan (1271–1368) to early Ming (1368–1644)—around 200 years—and each single change was backed by a tremendous social and cultural shift. The present study explores the style change occurring between late SS and early Yuan, from SSG style to early Yuan style. Its technological shift has been discussed in previous chapters (see also Chapters 2 and 4). The present objective is to understand what backgrounded the social driving force promoting the style change? And, what opposite force insisted on the prior SSG style in Yuan society?

DEFINITION OF ARTIFACT STYLE AND CERAMIC STYLE

When defining an artifact style, its societal association is usually emphasized by archaeologists or anthropologists. As Wiessner (1985, 161) stated: " Style, as I see it, has a behavioral basis in the fundamental human cognitive process of personal and social identification through stylistic and social comparison." For a long period of time a group of people lived in the same region and developed a common consciousness and lifestyle, which identified them as belonging to a common society or class, as distinguished from others.

All those distinguishable characteristics shape local cultural style, concretely exhibited in handcrafts, custom activities, dialects and others. Thus, a craft or artifact style is actually a miniature of local cultural style, created from local society. Ceramic product is considered to be the best cultural carrier to sensitively reflect and display social and cultural shift over time or space. Therefore, a regional ceramic style evolution is usually regarded an indicator of local social and cultural shift by researchers.

In the 1970s and 1980s, in terms of measurable variations presented in ceramic appearance, such as size, form, design or décor, to establish quantitative or qualitative analytical data was considered to be a scientific method for analyzing ceramic style change (Jones and Leonard 1989, 1–3; Conkey 1989, 118). However, to most Song elite celadon, in addition to the above variations, the highly visible variation should be the subtle nuance of glaze hue and texture, which is actually difficult to be quantified, at times depending on viewers' visual experience.

For instance, SSG-style elite Longquan celadon glaze hue was usually described as *fen-qing*, green-bluish with somewhat opaque pink-white, or *meizi-qing*, blue-greenish analogous to immature plum. To actually realize these descriptions, viewers should be required to have some common life experience. Therefore, it is somewhat difficult to precisely determine each single elite Longquan celadon product's hue or texture style.

DEVELOPMENT OF ELITE LONGQUAN CELADON STYLES

Scheme 1 briefly presents both elite style and popular style of Longquan celadon development from middle SS to early Ming. For approximately 200 years, popular style had no distinct variety, whereas elite style was considerably dramatic. Moreover, it also reveals a relative difference between elite and popular styles in various periods. For instance, it is apparent that the 2nd elite style had the smallest difference with contemporaneous popular style. It means this period of elite products were somewhat difficult to distinguish from popular products, particularly during late Yuan (Xu 2007, 29).

Style's Characteristics and Changes

According to Figure 1 (Pl. 20) and previous descriptions, briefly organized highly-visible characteristics of the 1st elite style, SSG-style Longquan celadon, are: (1) glaze to be thick in *fen-qing* or *meizi-qing* hue; (2) surface usually craze-free; (3) simple and clean-cut form without burdensome décor or design; and, (4) moderate size in each single object, such as vase's height usually 20–30 cm, with dish or bowl's diameter 10–20 cm.

When compared with SSG-style, the 2nd elite style, early Yuan-style Longquan celadon distinctly displays some changes (Figure 2; Pl. 20), such as: (1) thin glaze in pale bluish hue, somewhat similar to Jingdezhen's Qingbai porcelain; (2) surface mostly craze-free; (3)

common stamping or engraving of some fixed designs or parallel longitudinal or latitudinal ridges; and, (4) large-sized products, such as flower vase's height commonly 40–60 cm, and more dishes or bowls over 30 cm in diameter, nearly doubling previous SSG-style.

Furthermore, the 3rd elite style, early Ming-style Longquan celadon, presents: (1) thick glaze in saturate *bi-lü* (dark-green, also labeled jasper-green) hue; (2) surface mostly craze-free; (3) design and décor following early Yuan-style; and, (4) large-sized products, similar to early Yuan-style (Figure 3; Pl. 20). In fact, the early Ming-style elite Longquan celadon looks to be a mix of early Yuan- and SSG-style products. For instance, glaze was distinctly thickened to pursue SSG-style celadon's saturated and substantial color sense; whereas the whole object's size and decoration followed early Yuan style.

It actually also verifies that early Ming Longquan potters once attempted to revive SSG-style celadon. However, SSG-style product had not been this period's elite ceramic market's mainstream. After the reign shift from SS to Yuan, the new elite class consumers—Mongolian (蒙古人) and Semuren (色目人)—required large-sized elite ceramics for their lifestyle. Large-sized ceramic products became a new market trend. Market trend is the most crucial consideration for commercial ceramic producers or potters.

However, when the product's size was commonly enlarged, its materials were probably replaced with those of cheaper, lower quality, or its glaze was thinned to balance the cost and profit. Moreover, to prevent monotony on a large-sized object, denser designs were necessary that achieved the new style—early Yuan-style elite Longquan celadon.

Then, after the new style was gradually accepted by contemporary society for nearly one hundred years under Yuan regime, Han society was actually accustomed to those changes. It resulted in the early Ming-style elite Longquan celadon mostly following Yuan style rather than SSG style, in larger size with dense designs. Figures 1–3 briefly displays three elite styles of product, providing a simple comparison.

ATTRIBUTES OF SSG-STYLE ELITE LONGQUAN CELADON

Elite ceramic development is usually a response to highly-stratified societal demand. The ruler and high-ranking officials form the elite class, differentiated from the mass populace. They require or desire some high-quality and elegant objects for their association with a luxurious lifestyle or identification of social status. An elite ceramic is usually manufactured by the most masterful potters using the best raw materials and technology, with some specific designs, based on elite class consumers' taste and demand. Therefore, elite style essentially bears luxury and social symbol attributes.

As Braun (1995, 136) argued: "Stylistic practices also may not have social effects in isolation from those of other social practices." Therefore, how much power or the extent that a style can practice its attributes on local society depends on how much support the local society provides. Moreover, style as a cultural phenomenon has the multifaceted nature in local society (Plog 1995, 369). Therefore, viewing a style's attributes and social effect should keep in broader perspective.

Stylistic Attributes of SSG-style Elite Longquan Celadon

As one of the most famous elite ceramics, SSG-style Longquan celadon had a considerably steady market share, around 35–40 percent, during late SS (see also Chapter 3). Its consumers included contemporary political elite class members, such as the royal family

and high-ranking officials, and economic elite class, such as rapidly-rising wealthy middle class, particularly rich merchants. Therefore, this style embodied two essential attributes: luxurious commodity and elite class symbol.

With the luxury attribute, SSG-style elite Longquan celadon products display high-quality with bright, vivid and elegant visual impression, representing high market value and the owner's luxurious lifestyle. Market value should be an indicator to estimate this style's power as a luxurious or precious commodity. During the final two decades of SS, many SSG-style elite Longquan celadon hoard sites were created due to wars and social instability, particularly in eastern Sichuan. It projected this style was cherished and exerted a very powerful social and economic effect during SS (see also Chapter 3).

With the elite class symbol attribute, the style represents elite class members' social status. As Neitzel (1995, 397) explained: "… particular classes of status markers may exhibit variations not only in their relative frequencies among different social classes, but also in their formal appearance." Those distinguishable variations on appearance characterized this marker's style, conveying information about social position and power. And, further, some variations can also be given sacred meanings (Neitzel 1995, 397).

With the corona of imperial ware—SSG ware—the style of SSG-style Longquan celadon was potentially given somewhat sacred meanings. It not only strengthened the social function of this style itself—as a symbol of elite class with honor—but also the social effect—bringing amazing fascination in contemporary society and further influencing value systems and aesthetics. It is not hard to understand that SSG-style elite Longquan celadon absolutely benefited SS politics, economy, society and aesthetics. Conversely, it was also possible the most fatal victim once the dynasty was replaced, particularly when the new reign was established by a tribe—Mongolian—with a completely different cultural background.

A DRIVING FORCE FOR SSG-STYLE CHANGE IN EARLY YUAN

At the same time, a new social driving force for the new style, early Yuan-style elite Longquan celadon, was quickly generating in this politically, economically and socially advantageous climate.

Political Environment during Early Yuan

Under the new regime, Yuan Dynasty, political and economic environments were apparently disadvantageous for continuing the prior SSG-style Longquan celadon production. SS was the last country to be conquered, before Mongolian tribe establishing his 'Great Yuan' Empire in Chinese territory. The new rulers, Mongols were at the top of new social structure, followed by Semuren, Hanren (漢人) and Nanren (南人).

The Nanren referred to the southern Han, previous SS's occupants, positioned at the bottom of new social structure. Hanren referred to the northern Han, previously ruled by Jin Dynasty (1115–1234) during SS. And, Semuren was referring to those people from Central and West Asia, following Mongols' entry into China. New social structure, predominantly political and economic, created new elite class, primarily consisting of Mongols and Semuren. Therefore, the northern and southern Han lost their superiority and prior social status.

After middle Yuan, the court reopened imperial examination, providing Han intellectuals with an opportunity to participate in the new political system, albeit by employing a considerably unfair model. In fact, it was still difficult for the Han to enter the new government

system, particularly southern Han (Song et al. 1976, 2019). Such a situation is similar to potential political persecution of previous SS elite members, creating a disadvantageous social atmosphere for SS culture.

In fact, several of SS's educated chose to be killed rather than serve in Yuan official system, such as famous Wen Tianxiang (文天祥 1236–1283), Lu Xiufu (陸秀夫 1237–1279) and others (Song et al. 1976, 3158). And, several withdrew from society and lived in obscurity, such as Xie Fangde (謝枋得 1226–1289) (Tuo Tuo et al. 1977, 12687–12690). Compared with the northern Han, fewer southern Hans served in Yuan government (Song et al. 1976). It also proves that the entire political atmosphere was considerably disadvantageous for southern Han throughout the entire Yuan.

Under such a political atmosphere in the South of China, SSG-style Longquan celadon—the best representative of SS elite art and culture—doubtlessly became a political taboo. It normally fomented a social driving force, accelerating the decline and change of SSG-style elite Longquan celadon. Moreover, the new elite classes were distinctly not interested in SS celadon. In contrast, they seemed to demonstrate something of a preference for white porcelain.

Elite Longquan celadon production gradually reached its lowest ebb since early Yuan. However, at the same time, popular Longquan celadon production was seemingly not influenced. Its domestic and overseas markets were quickly extending with Mongolian territory enlarged and transportation system improved (Mori 2012, 6; Xu 2007, 27–28). According to current Chinese archaeological materials, compared with SS Longquan celadon products distribution, Yuan clearly had a larger range (Map 1).

Economic Environment between Late SS and Early Yuan

As discussed in the previous chapter (see also Chapter 3), eastern Sichuan had the largest elite ceramic market during SS, particularly with SSG-style elite Longquan celadon and Jingdezhen Qingbai porcelain occupying considerably large market share. However, during the final two decades of SS, this area suffered from brutal and serious destruction, due to frequent Mongolian military invasions. Many local people died at that time, and most of the rich, who were primary consumers of SSG-style elite Longquan celadon products, fled this area (Song et al. 1976, 4206). Some survivors were regarded as captives and sent elsewhere as labor (Song et al. 1976, 2891).

The local society thoroughly collapsed and population sharply decreased, largely impacting local economy and inflicting heavy losses on elite ceramic market. Population alteration is one of the most critical factors influencing a location's economy (Rice 1984, 255–273). After a few decades, new population structure, new immigrants with completely different tastes and value systems from previous SS, should change eastern Sichuan economy. It implied the previous SSG-style elite Longquan celadon market revivification became difficult after the end of SS in this area.

In the 15th year Zhiyuan (至元) (1278), Yuan court formally designated the Fuliang Ci ju (浮梁磁局) as an official institute to manage ceramic production at Jingdezhen, Jiangxi today (Song et al. 1976, 2227). Some Jingdezhen kilns were designated for production of white porcelain to supply official use. Jingdezhen white porcelain products seemingly quickly captured new elite ceramic market's full attention from the beginning of Yuan Dynasty.

In fact, Jingdezhen was gradually playing a crucial role in Yuan elite ceramic production. A kind of '*tian-bai* (甜白)' white ware, also called '*Shufu yao* (樞府窑)' porcelain, and a

76 | A Contemporary Social Atmosphere

Scheme 1. Development of elite and popular Longquan celadon styles. The upper line in various colors presents three elite styles, respectively, whereas the lower line (yellow line) popular style.

Map 1. A referable distribution range of Longquan celadon products during SS (blue dots) and Yuan (red dots) is presented, and the triangular dot points to the site of Longquan.

Style	Elite Longquan celadon vase/jar	Description
SSG (Figure 1)		Glaze hue: *fen-qing* or *meizi-qing* Glaze thickness: ~0.8 mm Vase size: most 20–30 cm in height Form and decoration: most wide lower-bellied body without design
Early Yuan (Figure 2)		Glaze hue: pale blue or green Glaze thickness: 0.2–0.4 mm Vase size: most 40–60 cm in height Form and decoration: wide upper-bellied body with denser design
Early Ming (Figure 3)		Glaze hue: *bi- lü* (jasper-green color) Glaze thickness: over 0.8 mm Vase size: most 40–70 cm in height Form and decoration: wide upper-bellied body with denser design

Figure 1. SSG-style vases. Suining City Museum (After Asahi Shimbun 1998, Pl. 3); Kuboso Memorial Museum of Arts, Izumi (After Curatorial Division, Nezu Museum 2010, Pl. 18).

Figure 2. Early Yuan-style jar and vase. National Museum of Korea (After Shen 2012, 243 and 138).

Figure 3. Early Ming-style jar and vase. Longquan Celadon Museum (After Mori et al. 2012, Pl. 170); Tokyo National Museum (TNM Image Archives).

Figures 4a (left) and 4b (right). An early Yuan-style Longquan celadon vase, height: 33.3 cm, and an early Yuan-style Jingdezhen Qingbai porcelain vase, height: 22 cm, unearthed from Sinan wreck. National Museum of Korea (After Shen 2012, 95 and 94).

Figures 5a and 5b. Early Yuan-style Longquan celadon vase and incense burner found in Xian Yushu tomb. Hangzhou Museum (After Zhejiang Provincial Museum 2000, Pls. 221 and 222).

Figures 6a and 6b. Alleged Ge ware. National Palace Museum, Taipei; Palace Museum (After Palace Museum 1998, Pl. 11).

new underglazed blue porcelain, also called 'blue and white (青花),' had been successfully created during middle Yuan (Tite et al. 1984, 139; Li 1995, 70–71). Jingdezhen apparently acquired more predominance than Longquan in Yuan's political and economic environments, although both were once primary competitors in SS's elite ceramic market.

Elite Longquan celadon lost its competitiveness and market predominance that enforced those Longquan producers or potters to change their elite product's style. Moreover, once white porcelain became the market mainstream and market-value indicator, to a certain degree, its style should influence other contemporary elite ceramics development. It is also apparent some early Yuan-style elite Longquan celadon products were influenced by Jingdezhen white or Qingbai porcelain (Figures 4a and 4b; Pls. 21 and 22).

AN INSISTENT FORCE FOR SSG-STYLE CELADON

The larger the political and economic setback, the stronger the resistance force to the new style and trend in southern Han society. In fact, the style of SSG-style elite Longquan celadon was seemingly always subsisting in southern Han's memory throughout the entire Yuan Dynasty. According to archaeological and historical materials, some SSG-style elite Longquan celadon objects circulated in Yuan society that not only reflected a somewhat complicated and entangled social atmosphere and ethnic emotion, but also verified a potential insistent force for this SS style of elite celadon.

Charlton's (1968, 99) study of the 16th–17th century Aztec ceramic style change following colonization of Spain, stated: "The major changes involved not the replacement of Aztec pottery by a new ceramic tradition Rather, the changes ... were those of minor aesthetic and technical losses and re-emphases in tradition." Although the foreign invader probably alters local crafts' style in terms of political or economic interference, it could not replace local ceramic tradition, ware usage or even lifestyle habits in a short time. To Han society in China, Yuan rulers and elite classes were just a group of outside invaders.

Origin of Insistent Force

As previously mentioned, SSG-style elite Longquan celadon products were primarily some elegant objects for luxurious living, such as flower vases, incense burners, incense boxes or teaware (see also Chapters 1 and 3). These genres were regarded as worshiping utensils in temples or decorative objects in elite class members' houses. During SS and continuing into Yuan, many Zen temples housed SSG-style elite Longquan celadon worshiping utensils.

For instance, an archaeological site excavated in Anji (安吉), Zhejiang today, was surmised to be a Zen temple during Yuan or earlier (Zhang 2011, 64–65). An incense burner, box, and two bowls with carved lotus petals design, as well as two basins, typical SSG-style Longquan celadon products. In addition, in medieval Japan SSG-style worshiping products for local Zen temple usage were energetically introduced, primary influenced by SS Zen temples (see also Chapters 7 and 8). It also indirectly reflected SS Zen temples were accustomed to using this style of Longquan celadon products.

Many southern intellectuals still cherished SS's objects, particularly those imperial wares or allied objects. Xian Yushu (鮮于樞), one of the famous literati, died in 1302. In his tomb, a pair of SSG-style Longquan celadon flower vases and an early Yuan-style incense burner, were found (Figures 5a and 5b) (Zhang 1990, 23–24). In addition, in Ren

Renfa's (任仁發 1255–1328) tomb, SSG ware, SSG-style and early Yuan-style Longquan celadon objects were found (Tian 1982; Shen and Xu 1982).

It is apparent that a number of SSG-style elite Longquan celadon objects were still preserved or circulating in early Yuan society. Mixing ethnic emotion and Song literati's hobby of collecting antiquities pervaded complex social atmosphere within the southern Han educated community, who seemingly never forgot SS or even Song culture.

Kong Qi (孔齊), a Yuan writer, related several antiquities' collecting stories in his writings. Mr. Wang was an educated southern Han. Not rich, he collected antiquities as a hobby, particularly Song imperial ware, including Ding white ware, SSG celadon and old bronze (Kong 1965, vol. 4: 4–5). However, when the social situation became unstable and confused during late Yuan, to protect his collections, he placed them in his friend's house, considered a somewhat safe location. Unfortunately, almost all his collections were destroyed during the Red Turban Rebellion (1351–1368).

It is one of several similar stories. Including previously mentioned Xian's and Ren's tomb burials, some amount of SSG-style elite Longquan celadon was estimated to still be circulating in Yuan society or antiquities market. Then, how many SSG-style Longquan celadon objects existed in early Yuan society? Sinan wreck's, a commercial ship departing from Qingyuan (Ningpo) harbor in 1323 heading to Japan, salvages probably provided a rough estimation. Thirty seven pieces of SSG-style object were mixed in the load of Longquan celadon products, more than 12,000 pieces of early Yuan-style (see also Chapters 7 and 10) (Mori 2013, 152).

Moreover, several legends related to SSG ware imitation or allied products were created and circulated in Yuan or later. It actually also reflected that there was still a market demand for SSG-style celadon product and other Song imperial wares. One of the most famous legends is Ge ware (哥窯) manufacture.

Ge Ware Legend

Ge ware is usually discussed in connection with SSG ware and SSG-style elite Longquan celadon by Chinese ceramic researchers (Li et al. 1989; Cai 2004; Tokudome 2012, 33–36; Zheng and Lin 2015). According to historical texts, Ge ware's chief potter was Zhang Shengyi (章生一), who, with his younger brother, Zhang Shenger (章生二), were Longquan residents and experts in manufacturing celadon (Gu 1975, 154–155). The older brother mastered imitation SSG ware, and created a unique SSG-like celadon product, called 'Ge ware.' However, stories regarding them are still controversial.

Moreover, according to Ming writings, Ge ware was ranked one of the four most elegant celadon wares, in the following order: Chai (柴); Ru (汝); Guan (官, the SSG); and, Ge (Gao 1996, 404). The similarity of Ge ware and SSG ware was also emphasized in those writings. However, based on the present study, considering contemporary social atmosphere—somewhat strongly cherishing the memory of SS culture—in early Yuan and even later southern society, to generate such Ge ware stories or legends was seemingly normal.

Thus, regardless of whether Ge ware was really subsistent, via this legend, some facts should be able to be confirmed: (1) Ge ware appeared after the end of SS, when SSG ware was no longer produced; (2) this legend itself should be a byproduct of a society strongly pervaded by the insistency of SS culture; and, (3) Ge ware should be one type of elite Longquan celadon products because its chief potter and kiln were closely associate with Longquan. Therefore, it is inevitable to connect Ge ware with SSG-style elite Longquan celadon.

Ge ware legend's creation actually also reflected that SSG ware or SSG-style Longquan celadon was memorized during Yuan or even later. Then, if Ge ware style is really as modern ceramic researchers' description, current archaeological materials reveal its output should be very limited at that time (Figures 6a and 6b) (Zheng and Lin 2015, 77; Ts'ai 1989, 78; Ozaki 1933, 13–15). Further, it also confirmed there was always a small market demand of SSG ware or SSG-style Longquan celadon after the end of SS, exhibiting a sentimental attachment to SS culture.

CONCLUSION

Politics not only determines societal structure, particularly the component of elite class, but also the orientation of economic development. Political and economic environments' rapid shifting created a strong social driving force which guided a new elite ceramic market trend, and further, determined technological choice, product style and production morphology. Moreover, it also gradually changed people's aesthetic and value systems to eventually support the new style.

Once the old style had been abandoned, those attached stylistic attributes should quickly wither. For instance, the stylistic attributes of SSG-style elite Longquan celadon, symbolizing a luxurious or high-quality lifestyle and high social status and position during late SS, were quickly losing their social effects with SS elite classes' collapse after the end of SS. At the same time, the new style, early Yuan style, was gradually acquiring support from the new elite class.

However, behind the style change of elite Longquan celadon, from SSG style to early Yuan style, although the significant social driving force pushed for the latter, the other potential force in southern Han society never disappeared to insist on the former. Under political and economic disadvantageous environments, the insistent force was relatively weak. Then, its subsistence sufficiently reflected a complicated social atmosphere—with strong ethnic emotion and entangled sincerity for SS culture—throughout the entire Yuan Dynasty.

PART 2
Elite Longquan Celadon in Japan's Medieval Age

Chapter 7

Kamakura Period: Choice of Elite Longquan Celadon

'Trade' usually refers to international commerce. However, as James R. Lee (2000, 17) argued: "Of course, trade is much more than just economics. Through trade, products from one country become a part of another country's social and environmental fabric." It should influence trading countries' economic, social and even cultural development. Then, the kind of influence depends on individual trade morphology. For instance, with two countries with different civilizations, the more advanced country usually exports product, conversely, the less advanced exports raw materials. This sort of trade pattern should have greater influence on the latter than the former.

Trade occurring between Japan and China during the 11th–14th century was in the above pattern. According to goods inventory, Japan exported to Chinese Song (960–1278) and Yuan (1271–1368) primarily timbers, sulfur, gold nuggets, pearls and other raw materials. In contrast, China exported to Japan textiles, ceramics, medicine, books, studio utensils and other products (Mori 2009, 54–55). These products represented Song's and Yuan's highly-developed crafts technology and culture which should have a significant impact on medieval Japanese society.

However, among massively imported ceramics, Southern Song (SS 1127–1278) Longquan celadon had a crucial significance, particularly its elite product—SSG-style (Southern Song Guan (imperial) style) celadon—in shaping medieval Japanese elite class culture. Focusing on imported elite Longquan celadon in Kamakura Shogunate period (1192–1333), the objective of the present study is to determine those imported products' characteristics, distribution and consumption in contemporary Japanese society.

Furthermore, beyond this trade itself, why was elite Longquan celadon chosen, and particularly, SSG-style products cherished? As previously mentioned, trade itself was not simply commercial behavior, but was accompanied by complicated cultural exchange, transmission or even transplantation. Therefore, did the simultaneous introduction of SS Zen school and culture create an advantageous environment to accept and choose elite Longquan celadon in Japanese society? Moreover, was the connection between SSG-style Longquan celadon and SS culture or Zen school in contemporary Japan recognized? These issues are also explored in the present study.

ELITE LONGQUAN CELADON IN ARCHAEOLOGICAL SITES

Due to ceramic's intrinsic fragility, it is inevitable to have a certain proportion of damage when loading or unloading and in the transportation process. Therefore, archaeological materials of trade ceramics probably come from export and import harbor or dock sites. Moreover, because ancient sailing carried considerable risk that usually resulted in shipwreck, some archaeological materials came from shipwreck sites. In the present case, in addition to two primary consumption cities—Kamakura (鎌倉) and Hakata (博多), an export dock site in Ningpo (寧波), China, shipwreck site in Sinan (新安), Korean sea area, and import harbor site in Hakata, Japan, a considerable amount of archaeological material is obtainable.

Ningpo Dock Site Findings

Ningpo, also called Mingzhou (明州) in Song and Qingyuan (慶元) during Yuan, in Zhejiang province today, is primary trade port for Northeast Asian countries, particularly Korea and Japan. In 1978–79, Ningpo dock site was excavated, containing a chronological archaeological stratification—from Tang (618–906) to Yuan (Lin 1981, 105–107). It verified that this harbor use began with Tang, and was prosperous in Song and Yuan, gradually declining in late Yuan.

Significant amounts of ceramic fragments were found at this dock site, including Yue ware (越窯), Wuzhou ware (婺州窯), Longquan celadon, Jingdezhen Qingbai porcelain and other kiln wares. However, in Song-Yuan stratification—from late SS to early Yuan—in addition to massive general-quality ceramic relics, a few high-quality elite Longquan celadon and Jingdezhen Qingbai porcelain fragments were found (Lin 1981, 115–116).

Elite Longquan celadon apparently mixed SSG-style and early Yuan-style products. The former is some typically thick glaze in *fen-qing* or *meizi-qing* hue fragments, including mallet-shaped flower vases with fish décor, bottle-shaped vases, and *li*-shaped and cylindrical incense burners, as well as bowls with carved lotus petal design, all genres belonging to SSG-style branded products (Figures 1a and 1b) (see also List 1). The latter is some thin glaze with various stamped designs in variously-sized tableware, of somewhat inferior quality.

Ningpo dock's archaeological materials characterized Ningpo harbor's trade. In ancient China, various harbors along the eastern coastline conducted different areas trade. Therefore, each single harbor's archaeological materials present considerable differences. Compared with the adjacent harbor, Quanzhou (泉州), in Fujian province today, the other exporting Longquan celadon products' port in the South of China during Song and Yuan primarily conducted trade with Southeast Asia, Middle East, Near East and Africa (History Department of Xiamen University 1975, 20).

A shipwreck was found at Quanzhou gulf, which sank in 1271. In addition to a considerable amount of spices and medicinal goods, there was a large amount of ceramics, including general-quality Longquan celadon and black Jian ware (建窯) and other Quanzhou local kilns' products. However, a bowl with carved lotus petal design is SSG-style elite Longquan celadon product (Quanzhou Wan Song Dai Hai Chuan Fa Jue Bao Gao Bian Xie Zu 1975, 4). In fact, this type of bowl was seemingly the only genre of elite Longquan celadon products exported to Middle East or Southeast Asian countries during late SS (Tampoe 1989, 64–65; Okano 2008, 24).

Contrastively, Ningpo dock's abundant genres and large quantity indicated Japan was the most crucial import country of elite Longquan celadon products at that time. Trade ships

periodically departed from Ningpo via Korea to Japan's Hakata harbor, or directly to Hakata, from summer to autumn, and returned to Ningpo in spring following seasonal winds (Map 1) (Mori 1948, 298–299). At times, the ships did not experience smooth sailing en route to Hakata, shipwrecks being an inevitable risk of ancient sailing.

Sinan Shipwreck Site Findings

Sinan shipwreck, found in 1976 in the southwest sea area of Korea, was proved to be a trade ship, departing from Ningpo harbor in 1323 heading directly to Japan (Cho 2012, 9). Unfortunately, it suffered an accident. According to this wreck's salvage, the majority consisted of more than twenty thousand pieces of Song and Yuan ceramic products, with a minor amount of stones, bones, bronze artifacts and coins, as well as spices or incense and medicine (Cho 2012, 20). In addition, a few Korean ceramic products were also included, thought to have been loaded at Ningpo harbor.

Moreover, Longquan celadon products occupied more than 60% of the batch of trade ceramics, followed by Jingdezhen Qingbai porcelain, around 25%, and other kiln wares in smaller proportions (Cho 2012, 21–25). It reveals Longquan celadon was the dominant goods on this ship. Furthermore, among the large amount of Longquan celadon products, most was general quality, and only a small quantity belonged to high-quality elite, 37 pieces of SSG-style elite products and 117 pieces of early Yuan-style (Figures 2a and 2b) (Mori 2013, 152).

Sinan shipwreck preserved a complete inventory of loading, very crucial information for understanding the trade between Japan and China at that time. However, a noticeable phenomenon is that although this ship departed during early-middle Yuan, it contained a specific amount of late SS elite Longquan celadon products—SSG-style celadon. It implied that, although SSG-style products had not been produced for nearly a half-century, there was still market demand in Japan.

Moreover, the 37 pieces of SSG-style products included almost all SSG-style branded products; with various types of flower vases and incense burners, as well as tea bowls (see also List 1). It not only indicated there was still a certain amount of SSG-style Longquan celadon in the South of China during early Yuan, but also the effort Japanese traders made to seek and collect those previously-produced elite products. In contrast, of the 117 pieces of early Yuan-style elite products, in addition to few large-sized flower vases, incense burners and wine jars (Figure 2c), tableware was the staple commodity, such as variously-sized dishes and bowls.

Most imported elite Longquan celadon products, after unloading, were directly distributed to two major cities, Hakata and Kamakura, during Kamakura period. The former was the most crucial harbor and commercial city, with a concentration of rich traders and merchants, as well as grand temples. The latter was the political and religious center, where the elite class members were concentrated.

Hakata Harbor City Findings

Hakata, a prosperous harbor in Fukuoka city (福岡) today, was the primary trade port for China and Korea in medieval Japan, populated by many foreign traders and naturalized Chinese merchants (Naganuma and Haahizume 1952, 125–128). Busy commercial activity mingling exotic cultures characterized the Hakata scene. Beginning in 1977, an eight-year archaeological investigations and excavations unearthed massive Chinese ceramics.

According to archaeological materials and focusing on imported Chinese ceramics during the 11th–13th century, three varietal stages were presented: (1) rapidly increasing stage, the second half of 11th century, primarily white porcelain and a few Yue wares; (2) zenithal stage, the 12th century, primarily white porcelain and a specific amount of celadon products; (3) rapidly decreasing stage, the 13th century, primarily Longquan celadon and a few white porcelain wares (Orio et al. 1984, 338).

Beginning in the 12th century, Longquan celadon and the other southern celadon—Tongan (同安) kiln's products—began to be imported into Hakata. A discarded well, located at Gion (祇園) exit of today's subway, was excavated. A large amount of Longquan celadon with small amount of Tongan ware was found. They all were fired by accident and then discarded in this well. Most Longquan celadon products were bowls or dishes in uniform quality and style, brown-yellowish or pale-greenish glaze with engraved flower design and combing patterns, belonging to early and middle SS products.

It was surmised that these Longquan celadon products belonged to local shipper's or wholesale dealer's stock (Orio et al. 1984, 339). However, it is apparent that in the second stage, imported Longquan celadon products were general-quality tableware, primarily for local inhabitant's daily usage. In some tombs in Hakata, a couple of Longquan celadon bowls were buried with tomb's host, placed near the head or by the side of the body (Suganami 2008, 241–242).

However, in the 13th century, Kamakura Shogunate period, although the integral quantity of imported Chinese ceramics distinctly decreased, Longquan celadon products gradually dominated imported ceramics. And, a specific amount of elite Longquan celadon products had appeared in Hakata during the second half of this stage.

Three SSG-style Longquan celadon bowls with carved lotus petal design were found at Gokushomachi (御供所町) site in Hakata-ku, where several temples were concentrated at that time, including traditional Shinto shrines and Zen temples (Curatorial Division, Nezu Museum 2010, 125). On one of them, 'Bunei 2-nen (文永二年, 1265)' written in ink indicated a possible imported date for these bowls (Figures 3a and 3b; Pl. 23) (Tanaka and Satō 2008, 119; Morimoto 2010, 131).

It implied that, at latest, in the final couple of decades of SS, SSG-style elite Longquan celadon had been imported to Japan, and probably supplied for local temples' usage, as worshiping utensils or monks' teaware. However, due to Mongolian intermittent invasions and attacks on Hakata in the 1270s and 1280s, the trade between Japan and China was interrupted for decades (Yomiuri Shinbun Seibu Honsha 2004, 22). Then, after Mongolian replaced SS reign and established Yuan Dynasty in China, Kamakura Shogunate tried to recover trade with Yuan.

Archaeological materials unearthed from Gokushomachi and Gofukumachi (呉服町), two adjacent zones in Hakata, displayed typical characteristics following trade recovery, the first half of the 14th century. The former concentrated several crucial Zen temples, particularly famous Shōfuku-ji (聖福寺) and Shōten-ji (承天寺). The latter housed rich traders, merchants and official elite class members. It is apparent that regardless of style, quality and genre, elite Longquan celadon products coming from the two archaeological sites displayed a considerable degree of consistency with Sinan shipwreck's (Figures 4a and 4b; Pl. 24).

Kamakura Town Findings

Kamakura's archaeological investigation and excavation began in the 1990s. Archaeological materials revealed it was the major consumption town for elite Longquan

celadon products during late Kamakura (Mori 2013, 151). Many fragments were found not only at some grand Zen temples sites, such as Kenchō-ji (建長寺), built in 1253, Engaku-ji (円覺寺), built in 1282 and Kakuon-ji (覺園寺), built in 1296, but also in some samurai houses and even in stores on downtown streets.

A quantity of large-sized wine jars decorated with parallel longitudinal ridges and large-sized dishes with stamped fish design was found in samurai homes, surmised to be for social gatherings or luxurious living (Figures 5a and 5b; Pl. 25) (Kamakura Kōkogaku Kenkyūsho 1989, 16; Curatorial Division, Nezu Museum 2010, 126). In addition, a batch of elite Longquan celadon products was found in stores on downtown streets, primarily some teaware and tableware, such as bowls, dishes and basins, indicative of urban lifestyle (Kamakura Kōkogaku Kenkyūsho 1989, 18–21).

The above two batches of elite Longquan celadon archaeological materials mostly belonged to early Yuan style, at times mixing in a few SSG-style products. However, coming from those grand Zen temples sites, most belonged to SSG-style objects, including worshiping utensils and teaware, such as flower vases, incense burners, tea bowls and bowl stands (Morimoto 2010, 135–136; Ōmiwa 1983, 26, 51 and 75).

Integrally viewing elite Longquan celadon archaeological materials from the two cities, Hakata and Kamakura, reveals a distinct distribution and consumption pattern—most SSG-style worshiping utensils for grand Zen temples, and few SSG-style products with major early Yuan-style tableware for elite class members. However, teaware gradually became widespread due to the popularity of drinking tea in contemporary society.

IMPORTED ELITE LONGQUAN CELADON PRODUCTS

It is apparent that elite Longquan celadon was virtually influencing Japanese lifestyle and culture, particularly elite classes'. Then, what was the market structure for imported elite Longquan celadon products in Japan? And, did Japanese market merely follow contemporaneous China's, or have its own structure?

Elite Longquan Celadon Market in China and Japan

In fact, elite Longquan celadon and Jingdezhen Qingbai porcelain are two of the most famous branded products in domestic elite ceramic market during late SS and early Yuan, particularly in the South of China. However, elite Longquan celadon was commonly known for its worshiping utensils, particularly various forms and designs flower vases and incense burners. In contrast, Jingdezhen Qingbai porcelain tableware commanded considerable market share at that time (see also Chapter 3). Both had their individual predominance in a keenly competitive domestic market.

Archaeological materials coming from Suining (遂寧) and Dongxi (東溪) hoard sites represent a microcosm of elite ceramic market structure during late SS (see also Chapter 3). In the two batches of hoards, it is apparent that various designs of elite flower vases and incense burners, along with tea bowls, formed the solid backbone of SSG-style Longquan celadon products in domestic market. However, after the end of SS, the early Yuan-style products replaced SSG-style. Thus, as Sinan wreck revealed, mixing a few SSG-style and major early Yuan-style elite products projected domestic elite Longquan celadon's market structure.

Japan began to energetically import elite Longquan celadon products somewhat late, after the production zenith of SSG-style products during late SS. However, given Japanese

traders were desperately seeking SSG-style Longquan celadon in China, the early Yuan should be the best time. Although somewhat delayed, it is seemingly not too late. After trade with China resumed, Japanese traders were more eager to import elite Longquan celadon products during late Kamakura.

Dispatching Ships to Seek SSG-style Longquan Celadon

Trade is actually also an extension of political diplomatic activities. When the political relationship worsens between two countries, trade should be influenced. After a couple of decades of interruption, Japan resumed trade with China during early Yuan, and periodically dispatched commercial ships, named after Zen temples, such as 'Kenchōji-sen ship (建長寺船)' or 'Tenryūji-sen ship (天龍寺船),' to China's Qingyuan (Ningpo) harbor (Shiba 1932, 329–330).

Then, the purpose of dispatching ships was somewhat complicated. Miura (1914, 4) briefly identified three purposes: (1) to raise funds for the new temple construction; (2) to resume trade between Japan and Yuan; and, (3) to re-establish diplomatic relationship with Yuan. Moreover, it also probably functioned to balance Japanese domestic political and religious power at that time (Miura 1914, 5). It means those trade activities were actually entangled with considerably complicated relationship between medieval Japanese religion and politics.

Chief traders of those dispatching ships doubtlessly enjoyed the privilege of official permission for overseas trade; however, they also had to fulfill the obligation to serve domestic religious and political patrons, including donating a colossal sum of money for building temples, or bringing back precious or luxurious commodities for rulers or elite class members, or even commissioning official documents (Miura 1914, 9). Therefore, they should meticulously plan and carefully consider which goods would be useful and highly profitable.

Sinan shipwreck was considered to be one of those dispatching ships at that time, and its goods inventory provided the referable information related to those dispatching ships' load. Nearly 98% are ceramics, further, more than 60% Longquan celadon products. It implied that Longquan celadon products were abundantly supplied in the South of China at that time, and had a considerable market demand and high market value in Japan. Furthermore, among around 150 pieces of elite Longquan celadon products, in addition to 117 pieces in early Yuan-style, 37 pieces are SSG-style objects, which should be antiquities at that time. However, these few SSG-style objects would be the best gifts to send to Zen temples or elite class members.

SSG-style Longquan Celadon in Japan during Late Kamakura

List 1 roughly arranges the previous archaeological materials, from export dock, shipwreck, import harbor and consumptive cities, focusing on the indicative genres and types of SSG-style elite Longquan celadon objects, such as various types of flower vase, incense burner and tea bowl. In addition, Kyoto and Tokyo are later capitals, respectively, after Kamakura period, where a specific amount of archaeological SSG-style objects was found (see also Chapter 8). 'Edo-Col.' refers to Edo period (1603–1868) collections, recording the last Shogunate period of surviving SSG-style objects (see also Chapter 9).

List 1. Genres and types of SSG-style elite Longquan celadon objects found in above archaeological sites.

genre site/type	flower vase or vase					incense burner		teaware
Ningpo		√		√		√	√	√
Sinan	√	√	√	√		√	√	√
Hakata		√				√	√	√
Kamakura		√				√	√	√
Kyoto					√			√
Tokyo		√	√			√	√	
Edo-Col.	√	√	√	√	√	√	√	√

Although elite Longquan celadon products were always imported throughout medieval Japanese history, including SSG-style, Yuan-style and Ming-style products, the latter two were regarded as general consumptive goods. Their value and influence were limited. In contrast, SSG-style and few early Yuan-style elite objects, from initial import in late Kamukura, were specially cherished and seriously influenced medieval Japanese culture.

It is conceivable Japanese traders probably never stopped seeking SSG-style objects in China; then, late Kamakura would be the last opportunity to acquire them from China. Fortunately, as List 1 revealing, most SSG-style branded products had been imported by that time, including various types of flower vase, incense burner and teaware (see also Chapter 3). As previously mentioned, these imported objects were primary distributed to grand Zen temples' monks or elite class members. Then, why did these major users choose or prefer SSG-style elite Longquan celadon products?

WHY ELITE LONGQUAN CELADON WAS CHOSEN

Beginning in the second half of the 13th century, when the habit of drinking tea was introduced in Japan, various Chinese teaware, including tea bowls, tea bowl stands, pots, grinders and others, became the next wave of imports. At the same time, with Zen school and SS culture massively transplanted, many relevant crafts were also introduced.

Map 1. Sailing route between Ningpo and Hakata harbors during Song and Yuan.

Figures 1a and 1b. SSG-style Longquan celadon fragments unearthed from Ningpo dock site. Zhejiang Provincial Institute of Cultural Relics and Archaeology (After Lin 1981, Pls.11–5 and 11–8).

Figures 2a (left), 2b (middle) and 2c (right). SSG-style bottle vase, early Yuan-style incense burner and wine jar found in Sinan wreck. National Museum of Korea (After Shen 2012, 150, 77 and 219).

Figures 3a and 3b. One of three SSG-style Longquan celadon bowls with carved lotus petal design and with writing in ink on the interior of this bowl, dated 1265, unearthed from Hakata harbor site. Fukuoka City Archaeological Center (After Curatorial Division, Nezu Museum 2010, Pl. 67).

Figures 4a (upper) and 4b (lower). Imported elite Longquan celadon products unearthed from Hakata harbor city site. Fukuoka City Archaeological Center (After Tanaka and Satō 2008, 120; Curatorial Division, Nezu Museum 2010, Pl. 66).

Figures 5a (upper) and 5b (lower). Imported elite Longquan celadon teaware and tableware unearthed from samurai homes site in Kamakura town. Kamakura City Board of Education (After Curatorial Division, Nezu Museum 2010, Pls. 77 and 79).

Japanese Zen Monks' Guidance

Trade requires market supply and demand balance. It means that the import country's demand should obtain enough supply in export country. And, the former also probably inspired the latter production. Chinese traders, who were familiar with both markets' situations, actually played a crucial role in trade between Japan and China during Kamakura period (Nakamura 2013, 95). However, Japanese Zen monks, particularly those who had visited or studied in Chinese Zen temples during SS, further, played a critical role in choosing SSG-style elite Longquan celadon for importing at that time.

As previously emphasized, most imported elite ceramics were distributed to among various grand Zen temples and elite class members. The former was conducted by abbots or high-ranking monks who usually experienced SS's Zen temple life and were familiar with SS culture. The latter, to a considerable degree, relied on high-ranking Zen monks' support to consolidate their reign, because of the special relationship between religion and politics during Shogunate periods in Japan. Therefore, Zen monks actually had a certain degree of influence on contemporary economy, society and cultural development.

In fact, medieval Zen monks were not only Japanese intellectuals, and respected by rulers and elite class members, but also SS culture-proficient, introducing and extending its transmission in Japanese society. Therefore, Japanese Zen monks certainly offered the most crucial guidance for SSG-style Longquan celadon products' importation and usage. Eisai (榮西) and Enni (圓爾) were two of the most influential Zen monks during late Kamakura.

Eisai's Influence

Eisai (1141–1215) visited China to study at Linji-zen (臨濟禪) School, twice, in 1167, and 1187–1191, respectively. After returning to Japan, he constructed Shōfuku-ji in Hakata, one of the earliest Japanese Zen temples. In addition to bringing back southern sect Zen doctrine, he also introduced tea planting and the tea drinking habit (Wada and Ishihara 1958, 155–156; Shiraishi 1973, 67–68).

Drinking tea was popular in SS society, particularly loved by intellectuals and Zen monks. It actually became a contemporary high-quality lifestyle indicator. However, in the initial stage of tea's introduction in Japan, it was primarily used by monks in Zen temple rites or life. Furthermore, Eisai enthusiastically promoted drinking tea to Japanese society and even suggested its function in preserving one's health (Takemoto 2014, 64–66).

Thus, drinking tea was gradually established as a fashion that also inspired teaware market demand in Japan. Some famous Chinese ceramic teaware products' importation to Japan quickly followed this fashion. In addition to elite Longquan celadon, Jian black glaze 'Tenmoku' tea bowl was also welcomed by Zen monks and elite class members (Kamakura Kōkogaku Kenkyūsho 1989, 18). It explains the three archaeological SSG-style Longquan celadon tea bowls' appearance in Hakata, as previously mentioned, dated 1265.

Enni's and other Zen Monks' Influence

Enni (1202–1280) visited China and studied Zen school in 1235–1241. After returning to Japan, he obtained the rich trader, Xie Guoming's (謝 國明) patronage to build the grand Zen temple, Shōten-ji in Hakata. In his lifetime, Enni had a close relationship with Xie, particularly in promoting Zen school and SS culture in Japan during late Kamakura.

Xie, a naturalized SS merchant and Zen school proponent, was born into a merchant family in Mingzhou (Ningpo) (Shiraishi 1973, 68–69; Yomiuri Shinbun Seibu Honsha 2004, 20). He not only enthusiastically sponsored Zen temples' construction and renovation, but also became an educated merchant, representing typical SS rich middle class, the major consumers of SSG-style elite Longquan celadon products during late SS (see also Chapter 3). In fact, Xie was very familiar with both SS domestic and Japanese elite ceramics market.

Xie and Enni's relationship mimicked that of contemporary commerce and religion. As Mark Humphries (1998, 220) argued: "… the social dynamics fostered by trade networks provided an environment of close personal interface and geographical mobility which were crucial for any kind of religious diffusion …" The close relationship established was advantageous to each other. At that time, it was also advantageous for SS culture's transmission and SSG-style Longquan celadon products' marketing in Japanese society.

In the final decades of SS, because of Chinese society disorder and trade interruption, Japanese monks' visits to China largely decreased; however, SS Zen monks' visits or even relocation to Japan distinctly increased. For instance, among others, Lanxi Daolong (蘭溪道隆1213–1278), and Yishan Yining (一山一寧 1247–1317) were two of the most influential SS Zen monks in Japan (Nishio 1999, 2–9). Their arrival should bring a new wave of SS cultural impact to Japanese society during late Kamakura.

In fact, similar to Eisai or Enni, most Japanese Zen monks, in addition to studying Zen school doctrine, were actually also learning SS intellectuals' and Zen monks' lifestyle, including some literature and art activities. SSG-style Longquan celadon was one of the most popular elite ceramics, representing SS culture and art, and commonly known in SS society (see also Chapters 1 and 3). This all potentially paved the way—a SS culture-friendly environment—for choosing and accepting SSG-style elite Longquan celadon in contemporary Japan.

SSG-STYLE LONGQUAN CELADON AND SS CULTURE

As previously mentioned, after the end of SS, Chinese domestic elite ceramic market underwent a rapid change. SSG-style elite Longquan celadon was no longer supplied; rather, somewhat inferior early Yuan-style products appeared (see also Chapter 6). And, Jingdezhen Qingbai porcelain was gradually monopolizing the entire domestic elite ceramic market. However, according to Sinan shipwreck's load, Longquan celadon was still the dominant import and there was still a large demand for elite Longquan celadon in Japan.

The market demand's deviation from China's projected Japanese market gradually toward independence at this stage. It really reflected the shift of from previous Chinese traders' controlling imported goods and profit to Japanese traders' being able to make a more independent choice (Mori 1950, 52–53). In fact, it is also apparent that following the final decades of Kamakura Shogunate, SSG-style elite Longquan celadon indeed became a new symbol of *Karamono* (唐物), coming from China's elegant crafts items. Did such a strong preference for SSG-style celadon signify a profound identification with SS culture in Japanese society?

SS Zen School and Cultural Link to SSG-style Longquan Celadon

Zen school is one branch of Mahayana Buddhism. However, when Zen school absorbed traditional Chinese Confucian and Taoist thoughts, Confucianism was also infused Zen

school elements to give a new interpretation and practice, called Neo-Confucianism during Song. Neo-Confucianism was created and energetically promoted by most Song intellectuals, particularly by Zhu Xi (朱熹 1130–1200) during SS (Tamamuro 1937, 81–82).

This new ideological trend simultaneously promoted a new worshiping pattern—simple and respectful rites to gods, ancestors or dead family, with no tiresome and wasteful offering (see also Chapter 1). In fact, after Zen school gradually gained a foothold with contemporary intellectuals, frequent communication between literati and Zen monks created unique SS literature, art and culture. SS Zen elements were omnipresent in SS people's lives and culture.

Furthermore, most Zen temples discouraged gold, silver or bronze precious materials as worshiping utensils. That also made ceramic utensils the best choice (Guo 2001, vol. 4: 12). And, regardless of formal rites in temples or individual home worship, incense and flowers (*xiang-hua* 香華) were the only required offerings (Guo 2001, vol. 5: 5; vol. 7: 5). Moreover, to offer a bowl of tea to a Zen monk or the gods was also considered appropriate (Hong 1982, vol. 14: 121).

Such a simplified worshiping culture created a new ceramic market demand for flower vase, incense burner and teaware. In fact, several southern kilns were eager to compete in this wave of demand. Longquan potters endeavored to develop high-quality worshiping products. Particularly, its successful imitation of the SS imperial ware's (SSG ware) style, and innovative designs created several unique SSG-style elite Longquan branded products, occupying a considerable elite ceramic market share (see also Chapter 3).

In flourishing Zen school regions, the southern Zhejiang, Sichuan and Fujian today, Zen temples stood in great numbers along with the SSG-style Longquan celadon products' market. Moreover, these southern Zen temples were also Japanese monks holy pilgrimage places. Thus, it seemed reasonably to surmise that Japanese Zen monks should deeply experience a unique cultural atmosphere in SS society—dominated by Zen school, Zen literature and art.

SSG-style elite Longquan celadon not only possessed the SS imperial ware's corona, but also became the best endorsement of SS art and culture. Moreover, unlike imperial ware to be limited for populace's use and export, as a commercial ceramic, SSG-style Longquan celadon product was free of those limitations. With its overseas market expanding, it actually became the most efficient transmitter of SS's art and culture.

CONCLUSION

Archaeological materials revealed nearly all SSG-style and early Yuan-style elite Longquan celadon branded products had been imported to Japan during late Kamakura (see also List 1). And, most SSG-style flower vases, incense burners and tea bowls were distributed to grand Zen temples at that time, whereas, most early Yuan-style products, such as tableware and wine jars, and few SSG-style were distributed to elite class members. This distribution pattern didn't change until the beginning of Muromachi Shogunate period (1392–1573).

At the same time, SSG-style elite Longquan celadon was gradually acknowledged and accepted by contemporary Japanese society, particularly with the prevalence of drinking tea. However, to choose and accept SSG-style celadon, rather than Jingdezhen Qingbai porcelain or others Chinese kilns ware, cannot but acknowledge Zen monks' guidance. In addition to transmitting Zen school doctrine, they enthusiastically introduced SS educated

lifestyle and culture that not only significantly influenced medieval Japanese elite class members' knowledge, aesthetic and value system, but also paved the way for accepting SSG-style Longquan celadon—the best endorsement of SS art and culture.

As Bryn Williams (2010, 162) concluded regarding foreign objects' meanings in his Chinese object case study: "Objects in the Chinese style do not speak for themselves in any meaningful way, nor do they speak for China or even from China." Then, how to identify those exotic objects depends on the depth of local people's comprehension of their attendant culture. The deeper the realization of SSG-style elite Longquan celadon products' links with SS culture, the stronger the desire for this style of objects. However, this unique preference was gradually intensified and deepened after the Kumakura period in Japanese society.

Chapter 8

Muromachi and Sengoku Periods: SSG-style and *Kinuta*

As previously discussed, most imported elite Longquan celadon products were sent to grand Zen temples and elite class members' houses during late Kamakura period (1192–1333). And, contemporary Zen monks played a critical role in guiding medieval Japanese society to accept Southern Song (SS 1127–1278) culture and SSG-style (Southern Song Guan (imperial) style) Longquan celadon, particularly those who spent several years studying in China during SS (see also Chapter 7).

In fact, Zen monks continuously influenced elite class members' awareness of those imported Chinese crafts, called *Karamono* (唐物), after Kamakura period, during Nanboku-chō (South and North courts period 1334–1392) and the first half of Muromachi (1392–1573) periods. Focusing on those previously-imported SSG-style and newly-imported Yuan (1271–1368)-style and Ming (1368–1644)-style elite Longquan celadon products, the first objective of the present study is to understand how they were used, and how their attributes and social function were defined during these periods.

However, due to frequent wars and social instability, many Zen temples' or elite class members' treasures were destroyed, lost or redistributed during the second half of Muromachi and Sengoku (1467–1603) periods. At the same time, the tea ceremony was vigorously developed, creating a group of tea ceremony performers who replaced previous Zen monks' role to become the most influential figures in contemporary thought, art and cultural development. They re-defined those exotic objects, particularly previously-imported *Karamono*.

The second objective here is to explore how those surviving SSG-style Longquan celadon objects were re-defined and given a new cultural significance, particularly after being subsumed into tea ceremony system during Sengoku period.

ELITE LONGQUAN CELADON IN NANBOKU-CHŌ PERIOD

Medieval monks were commonly able to read and write Chinese, comparable to Chinese literati. Via their records or writings, such as a temple's inventory, or high-ranking monk's diary or biography, crucial information related to contemporary Zen temples' apparatus and monks' lives was preserved. *Butsunichian Kōmotsu Mokuroku (*佛日庵公物目錄*)* and *Boki Ekotoba (*慕歸繪詞*)* are two important historical documents.

Butsunichian Kōmotsu Mokuroku Catalogue

Butsunichian Kōmotsu Mokuroku catalogue was finished in 1363, recording the properties of Engaku-ji temple (圓覺寺) with notes about some artifacts' history and condition, such as loss, damage and relocation (Engakuji Butsunichian 2017). Engaku-ji is one of the earliest and most crucial Zen temples, built in Kamakura town during 1282. However, it suffered from recurring fires during Muromachi and Edo (1603–1868) periods. Archaeological investigations of this temple site began in the 1970s (Zokutōan Keidai Iseki Hakkutsu Chōsadan 1990, 7).

Zokutōan (續燈庵) was a building belonging to one crucial portion of the Engaku-ji temple configuration, completed in 1352–1355. In its underground circular structure, archaeological workers found more than 300 relics during the 1990s. And, in the lowest deposit stratum, few SSG-style and Yuan-style Longquan celadon objects with a considerable number of Ming-style fragments were unearthed, including incense burner, tea bowl and tableware, surmising to be discards from 15–16th century fires (Zokutōan Keidai Iseki Hakkutsu Chōsadan 1990, 13–14; Morimoto 2010, 135–136).

It verified Engaku-ji possessed a certain amount of elite Longquan celadon products before those fires, particularly a few SSG-style objects. In fact, according to *Butsunichian Kōmotsu Mokuroku* catalogue, this Zen temple once possessed considerably rich Song and Yuan objects, including paintings, calligraphies, worshiping utensils, teaware, writing utensils and others, before 1363.

Focusing on recorded "青磁 (celadon)" objects, in addition to one deleted entry, three entries individually enumerated three set of celadon worshiping utensils: "本堂分 青磁花瓶香呂一對…弥勒堂分 青磁花瓶香呂一對…觀音堂分 青磁花瓶香呂一對." Each single set consisted of a celadon flower vase and incense burner, offered in individual halls: Gautama Buddha Hondō main hall, Maitreya (Miroku), and Avalokiteśvara (Kannon) halls (Sato 2015).

However, due to a dearth of further descriptions of their form or style, we actually don't know whether they belonged to Longquan celadon. Then, referring to the above Zokutōan site's archaeological materials, they should be SSG-style or early Yuan-style elite Longquan celadon products. In addition, two celadon tea bowls and bowl stands were also recorded in the catalogue. Others, like bronze incense burners, candle stands, flower vases, lacquer stationery boxes, ink-stones, and writing utensils were also recorded.

Butsunichian Kōmotsu Mokuroku catalogue not only documented Japanese Zen temples' property and apparatus in detail, but also outlined contemporary Zen monks' lives and celadon worshiping utensils usage. At the same time, it also specified '青磁 (celadon),' the term used to refer to imported elite Longquan celadon objects during Nanboku-chō period.

Boki Ekotoba Scroll

Boki Ekotoba scroll described the life story of Kakunyo (覺如 1270–1351), a Zen monk in Hongan-ji temple (本願寺), Kyoto. It was painted in ten volumes after Kakunyo died (Shibudō and Kokuritsu Bunkazai Kikō 1981). However, volumes 2 and 7 were missing and added them later, around 1482. This scroll is crucial material for further understanding medieval Japanese Zen monks' lives, including their religious practice and social activities with elite class members, as well as their living space configuration and relevant utensils' usage in Zen temples.

In section 3, volume 5, a considerably complete social activity scene was displayed (Figure 1). In the temple's Zashiki (座敷) living room, eight persons, including Kakunyo, presumably educated monks and elite class members, were seriously composing Waka (和歌 Japanese poetry). Viewing this Zashiki, three paintings were hanging on the main wall; in front of them a set of decorative objects was placed, including a celadon *li*-shaped incense burner centered on both sides by a pair of flower vases identical in material (possible bronze) and form. Moreover, each single object was matted with a celadon tray (Figure 1a; Pl. 26). In the foreground, there was a desk with several scrolls on top. This celadon *li*-shaped incense burner and three trays were painted in thicker blue-green resembling SSG-style Longquan celadon.

In addition, next to Zashiki was the kitchen, where several persons were busily preparing food. Among various functional kitchenware items, some bowls, jars and a pot seemed to be celadon products, painted in thin blue-green, surmising to be somewhat inferior Yuan-style Longquan celadon (Figure 1b; Pl. 27). The same quality products were also found in section 1, volume 10. Two celadon flower pots were placed on a wooden shelf located outside the house (Figure 2). Those somewhat inferior Longquan celadon products are similar to Sinan wreck's early Yuan-style Longquan celadon (Figures 3a and 3b; Pls. 28 and 29).

However, section 2, volume 10, depicts the seriously ill Kakunyo, lying in a Zen room, with a large Buddha painting hanging on the main wall, and a worshiping table in the foreground (Figure 4). A set of worshiping utensils, so-called Mitsugusoku (三具足)—a flower vase, incense burner and candle stand—was offered. Obviously, a celadon flower vase is in the center with bronze candle stand on its right, and celadon incense burner on its left (Figure 4a; Pl. 30).

Furthermore, after Kakunyo died, another worshiping table was placed close to Kakunyo's head in the Zen room (Figure 5). And, another set of Mitsugusoku, celadon flower vase, incense burner and bronze candle stand, was offered in the same arrangement pattern on the tabletop (Figure 5a; Pl. 31).

Comparing these celadon objects' style, quality and genre in this scroll, the most elegant celadon objects were used in Zen rooms and Zashiki living room. They resemble SSG-style elite Longquan celadon products, thick glaze in *fen-qing* or *meizi-qing* hue. In contrast, the somewhat inferior quality Longquan celadon wares, Yuan style in thin glaze in pale-bluish or pale-greenish hue, were used in kitchen or outdoors. This scroll not only provided crucial information related to Zen temple's furnishings and usage of elite Longquan celadon objects, but also realistically displayed contemporary Zen monk's lifestyle.

Two subjects—literature and religion—were required for contemporary Zen monks' education. The Zashiki was a meeting room for guests and for producing literature, such as composing poetry, writing and painting. In contrast, Zen room was for practicing religion, such as explaining or discussing doctrine, and worshiping. Different attributes' spaces should require various configuration and furnishings. Zashiki could have more free choice and application, regardless of paintings or decorative objects. In contrast, Zen room was seriously furnished with regulated Buddhist painting and fixed worshiping utensils (Kawada 1981, 98).

Integrating *Butsunichian Kōmotsu Mokuroku* catalogue and *Boki Ekotoba* scroll, focusing on elite Longquan celadon objects, some facts are discernible during Nanboku-chō. They are: (1) *hanji* (漢字) '青磁 (celadon)' was used and referred to imported SSG-style or Yuan-style elite Longquan celadon products; (2) most Zen temples probably owned a specific amount of elite Longquan celadon objects; (3) SSG-style celadon flower

vase paired with incense burner in a fixed arrangement pattern was used in Buddhist halls or Zen rooms, whereas they were also usually used as decorative objects to more freely furnish Zashiki; and, (4) those somewhat inferior quality Yuan-style Longquan celadon products were used as kitchen ware or outdoor flower pots.

An object's social function or cultural significance is usually affiliated with its users' status and social influence. Imported elite Longquan celadon products were primarily used by Zen temples' monks, who were contemporary intellectuals and closely communicated with elite class members, thereby wielding significant social influence. In fact, Zen monks' lifestyles were gradually becoming indicative of high-quality living and education in contemporary Japanese society. And, their daily-use utensils or objects in Zen temples also became valuable.

ELITE LONGQUAN CELADON IN MUROMACHI SHOGUNATE

With the communication between Japanese and Chinese Zen monks continuing following late Kamakura, massive Song and Yuan literature, paintings, calligraphies and crafts flowed into Japan, creating a wave of *Karamono* collection. Particularly, collecting paintings simultaneously inspired the flourishing development of Japanese ink painting during Muromachi period (Tanaka 1977, 40). However, most imported *Karamono* were possessed by some grand Zen temples at that time (Ishida 2003, 400).

Zen school and temples were continuously supported and protected by the new reign—Muromachi Shogunate. And, Zen monks' education and lifestyle were further admired and regarded as a paradigm of elite class members (Morisue 1966, 24). Thus, it was inevitable that some Zen temple's treasures or utensils were gradually transferred to elite class members via various avenues, and became a crucial part of their collections.

The third-generation Shogun, Ashikaga Yoshimitsu (足利 義滿 1358–1408), built the Kitayama villa (北山莊), later named Kinkaku-ji temple (金閣寺) in Kyoto today, to house his collections, surmised to have been handed down to the eighth-generation Shogun, Ashikaga Yoshimasa (足利 義政1436–1490), who built Higashiyama villa (東山莊), later named Ginkaku-ji temple (銀閣寺) in Kyoto today, to preserve his collections.

The batch of collections, according to some relevant records, derived from two lost original documents *Gomotsu On'e Mokuroku (御物御畫目錄)* and *Kundaikan Sōchōki (君台觀左右帳記)*, such as *Okazarisho (御飾書)*, a catalogue finished by Sōami (相阿彌) in 1523 recording decorative furnishing in Shogun prefectural Zashiki, probably included a certain amount of SSG-style elite Longquan celadon objects (Iezuka 2011, 71).

Elite Longquan Celadon in Late Muromachi

Okazarisho is thought to partly reveal Yoshimasa's collections (Yano 2000), containing drawings with labels for various forms of flower vases and incense burners and other genres. Most objects were labeled after their form or design. For instance, "銀杏ノ花瓶 (Ichō no kabin, ginkgo flower vase)" depicted a flower vase resembling the shape of a ginkgo leaf, or "結龍花瓶 (Ketsuryū kabin, weaving dragon design flower vase)" presented its design as intertwining dragons.

However, a mallet-shaped vase without any design or décor with a note "青磁ノ物 (celadon object)" was labeled "槌花瓶 (mallet-shaped flower vase)" (Figure 6). This type of vase was called "紙槌瓶 (paper-mallet vase)" in contemporaneous China, and suggested

as flower vase for study rooms (Gao 1996, 464). It is seemingly able to be confirmed that, as Yoshimasa's art advisors, Sōami and Nōami (能阿彌) not only compiled Shoguns' collections, but also provided expertise regarding Chinese crafts, writings and relevant knowledge (Iezuka 2011, 68–71).

Furthermore, although this type of vase in China was once manufactured by Northern Song (960–1127) Ru imperial, SS imperial and late SS Longquan potters, because the former two products weren't allowed to export before that time, Yoshimasa's mallet-shaped flower vase should be previously imported SSG-style Longquan celadon product. Thus, it is clear that '青磁 (celadon)' term particularly referred to SSG-style Longquan celadon, and a specific amount of SSG-style Longquan celadon objects were collected by Ashikaga family during Muromachi period.

The '*Kanpūzu (觀楓図)* maple-viewing painting,' a Byōbu (屏風) wind wall screen painting created by Kanō Hideyori (狩野 秀賴) during late Muromachi (Figure 7; Pl. 32), described contemporary elite class members' social activity in the outdoors. Several persons, including elite class female members with their children, a monk, and a samurai were enjoying drinking tea in an autumn scene in the suburb of Kyoto (Tokyo National Museum 2018).

A couple of celadon tea bowls with carved lotus petal design were painted in blue-green color, surmising to be SSG-style Longquan celadon products. This type of elite Longquan celadon tea bowl was popularly used by Zen monks, elite class members and even rich middle-class citizens when drinking tea was prevalent in medieval Japanese society (see also Chapter 7).

The Diminishment of Elite Longquan Celadon Objects

Ōnin (應仁) War, occurring in 1467–1477, is commonly considered a critical turning point in medieval Japanese political and societal development. It resulted in Ashikaga Shogunate reign's rapid decline and social instability. Moreover, the nearly constant military conflicts and wars that immediately followed further worsened this situation. The original elite class structure was breaking down, and most temples lost support and protection. Consequently, extensive Shogunate's, elite class members' and temples' treasures were destroyed and continually disappeared (Iezuka 2011, 68; Shimao 2011, 74).

At the same time, in addition to the original Kuge (公家), including Emperor and his family and subordinates, there was a new elite class was consisting of new Buke (武家), the real ruler Shogun (Samurai) with his subordinate and servants, and new local powerful Domains, as well as some newly-established rich merchants. And, some precious treasures, including previous *Karamono*, were also gradually transferred to these new elite class members (Takemoto 2014, 89–90).

According to *Hongan-ji monjo* document (本願寺文書), Hongan-ji temple originally owned a precious '白天目(Haku tenmoku)' tea bowl, always desired by Oda Nobunaga (織田 信長 1534–1582), one of three most powerful Samurais during Sengoku period. However, this tea bowl was eventually regarded as an exchange by this temple's abbot for Oda's protection (Takemoto 2014, 92–93). In fact, for several years following, Hongan-ji sent more than one treasure to Oda to continuously ensure its safety.

Hongan-ji, located in Kyoto, was mentioned in previous *Boki Ekotoba*. This Zen temple possessed considerable amount of *Karamono*, including a certain amount of SSG-style or Yuan-style Longquan celadon objects. However, Hongan-ji temple's story is similar to many at that time that reflected the transference of extensive treasures from some grand Zen

temples to new elite class members, particularly to those new Shoguns and Domains during late Sengoku.

ELITE LONGQUAN CELADON IN ARCHAEOLOGICAL SITES

Elite Longquan celadon archaeological materials came from Domains' castle ruins, fired prefecture sites, or temples or rich merchant's storage sites, belonging to the survivals of late Muromachi or late Sengoku and even early Edo.

Ichijōdani Asakura Family (一乗谷朝倉氏) Castle Ruins

Ichijōdani Asakura family's castle was located in Fukui (福井), Fukui prefecture, close to Kyoto. Asakura family, a powerful Domain in Ichijōdani, established his independent reign and castle from 1477 to 1573. Due to this castle's location close to the capital, Kyoto, it became a crucial shelter during wartime for elite class members. However, in peace time, this was also a famous location of vacation. Therefore, it was constantly teeming with elite class members, high-ranking monks and rich merchants during its heyday (Fukuiken et al. 2017).

Archaeological excavations revealed that some intact celadon incense burners were found at the prefecture site, mostly Longquan celadon in Yuan style or early Ming style (Figure 8a) (Hiroshima Prefectural Museum of History 1995, 91). In addition, in a medical house site, several Ming-style Longquan celadon objects were found, including dishes, bowls, wine jars, and some medical books and utensils (Figure 8b) (Fukuiken et al. 2017). Medical practitioners were among to those who organized feudal Domains at that time (Kanai 1962, 80).

Nishiyama Kōshō-ji temple (西山光照寺) was surmised to be affiliated with Asakura castle. It was built earlier before Asakura castle construction, and once prosperous and then declined with Asakura reign's. In its underground storage, a Ming-style Longquan celadon flower vase with circular handles and a cylindrical incense burner with Bagua (八卦) relief design were found (Figures 8c and 8d).

It is apparent Yuan-style or Ming-style Longquan celadon products were extensively used in Asakura Domain during late Muromachi. However, a couple of fragments found nearby at Nishiyama Kōshō-ji temple site clearly belonged to the relics of a SSG-style elite Longquan celadon mallet-shaped vase with fish décor (Figure 8e). Thus, it is surmised that this temple or Asakura family once possessed a few SSG-style elite Longquan celadon objects.

Kusado Sengen-chō (草戸千軒町) Ruins

Kusado Sengen-chō ruins belonged to a flooded port town, located at the mouth of Ashida River (芦田川), in Fukuyama, Hiroshima today. A minor commercial port, after a short interval of prosperity during Kamakura and Muromachi periods, respectively, it then flooded during early 16th century (Hiroshima Prefectural Museum of History 2005, 12). Large-scale archaeological excavation began in 1990. A considerable amount of ceramics, wooden materials and Chinese coins and other objects were unearthed.

According to a list compiled by the National Government, among 165 pieces of Chinese trade ceramics, around 58% are Longquan celadon products, including SSG-style, Yuan-

and early Ming-style bowls and basins (Figures 9 and 9a; Pl. 33) (Hiroshima Prefectural Museum of History 2005, 36–39). However, a few flower vases and other genres were also imported at that time. For instance, a couple of fragments clearly belonged to a flower vase, identical to the intact flower vase found in Sinan wreck (Figures 9b and 10; Pls. 34 and 35) (Hiroshima-ken Kusado Sengen-machi Iseki Chōsa Kenkyūjo 1981, 76; Nishida 2010, 16 and 122).

Integrally viewing Kusado Sengen-chō ruins' Longquan celadon materials, few SSG-style Longquan celadon products with large amount of Yuan-style were imported during late Kamakura, and a considerable amount of early Ming-style products imported during Muromachi period. Moreover, according to some inscriptions, written in ink on unearthed wooden artifacts, Kusado Sengen-chō should be the home of several rich merchants or traders, probably also the batch of Longquan celadon products' owners (Hiroshima Prefectural Museum of History 2005, 12).

Ryōsen-ji Temple (靈仙寺) Ruins

Two fragments, possible belonging to two pieces of SSG-style mallet-shaped vases with phoenix décor, were found in Ryōsen-ji temple ruins, at Sefurisan mountain (脊振山), located on the border of Saga-ken (佐賀縣) and Fukuoka-ken (福岡縣) (Figure 11) (Nishida 2010, 16; Itokoku Rekishi Hakubutsukan and Kyūshū Rekishi Shiryōkan 2016). Sefurisan was a famous holy mountain, always regarded as a practicing Buddhist sacred land in medieval Japan. Moreover, when Eisai (榮西) brought young tea trees from China in 1191, it was said that they were first planted here (see also Chapter 7).

In addition, a ceramic Buddhist scripture cylinder, incense box, bronze mirror and other relevant worshiping utensils were also found at the ruins (Itokoku Rekishi Hakubutsukan and Kyūshū Rekishi Shiryōkan 2016). All circumstantial evidence implied that Ryōsen-ji had enjoyed a golden age in conjunction with this regional tea farm's prosperous development before late Muromachi. However, it fell into disuse during Sengoku period (Wikipedia 2017).

Prefecture Site in Downtown Kyoto

The political and religious center was relocated in Kyoto after the end of Kamakura Shogunate. At the same time, Kyoto also energetically established its 'Five Mountains and Ten Monasteries (Gosan Jissetsu五山十刹)' Zen temples system to compete with that of Kamakura beginning in the Nanboku-chō period. And, in the sequent Muromachi Shogunate period, Kyoto was still the elite class members' and Zen temples' concentrated capital.

In the downtown area, an archaeological site, formerly the Fujiwara family's (藤原氏) prefecture during Heian period (794–1185) and later becoming the Gotō Shōzaburō family (後藤庄三郎) home site during early Edo period, was excavated. The first-generation Gotō was commissioned as an official gold regulatory agency by Tokugawa Shogunate (德川幕府). A batch of SSG-style elite Longquan celadon materials were unearthed from this site, surmised to be Gotō family's possessions (Curatorial Division, Nezu Museum 2010, 126–127).

The findings included SSG-style and early Yuan-style elite Longquan celadon objects (Figure 12; Pl. 36). A drum-shaped jar's fragment with stamped spreading flower design is early Yuan-style product, similar to Fengdongyan kiln's simultaneous product (see also

Figures 1, 1a and 1b. Several elite Longquan celadon objects used in Zashiki living room and kitchen. Hongan-ji temple (After Shibudō and Kokuritsu Bunkazai Kikō 1981).

Figure 2. Two flower pots placed on outside wooden shelf. Hongan-ji temple (After Shibudō and Kokuritsu Bunkazai Kikō 1981).

Figures 3a and 3b. Two flower pots (or tripod censers) similar to Figure 2 pots unearthed from Sinan wreck, early Yuan-style Longquan celadon products. National Museum of Korea (After Shen 2012, 84 and 156).

Figures 4 and 4a. Zen room scene, a set of Mitsugusoku: a celadon incense burner, celadon flower vase and bronze candle stand. Hongan-ji temple (After Shibudō and Kokuritsu Bunkazai Kikō 1981).

Figures 5 and 5a. Zen room scene, a set of Mitsugusoku: a celadon incense burner, celadon flower vase and bronze candle stand. Hongan-ji temple (After Shibudō and Kokuritsu Bunkazai Kikō 1981).

Figure 6. A drawing of mallet-shaped flower vase in *Okazarisho* (After Yano 2000, 108).

Figure 7. Elite Longquan celadon tea bowls with carved lotus petals design painted in '*Kanpūzu Byōbu (*觀楓図屏風*)* Maple-viewing painting' (red circles). Tokyo National Museum (TNM Image Archives).

Figure 8a. Longquan celadon incense burners unearthed from Ichijōdani Asakura family's castle. Ichijodani Asakura Family Site Museum (photograph courtesy of Ichijodani Asakura Family Site Museum).

Figure 8b. Some early Ming-style Longquan celadon objects unearthed from a medical house site. Ichijodani Asakura Family Site Museum (After Fukuiken [et al.] 2017).

Figures 8c (left) and 8d (middle). A flower vase and incense burner unearthed from Nishiyama Kōshō-ji temple site. Ichijodani Asakura Family Site Museum (After Fukuiken [et al.] 2017).

Figure 8e (right). A restored SSG-style elite Longquan celadon mallet-shaped vase with fish décor. Ichijodani Asakura Family Site Museum (After Fukuiken [et al.] 2017).

Figures 9 and 9a. A batch of Longquan celadon fragments unearthed from Kusado Sengen-chō ruins. SS fragments are displayed on upper row, with several Yuan-style fragments in middle section, and a considerable amount of Ming-style fragments on the bottom of the exhibit panel. Hiroshima Prefectural Museum of History (photographs courtesy of Hiroshima Prefectural Museum of History). Red circle is Figure 9b.

Figure 9b (left). A couple of fragments, belonging to a Yuan-style Longquan celadon flower vase, unearthed from Kusado Sengen-chō ruins, identical to Figure 10 vase.

Figure 10 (right). An intact flower vase found in Sinan wreck. National Museum of Korea (After Shen 2012, 140).

Figure 11. Two fragments of mallet-shaped vase with phoenix décor found in Ryōsen-ji ruins. Saga Prefecture Board of Education (After Nishida 2010, 16).

SSG-style and *Kinuta* | 117

Figure 12. A batch of SSG-style elite Longquan celadon objects and fragments unearthed from downtown Kyoto. Kyoto City Archaeological Museum (After Curatorial Division, Nezu Museum 2010, Pl. 80).

Figure 13. A batch of SSG-style elite Longquan celadon fragments unearthed from Toyama, Kaga and Daishōji Domains prefecture sites in Tokyo. Archaeological Research Unit, The University of Tokyo (After Curatorial Division, Nezu Museum 2010, Pl. 81).

118 | SSG-style and *Kinuta*

Figure 14. At least five types of flower vases mentioned in this drawing with notes, all SSG-style elite Longquan celadon branded products, 1554 (After Nishida 2010, 15).

Figure 7a in Chapter 5), surmised to be *mizu sashi* (水指 water jar) used in tea ceremony (Mori et al. 2012, 51). Another three pieces of SSG-style shards distinctly belonged to a *cong*-shaped vase. Moreover, several intact bowls and dishes are either SSG-style or early Yuan-style teaware or tableware.

Focusing on the batch of findings' style, beautiful *fen-qing* or *meizi-qing* hue SSG-style elite Longquan celadon objects seemed to be dominant, with few early Yuan-style objects. Further, the genres' assemblage indicates they should be some furnishings or utensils used in tea ceremonies during late Sengoku or early Edo.

Domains' Prefecture Sites in Tokyo

A couple of Domains' (大名) prefectures sites, including Kaga Domain (加賀藩), Toyama Domain (富山藩) and Daishōji Domain (大聖寺藩), located at the clinical building of medical department, Tokyo University today, were excavated in recent decades (Archaeological Research Unit, The University of Tokyo 2017). Domains, the high-ranking elite class members, were immediately under the real ruler Tokugawa Shogunate in Edo feudalism.

However, these Domains' prefectures once suffered from multiple firings. Toyama Domain prefecture site preserved a more complete architectural configuration. In its Zashiki, several SSG-style Longquan celadon fragments were found, surmising some discards after the first firing, occurring in 1682 (Figure 13) (Miyazawa 2013, 77). Although most fragments had been overfired and original color lost, they are doubtless some SSG-style elite Longquan celadon objects, including a mallet-shaped vase with fish décor, a *cong*-shaped vase, *li*-shaped incense burner and some desktop decorations. In addition, a Tenmoku (天目) tea bowl was also included.

Focusing on quality and style, they had a considerable similarity to the above Gotō's. In addition, of the three pieces of SSG-style elite Longquan celadon fragments found at Kaga Domain prefecture site, one of them was possibly a portion of a bottle-shaped vase with bamboo nodes design (Miyazawa 2013, 76). Moreover, three SSG-style shards were found at Daishōji Domain prefecture site.

Summary of Archaeological Elite Longquan Celadon

In fact, elite Longquan celadon archaeological materials are seemingly ubiquitous in today's Japan (Koyama 1969, 107). With political centers and elite class communities' northward migration, those precious and valuable *Karamono*, including elite Longquan celadon objects, were more widely distributed after Muromachi period. However, the above archaeological materials unveiled some crucial information related to these surviving elite Longquan celadon objects during late Sengoku and early Edo.

Firstly, earlier imported SSG-style elite Longquan celadon objects apparently transcended the later imported Yuan-style or Ming-style to survive. And, most SSG-style objects were distributed to those high-ranking elite class members, concentrated in the capital, Kyoto, or Tokyo; whereas Yuan- or Ming-style objects went to those lower-ranking elite class members, such as local Domain's servants or subordinates, and rich merchants. In addition, general-quality Longquan celadon products were used by general citizens.

Secondly, SSG-style elite Longquan celadon objects' attributes were transferred from previous temple's worshiping utensil, Zashiki's furnishings or monks' living necessity to gradually-flourishing tea ceremonies' items for social activities. A SSG-style elite

Longquan celadon object was not only a valuable antiquity, but also an indicator of high-quality and luxurious lifestyle at that time.

Particularly, those objects subsumed into tea ceremony system, such as various types of SSG-style elite Longquan celadon vases, incense burners, bowls and others, were further re-defined, re-valued, and given a new social function and cultural significance. Such shift is advantageous to their continuing survival. In contrast, most Yuan-style and Ming-style objects were not so lucky, culled from contemporary society.

RE-DEFINING SSG-STYLE LONGQUAN CELADON

Re-defining those old objects to meet contemporary social and cultural trend should be the best way to ensure their survival. SSG-style Longquan celadon objects are a good case in point. '*Kinuta (砧)*' widely refers to SSG-style elite Longquan celadon objects among modern Japanese and even Western researchers (Gray 1953, 41). So, how was SSG-style elite Longquan celadon connected with this term '*Kinuta*', becoming the latter incarnation during late Sengoku?

'*Kinuta*' in Tea Ceremony Texts

'*Kinuta*' was frequently mentioned in memoranda of tea ceremony events during Eiroku era (1558–1570) (Nishida 2010, 15). An earlier record noted "Sakai Sumiyoshiya Sōzaemon's (堺住吉屋宗左衛門)" tea ceremony in April 20, 1559 (Eiroku second year), written as "床ニ キヌタ キンセン花," meaning '*Kinuta*' flower vase with the seasonal flower, Calendula officinalis (金盞花), placed on Tokonoma (床) in the tearoom (Sen 1977, vol. 9: 33).

However, for several years following, in Matsue Ryūsen's (松江 隆専(仙)) tea ceremonies, a '*Kinuta*' flower vase was frequently used. For instance, on November 20, 1566 (Eiroku 9th year), the '*Kinuta*' with Tsubaki (椿 Camellia) was placed on the table on Tokonoma (Sen 1977, vol. 7: 126). And, in *Bunrui Sōjinboku* (分類草人木), a copy of old encyclopedia compiled in 1558, the complier mentioned a unique '*Kinuta*' flower vase in Matsue Ryūsen's possession. Further, he explained that because of this flower vase's 'ひびき(crazing)', it was named 'キヌタ(*Kinuta*)' (Shinshōsai 1971, 299).

In fact, although it is not clear whether there was more than one '*Kinuta*' flower vase, its close relationship with Ryūsen was confirmed. Ryūsen was allegedly a famous tea ceremony performer at that time. Additional scattered information related to '*Kinuta*' flower vase's form, size, color and other characteristics was mentioned in contemporaneous tea ceremony memoranda (Sen 1977, vol. 6: 179, 9: 62 and 10: 18). Thus, a somewhat definite image of '*Kinuta*' flower vase seemingly could be outlined: celadon vase in mallet shape, without any design and décor, and its surface with nuanced craze. Only SSG-style elite Longquan celadon vase met most, nearly all characteristics among imported Song, Yuan or even Ming celadon products.

Re-defining SSG-style Longquan Celadon

'*Kinuta*,' a mallet-shaped flower vase is similar to the '槌 (*Tsuchi*) 花瓶' previously mentioned in Sōami's *Okazarisho*, an earlier record. However, by using '槌 (*Tsuchi*)' to '砧 (*Kinuta*)' to describe the same form SSG-style flower vase, it implied a sort of ideological

change in Japan over the past several decades. The former—*Tsuchi*—regardless of name and meaning followed Chinese, whereas the latter—*Kinuta*—was pure Japanese with more derivative significance, from pictograph's description to phono-sematic cognition and eventually to a sort of special feeling or artistic conception. It reflected a sort of special atmosphere—trying to decrease Chinese cultural influence—in Japanese society.

In fact, in addition to the above mallet shape, according to *Bunrui Sōjinboku* and *Rikka Zukan* (立花圖卷), a painted scroll finished in 1554, several types of SSG-style Longquan celadon vases were used as flower vase at that time, such as bottle shape, bottle-shaped vase with bamboo nodes design, and cylindrical, *cong*-shaped (Figure 14) (Shinshōsai 1971, 298–299; Nishida 2010, 15). It is somewhat surprising that nearly all types of SSG-style elite Longquan celadon vases were still circulating in tea ceremony system activities during late Sengoku.

However, they were also separately given new definitions and names, such as the bottle-shaped vase with bamboo nodes design called '*Takenoko*竹の子 (筍 baby bamboo)', and cylindrical vase called '*Tsutsu*筒 (cylinder)'. These names, like '*Kinuta*,' were analogous to some specific natural objects, symbolizing a sort of Zen and tea combination spirit, which was pursued by most tea ceremony performers. Others, such as SSG-style incense burners, jars, boxes, bowls and basins, were also used in various tea ceremony events, and given new function and cultural significance.

Tea ceremony was developed into a crucial social activity, particularly supported by contemporary powerful politicians and rich merchants, who established good relationship with each other via such activities (Sasaki 1981, 256). Once those surviving SSG-style Longquan celadon objects or other *Karamono* were subsumed into tea ceremony system and re-defined to acquire a new attribute, they should be protected by the new cultural mechanism.

CONCLUSION

Beginning with late Kamakura, most imported elite Longquan celadon products were used and preserved in some grand Zen temples. Particularly, those SSG-style flower vases and incense burners were regarded as Zen rooms' worshiping utensils or Zashiki's decorative furnishings, and early Yuan-style bowl, dish, jar or pot as tableware or kitchen ware. It not only gradually defined those imported Longquan celadon objects' attributes and functions, but also shaped Zen monks' lifestyle to be the high-quality and educated living paradigm in contemporary Japanese society.

Following Muromachi period, Ashikaga Shoguns enthusiastically collected Chinese Song and Yuan *Karamono*. Several SSG-style Longquan celadon objects were gradually transferred to elite class members from previous grand temples. And, their decorative attribute and function were largely intensified. According to archaeological materials, many local Domains possessed some SSG-style objects in their prefectures. Thus, they became an indicator of elite class lifestyle.

However, since late Muromachi and Sengoku periods, frequent wars and unstable society not only disintegrated original elite class structure, but also massively destroyed precious *Karamono*. Those surviving *Karamono* or SSG-style Longquan celadon objects were partly regarded as gifts to send to new powerful samurais, and partly collected by newly-established rich merchants or tea ceremony performers.

Further, with tea ceremony energetically developing, part of surviving SSG-style objects were subsumed into the new social culture, and re-defined and given new significance. For instance, '*kinuta*' became the incarnation of mallet-shaped SSG-style Longquan celadon vase, to meet contemporary entangled and complicated social atmosphere—combining Zen and tea artistic conception with somewhat strong Japanese cultural autonomy and independent ideology.

Chapter 9

Edo Period: Elite Longquan Celadon Survivals

In the pre- and post-war periods, there was an upsurge of oriental antiquities and artwork collecting worldwide. Thus, a review of modern Japanese Chinese ceramics collections should frame global collecting structure. However, different from the West or even the country of origin, China, elite Longquan celadon collections in modern Japan have their uniqueness, primarily owing to their special provenances and historical background.

Beginning in late Kamakura (1192–1333), Chinese Southern Song (SS 1127–1278) and early Yuan (1271–1368) styles of elite Longquan celadon products were imported to Japan. For the next few hundred years, although political and societal shifts occurred and following Yuan-style and Ming-style elite Longquan celadon products were being imported, those previously-imported, particulary SSG-style (Southern Song Guan (imperial) style) objects, were always cherished by elite class members in medieval Japan. However, the end of Edo period (1603-1868) marked the termination of both Shogunate reign and medieval age.

Following Meiji period (1868–1912), the country confronted a greatly entangled and complicated political, societal and cultural transformation. Particularly, Meiji Restoration Movement, occurring around 1860s–1880s, not only thoroughly changed Japanese political system and social structure, but also reversed traditional value systems and ideologies. Westernization or modernization, actually two sides of the same coin, was the only option for contemporary Asian countries, including China, Japan and others at that time.

In such environments, those previously-imported *Karamono* were facing an unknown fate. Although some were destroyed or discarded, fortunately, some were preserved. However, after decades of intentional and intense westernization in Japan, when people were rethinking their tradition and culture, those formerly-discarded objects were partially re-embraced. Many elite Longquan celadon objects with known and unknown provenances were re-collected and preserved.

However, compared with pre- and post-war collections, mostly coming from contemporary China, those previously-surviving elite Longquan celadon objects not only distinctly radiated a sort of medieval Japanese historical aureole, but also reflected the unique Japanese aesthetic, rooted in Chinese SS culture. The objective of the present study is to understand the uniqueness of those historical survivals. Futher, in terms of tracing back their provenances and attendant stories, this study explores their usage and circulation in Edo society.

In 2010 and 2012, two recent exhibitions of elite Longquan celadon collections in Japan were held at Nezu Museum and Aichi Prefectural Ceramic Museum, respectively

(Curatorial Division, Nezu Museum 2010; Mori et al. 2012). They nearly completely displayed the most quintessential portion of elite Longquan celadon collections in Japan, particularly those heirloom SSG-style objects. Although it is inevitable that there are still undiscovered or unpresented objects, these exhibits have articulately projected modern Japanese collections' uniqueness. The present study actually benefited by these exhibitions.

ELITE CLASS MEMBERS' TREASURES

Chinese Song and Yuan elite Longquan celadon collections in modern Japan primarily came from three provenances: (1) elite class members' treasures during Edo period; (2) tea ceremony performers' or rich merchants' collections during Edo period; and, (3) pre- and post-war Chinese or international antiquities market offerings. However, the former two provenances characterized modern Japanese elite Longquan celadon collections.

Elite class members consisted of Kuge (公家), representing the Emperor and his family and subordinates, Buke (武家), representing Shogunate rulers' group, and several local powers—Domains (大名₁)—during Edo period. Moreover, these elite class members established a close social network in terms of kinship, marriage or political diplomacy and other avenues. At the same time, many precious *Karamono*, including elite Longquan celadon objects, were regarded as gifts to circulate within this network.

Elit Longquan Celadon Collections with Defined Provenances

List 1 itemizes a dozen elite Longquan celadon objects with defined provenances, coming from Edo period elite class members. They could be categorized by two genres of functional objects: the vase, mostly used as flower vase, and incense burner. It is apparent that Tokugawa family and several Domains are primary owners. In addition, collections' labels in all lists of the present chapter simply indicate 'shape-design (or décor),' such as 'mallet-phoenix' referring to mallet-shaped vase with phoenix décor, or 'bottle shape' to bottle-shaped vase without design and décor.

List 1. Elite class members' collections with defined provenances.

provenance	genre		style
	vase	incense burner	
Tokugawa-Emperor	mallet-phoenix (*Sensei*) (Fig. 1a)		SSG
Tokugawa-Emperor	mallet-phoenix (*Bansei*)		SSG
Owari Domain (Tokugawa family)	mallet-fish	cylinder shape (Fig. 1c)	SSG
	depressed globular shape		SSG
	cong shape (Fig. 1b)		SSG
Sasayama Domain	mallet-phoenix		SSG
Date Domain	mallet-fish		SSG
Iida Domain	mallet-fish		SSG
Masuda Domain	mallet-phoenix		SSG
Ōuchi Domain	cylinder shape		SSG
Tokugawa's doctor	bottle shape		SSG

Two pieces of SSG-style mallet-shaped flower vase with phoenix décor were allegedly Tokugawa Shogunate's treasures. However, Tokugawa Iemitsu (德川 家光 1604–1651), the third-generation Shogun, sent them to his sister Tokugawa Kazuko (德川 和子 1607–1678), the Emperor Go-Mizunoo's (後水尾天皇 1611–1629) queen Tōfukumonin (東福門院). Thus, both were moved from Tokugawa to Emperor's family during early Edo. And, later, they were inscribed by the Emperor Go-Sai (後西天皇 1654–1663), one in '千聲 (*Sensei* thousand voice)' (Figure 1a; Pl. 37) and the other in '萬聲 (*Bansei* ten thousand voice),' citing Chinese Tang Dynasty (618–906) poet Bai Juyi's (白 居易 772–846) poem (Konoe 1977, 135; Ono 2012, 263).

Then, after the queen died, both were passed on within the Emperor's family, separately. The *Sensei* was owned by Konoe Iehiro (近衛 家熙 1667–1736), and collected by Yomei Bunko (陽明文庫) today, built to preserve the Emperor's family documents and treasures (Ono 2012, 263). And, the *Bansei* was sent to Bishamondō Monzeki (毘沙門堂門跡), currently housed in Kuboso Memorial Museum of Arts, Izumi (和泉市久保惣記念美術館) (Nishida 2010, 117).

Tokugawa family should be the largest owner of surviving elite Longquan celadon objects after Muromachi Shogunate (1392–1573). Several pieces of elite Longquan celadon objects are housed in The Tokugawa Art Museum today, which primarily preserved Owari Domain's (尾張藩) treasures. The ninth son of Tokugawa Ieyasu (德川 家康 1543–1616), Yoshinao (義直 1600–1650) was appointed leader of Owari Domain in Nagoya today, and as this Domain's nineteenth-generation successor, Tokugawa Yoshichika (德川 義親 1886–1976) built this museum in 1935. Three types of SSG-style elite Longquan celadon vases, including a mallet-shaped with fish décor, *cong*-shaped (Figure 1b; Pl. 37) and depressed global bottle shape, and a cylindrical incense burner (Figure 1c; Pl. 37) are currently housed in this museum, belonging to this family's heirlooms.

In addition, a SSG-style mallet-shaped vase with fish décor was seriously burned. It was said to have been restored by Sen no Rikyū (千 利休 1522–1591), and later owned by Date Masamune (伊達 政宗 1567-1636), who established a close relationship with the Emperor and Tokugawa families; several records revealed frequent gift exchanges among them (Sen 1977, vol. 5: 83 and 135). Date Clan (伊達家) affiliated themselves with Kuge following the Kamakura period, and ruled Sendai Domain (仙台藩) in Tōhoku region (東北地區) today, during early Edo. This vase is now stored in Seikado Bunko Art Museum (靜嘉堂文庫美術館).

A SSG-style mallet-shaped vase with phoenix décor allegedly came from Sasayama Domain (笹山藩), Aoyama Clan's (青山家) in Hyōgo-ken (兵庫縣), today. Moreover, a similarly-styled vase was allegedly Masuda Clan's (益田氏), now owned by the Gotoh Museum (五島美術館) (Shimura 2011, 186-187). Masuda Clan was the samurai descendant beginning with the Kamakura period.

Further, a SSG-style mallet-shaped vase with fish décor was Watahan Nohara company's (綿半野原総業株式会社) donation to Iida City Museum (飯田市美術博物館). Watahan was a cotton producer, who constructed his factory on Iida Domain's (飯田藩) relics, in Shinano Province (信儂國), Honshū, during Edo period (Iida City Museum 2017). Iida was once Takugawa's servant during Sengoku period (1467–1603). However, how Watahan acquired this vase is not clear, surmising it was probably coming from Iida Domain's possession.

In addition, a cylindrical vase was allegedly Ōuchi Clan's (大內氏) possession, one of the most powerful clans during Muromachi period. After the 1560s, this clan distinctly declined. Because of clear crazing on this cylindrical vase, it was once thought to be Chinese Southern Song Guan (imperial) ware in the pre- and post-war periods during a wave of

excess enthusiasm for Song imperial ware (Mikasa 2010, 116). However, most contemporary researchers still consider it to be a SSG-style Longquan celadon vase.

A bottle-shaped vase was said to come from Tokugawa family's doctor, Oka Sessai (岡節齋1764–1848), who was interested in tea ceremony, and had close communication with the contemporary famous tea ceremony performer Matsudaira Fumai (松平 不昧 1751–1818). This vase is currently preserved in Hara Museum of Contemporary Art (原美術館) (Dejitaruban Nihon Jinmei Daijiten + plus 2017). Although some owners were not high-ranking elite class members, such as Tokugawa family servants or doctors, their collections probably came from their hosts' possessions.

Characteristics of Elite Class Members' Collections

Many previous elite class members' treasures had been scattered or lost after the end of Edo Shogunate. However, according to List 1, fortunate surviving elite Longquan celadon objects presented some distinct characteristics: (1) nearly all collections are in single style—SSG style—and in considerably uniform quality; and, (2) vase is the primary genre, and mallet-shaped with phoenix (or fish) décor is the dominant type. These characteristics projected the singularization of surviving elite Longquan celadon objects in transmission process.

Moreover, specific genres or types of elite Longquan celadon objects, such as SSG-style mallet-shaped vase with phoenix (or fish) décor, seemed to be monopolized by a few high-ranking elite class members, and circulated in a very small social network during Edo period. In contrast, some SSG-style Longquan celadon objects could be more freely owned by most elite class members, including those lower-ranking elite class members, such as Kuge or Buke's subordinates, doctors or servants. It reflected a fixed distribution pattern and circulation model.

RICH MERCHANTS AND TEA CEREMONY PERFORMERS' COLLECTIONS

Tea ceremony performers usually came from rich merchants' family, or had strong economic or financial backing during late Sengoku and early Edo periods (see also Chapter 8). They were educated in literature and art with Zen school training. Tea ceremony itself was actually a crucial social and mutually benefical activity for contemporary merchants and political elite class members (Sasaki 1981, 256).

Beginning in early Edo, the country had created several rich merchants, who by means of commercial monopoly and increasing their wealth and commercial territory achieved a tremendous Zaibatsu (財閥). 'Zaibatsu' is a special Japanese term referring to a sort of industrial or financial conglomerate that at times probably controlled or seriously influenced contemporary economy and finance of the country or government. However, they were also usually the owners of those old and precious *Karamono*, including elite Longquan celadon objects and special tea ceremony utensils.

Unfortunately, once the Zaibatsu declined, perhaps after a couple of generations of management, their family treasures or collections were usually transferred to another Zaibatsu. Kōnoike (鴻池), Mitsui (三井) and Hirooka (広岡) families were three of the largest Zaibatsus, possessing specific amount of elite Longquan celadon collections during Edo period.

Zaibatsus' or Tea Ceremony Performers' Collections

List 2 enumerates some elite Longquan celadon objects that came from those Zaibatsus or famous tea ceremony performers. Each single object is given a function, referring to tea ceremony items, such as flower vase, incense burner, *mizu sashi* (water pot) and tea bowl. However, at times their functions are not defined.

Kōnoike family were initially wine producers in Hyōgo-ken (兵庫縣) today, and later moved to Osaka as bankers and financiers serving for Tokugawa Shogunate and other elite class members during Edo period (Takeuchi 1993, 81-88). However, the end of Shogunate period brought about this family's downfall. A piece of drum-shaped jar with spreading flower design was probably used as *mizu sashi* (水指) in tea ceremony (Figure 2b; Pl. 37). It was allegedly Kōnoike family's possession, then later owned by Iwasaki (岩崎) family during Meiji period, founder of Mitsubishi (三菱) Zaibatsu and Seikado Bunko Art Museum (靜嘉堂文庫美術館) (Mori et al. 2012, 51).

List 2. Zaibatsus and tea ceremony performers' collections with known provenances.

provenance/(collector, now)	object	style
Kōnoike (Seikado BAM)	drum-flower (jar, *mizu sashi*) (Fig. 2b)	E-Yuan
Kōnoike (MOC, Osaka)	vase-iron stain (vase)	E-Yuan
Kōnoike ? (Masaki M.)	basin (*mizu sashi?*)	SSG
Mitsui (Mitsui M. M.)	cylinder (flower vase) (Fig. 2a)	SSG
Hirooka (Fujita M.)	vase-flower-ring (flower vase) (Fig. 2c)	E-Yuan
Nakamura (Seikado BAM)	vase-iron stain-ring (vase)	E-Yuan
Katagiri (Rokuon-ji)	bowl (tea bowl)	SSG
Kinshuku (Shōkoju-ji)	cylinder-flower (incense burner)	SSG

This jar's style is similar to Fengdongyan (楓洞岩) kiln's early Yuan product (see also Figure 7a in Chapter 5). This kiln was the most crucial for manufacturing elite Longquan celadon products during early Yuan. In addition, a vase with iron stains was said to come from Kōnoike family, currently housed in the Museum of Oriental Ceramics (MOC), Osaka (Mori et al. 2012, 67). An identical style of vase was found in Sinan wreck, surmising the same workshop's products manufactured during early Yuan.

A SSG-style basin is owned by Masaki Takayuki (正木 孝之 1895-1985), a rich merchant and enthusiast of Zen culture and tea ceremony during Meiji period. Masaki once acquired three precious calligraphies from Kōnoike family, later classified as important cultural property by Japanese government (Masaki Art Museum 2018). However, whether this SSG-style Longquan celadon basin was associated with Kōnoike family is not clear today.

Mitsui Takatoshi (三井 高利 1622-1694) created his family wealth as Tokugawa Shogunate and elite class members' financier and banker during early Edo. The family's successors were interested in tea ceremony and collecting relevant utensils. A SSG-style elite Longquan celadon cylindrical vase was called '筒 (*Tsutsu* cylinder)' (Figure 2a; Pl. 37), usually mentioned in tea ceremony performers' memoranda or diaries during late Sengoku and early Edo (Sen 1977, vol. 6: 80, vol. 9: 50 and 84). However, in its stock box

Elite Longquan Celadon Survivals

Figure 1. 1a (left). 1b (mid.). 1c (right).			
provenance	Tokugawa-Emperor *(Sensei)* H: 26.0 cm	Tokugawa family H: 25.4 cm	Tokugawa family H: 6.4 cm
Figure 2. 2a (left). 2b (mid.). 2c (right).			
provenance	Mitsui family H: 16.8 cm	Kōnoike family D: 24.6 cm	Hirooka family H: 25.4 cm
Figure 3. 3a (left). 3b (mid.). 3c (right).			
collector	Rokuon-ji H: 32.0 cm	Fujita Denzaburō H: 16.3 cm	Nezu Kaichirō H: 15.8 cm
Figure 4. 4a (left). 4b (mid.). 4c (right).			
collector	Sugahara Tsūsai H: 10.5 cm	Idemitsu Sazō D: 33.5 cm	Uragami Toshiro D: 15.2 cm

Elite Longquan Celadon Survivals | 129

Figure 1. Elite class members' collections during Edo period.

Figure 1a. Yomei Bunko (After Curatorial Division, Nezu Museum 2010, Pl. 17).

Figures 1b and 1c. The Tokugawa Art Museum (The Tokugawa Art Museum © The Tokugawa Art Museum Image Archives / DNPartcom).

Figure 2. Zaibatsus and tea ceremony performers' collections.

Figures 2a and 2c. Mitsui Memorial Museum, Fujita Museum (After Curatorial Division, Nezu Museum 2010, Pls. 6 and 53).

Figure 2b. Seikado Bunko Art Museum (Image courtesy of Seikado Bunko Art Museum).

Figure 3. Unknown provenances collections.

Figures 3a, 3b and 3c. Rokuon-ji, Fujita Museum, Nezu Museum (After Curatorial Division, Nezu Museum 2010, Pls. 9, 5 and 50).

Figure 4. Pre- and post-war entrepreneurs' collections.

Figure 4a. Tokiwayama Bunko Foundation (After Curatorial Division, Nezu Museum 2010, Pl. 47).

Figures 4b and 4c. Idemitsu Museum of Arts, Hagi Uragami Museum (After Mori et al. 2012, Pls. 62 and 76).

Figure 5 (left). A mallet-shaped vase with phoenix décor, height of 25.5 cm, Yuan. Daikōmyō-ji temple, Kyoto (After Arima 1991, Pl.125).

Figure 6 (right). A mallet-shaped vase with Xi(犧)-shaped décor, height of 20.9 cm, Ming or later imitation. National Palace Museum, Taipei.

an attached label in ink 'きぬた花入れ (*Kinuta* flower vase)' was ostensibly written by Sen no Rikyū (Nishida 2010, 115–116; Kyoto National Museum et al. 1990, 71). It made this vase more legendary and valuable.

In addition, an early Yuan-style flower vase with stamped spreading flower design and ring handles allegedly came from Hirooka Kyūemon (広岡 久右衞門 1844–1909), the ninth-generation successor of Hirooka family (Figure 2c; Pl. 37) (Nishida 2010, 122–123). Hirooka's family were rice merchants in Osaka during early Edo, and later commissioned to conduct financial affairs for elite class members. This vase was transferred to Fujita family, and is currently preserved in Fujita Museum, Osaka.

Nakamura Kichibē (中村 吉兵衞) was a rich Osaka merchant, whose family monopolized contemporary medicinal wine business, called 'Hōmeishu (保命酒)' wine during Edo period (Wikipedia 2018). A piece of early Yuan-style elite Longquan celadon flower vase with iron stains and ring décor allegedly came from Nakamura family, based on its stock box label, currently housed in Seikado Bunko Art Museum (Hasegawa and Yamada 2017, 5).

As the above revealed, some elite Longquan celadon objects were transferred somewhat frequently in Edo and following Meiji periods. At times, they were regarded as highly-valuable exchangeable commodities transferred among rich merchants, and also passed among tea ceremony performers or temple monks as a precious memorial, gift or dedication.

A tea bowl in simple and plain appearance was collected in Rokuon-ji temple (鹿苑寺). According to relevant records, this bowl was Katagiri Sekishū's (片桐 石州 1605–1673), a famous tea ceremony performer at that time, gift to Hōrin Jōshō (鳳林 承章 1593–1668), a monk, when they had a happy meeting and enjoyed drinking tea (Arima 1991, 158). The tea bowl had somewhat thick glaze in nuanced *meizi-qing* hue without any design, a typical SSG-style elite Longquan celadon product.

In addition, a SSG-style cylindrical incense burner with spreading flower design is the abbot of Shōkoku-ji temple (相國寺), Kinshuku Kentaku's (昕叔 顯晫 1611–1658) donation. According to a note in this incense burner's stock box, this donation date was 1640 (Arima 1991, 166).

Comparing Characteristics of Lists 1 and 2 Collections

Compared with List 1's elite Longquan celadon objects, List 2's characteristics apparently presented some divergences, such as: (1) mixing SSG-style and early Yuan-style objects; (2) lack of regularity in objects' style, genre or type; and, (3) accompanied by some legendary stories usually connected with some famous tea ceremony performers or their memoranda. Those attendant legends or stories were usually more attractive to contemporary collectors than the objects themselves.

These divergences projected List 2's objects' function distinctly targeting contemporary flourishing tea ceremony usage, with considerable flexibility in application of those objects for relevant activities. However, it also implied that specific types of elite Longquan celadon objects, particularly List 1's SSG-style objects, were unable to be acquired by List 2 owners during Edo period. It is seemingly comprehensible that two groups of elite Longquan celadon objects were separately used and circulated in two different social networks during Edo period.

As Scheme 1 presents, social network 1 consisted of Emperor, Shogunate families and local Domains, in which most SSG-style Longquan celadon objects circulated, based on List 1. In contrast, social network 2 was formed by tea ceremony performers (or Zaibatsus) and few elite class members, based on List 2.

Elite Longquan Celadon Survivals | 131

Scheme 1. Elite Longquan celadon objects circulating in two social networks, network 1 (left) and 2 (right); SSG-style: SSG-style elite Longquan celadon objects; Tea c. u.: Tea ceremony utensils.

Moreover, several tea ceremony performers were closely affiliated with some grand Zen temples, while maintaining very good relationship with some elite class members. It made the two social networks' linkage and communication somewhat subtle and complicated. For instance, Kōnoike Dōoku (鴻池 道億 1656–1736), a Kōnoike family member, and Kōnoe Iehiro, a member of the Emperor's family, usually had social meetings, where they appreciated and exchanged individual thought related to tea ceremony items, such as flower vases, incense burners or teaware (Konoe 1977, 97–98).

Therefore, it is surmised that a few SSG-style or early Yuan-style elite Longquan celadon objects probably transferred between networks 1 and 2, and they were probably used more freely and flexibly in some social activities. For instance, the depressed global bottle shape vase was probably used as flower vase or as dipper holder depending on the user's choice (Nishida 2010, 116). However, as a whole, List 1 objects' quality and exquisiteness absolutely surpassed List 2's, and specific types of SSG-style elite Longquan celadon objects were only kept and circulated in network 1, such as mallet-shaped vase with phoenix (or fish) décor.

COLLECTIONS WITH UNKNOWN PROVENANCES

As previously mentioned, during the Meiji Restoration most *Karamono* and Buddhist treasures were thrown away or destroyed. However, it also created an opportune moment for enthusiastic collectors and some professional antiquities dealers, who collected a certain amount of elite Longquan celadon objects at that time. Unfortunatedly, those objects' provenances were mostly unknown.

List 3 enumerates two temples' and three entrepreneurs' elite Lognquan celadon collections. The former lost their relevant records because temples were once racked by multiple fires, destructions and re-constructions. The latter mostly lost their previous documents because they were discarded during the Meiji Restoration era. However, it is able to be confirmed that List 3's collections should be Edo period remains.

132 | Elite Longquan Celadon Survivals

List 3. Elite Longquan celadon collections with unknown provenances.

collector	genre			style
	vase	incense burner	teaware	
Rokuon-ji	bottle-bamboo nodes (Fig. 3a)			SSG
Daikōmyō-ji			bowl-lotus	SSG
	mallet-phoenix			Yuan
Fujita Denzaburō	*Kinuta* (Fig. 3b)	*li* shape	bowl-lotus	SSG
Nezu Kaichirō	bottle shape	*li* shape	bowl	SSG
	bottle-bamboo nodes		bowl-lotus	SSG
	mallet-phoenix		bowl	SSG
	cylinder shape			SSG
		cylinder-flower (Fig. 3c)		E-Yuan
Kanō Jihē	mallet-phoenix			SSG

A SSG-style bottle-shaped vase with bamboo nodes design was collected in Rokuon-ji temple, Kyoto today (Figure 3a; Pl. 37). This temple is also called Kinkaku-ji temple (金閣寺), built on the original relic of Kitayama villa (北山荘), Ashikaga Yoshimitsu (1358–1408) Shogun's villa for preserving his Song and Yuan *Karamono* collections at that time (see also Chapter 8).

In addition, a SSG-style tea bowl with carved lotus petal design and gold border on its rim is currently housed in Daikōmyō-ji temple (大光明寺). This temple was built in Nanboku-chō period (1334–1392); however, over its history it was burned and destroyed several times, and the current building was completed in late Meiji (Daikōmyō-ji 2017). Moreover, this temple also possessed a mallet-shaped flower vase with phoenix décor, regarded as 'Tenryūji (天龍寺)' style of Longquan celadon product (Arima 1991, 165; Mori 2012, 6).

Fujita Denzaburō (藤田 傳三郎 1841–1912) is the first-generation entrepreneur, managing mines, newspapers and civil engineering constructions, such as railways and electric power generating stations. He and his descendants were interested in collecting tea ceremony utensils beginning with Meiji period (Hirota 1957, 79–81). Three pieces of SSG-style elite Longquan celadon objects, including a '*Kinuta*' vase (Figure 3b; Pl. 37), *li*-shaped incense burner and tea bowl with carved lotus petal design, were collected by Fujita family.

In the stock box of the '*Kinuta*' vase, an attached label in ink was written, "青磁砧形杓立 (celadon *Kinuta*-shaped dipper holder)" (Nishida 2010, 115). It means this vase was used as a dipper holder, rather than a flower vase as recorded in previous tea ceremony memoranda during late Sengoku or early Edo (see also Chapter 8). As previously emphasized, some elite Longquan celadon objects used in tea ceremony activities were more free or flexible during Edo period.

Nezu Kaichirō (根津 嘉一郎 1860–1940) began to acquire ancient artwork during Meiji period, accumulating amazing Chinese collections that became the crucial backbone of today's Nezu Museum (根津美術館) collection (Saitō 2014, 174). As List 3 enumerated, four types of SSG-style elite Longquan celadon vases, including mallet-shaped with phoenix décor, bottle-shaped, bottle-shaped with bamboo nodes design, and cylindrical, as well as a SSG-style *li*-shaped incense burner, an early Yuan-style cylindrical incense burner (Figure 3c; Pl. 37), and several SSG-style tea bowls, were collected.

A SSG-style mallet-shaped vase with phoenix décor is currently housed in Hakutsuru Fine Art Museum (白鶴美術館), Kobe. This museum opened in 1934 to display Kanō Jihē's (嘉納 治兵衛1862–1951) collections, the seventh-generation successor to the family enterprise, Sake brewing, beginning in the Edo period. However, he was interested in collecting ancient artwork and tea ceremony utensils during Meiji period, at a time when many antiquities were discarded.

Integrally viewing List 3 elite Longquan celadon objects, they display a high degree of homogeneity with both List 1 and 2. It not only implied the three batches of objects actually came from a common provenance—historical survivals—but also projected that only SSG-style and few early Yuan-style elite Longquan celadon objects survived after Edo period, and were continuously preserved. Conversely, it also implied Yuan- or Ming-style elite Longquan celadon objects were mostly culled from medieval Japanese society.

Furthermore, compared with pre- and post-war elite Longquan celadon collections in Japan, their characteristics were distinctly projected. After Meiji period, rich entrepreneurs continuously sought elite Longquan celadon antiquities worldwide. However, this period's provenances were relatively complicated and confused, with a few coming from Japan, extensive objects from China, or international auction market supply, rife with later imitations and contemporary fakes.

PRE- AND POST-WAR PERIODS COLLECTIONS

List 4 enumerates three modern entrepreneurs' collections of elite Longquan celadon objects in their museums, including Sugahara Tsūsai (菅原 通濟1894–1981), the creator of Tokiwayama Bunko Foundation (常盤山文庫), Idemitsu Sazō (出光 佐三1886–1981), the creator of Idemitsu Museum of Arts (出光美術館), and Uragami Toshiro (浦上 敏朗 1926-), the creator of Hagi Uragami Museum. However, they began collecting somewhat later, after Meiji period, primarily during pre- and post-war periods.

List 4. Elite Longquan celadon collections of pre- and post-war entrepreneurs.

collector	genre			style
	vase	incense burner	teaware/ others	
Sugahara - Tokiwayama B. F.	mallet-phoenix	li shape (Fig. 4a)	bowl-lotus	SSG
		li shape	bowl	SSG
			basin	SSG
Idemitsu - Idemitsu M. A.	vase shape	li shape		SSG
	vase-flower-ring		wine jar (Fig. 4b)	Yuan
			pot, dish	Ming
Uragami - Hagi Uragami M.	cong shape			SSG
		cylinder	box	SS-Yuan
	vase-flower			Yuan
	bottle shape			Yuan-Ming
			tea pot (Fig. 4c), dish	Ming

According to List 4, for each single museum, these enumerated objects are probably not all of their elite Longquan celadon collections. But they are representative of collectors' intention and contemporary antiquities market structure. Tokiwayama Bunko Foundation has considerably amazing SSG-style Longquan celadon collections, a SSG-style mallet-shaped vase with phoenix décor, two *li*-shaped incense burners (Figure 4a; Pl. 37), two tea bowls and a basin. Idemitsu Museum of Arts' collections present more diversification of styles, genres and types. In addition to SSG-style, Yuan- and Ming-style elite Longquan celadon objects were collected (Figure 4b; Pl. 37).

Uragami's collections were housed in Uragami Memorial Museum in Hagi Uragami Museum, Yamaguchi-ken. As multifarious as Idemitsu's collections are, his elite Longquan celadon collections distinctly display a chronological order, from SS to Ming (1368-1644) (Figure 4c; Pl. 37). Uragami Toshiro's son learned to be an art dealer in Mayuyama Ryūsendō (繭山龍泉堂) antiquities store in the post-war period. He tried to establish a systematic collection of elite Longquan celadon products, rather than only focus on traditional Japanese collectors' preference.

In fact, establishing a good relationship between collectors (or sellers) and art dealers was crucial and necessary at that time. Collectors could acquire genuine and high-quality antiquities or artwork. Many contemporary collectors actually relied on those trustworthy dealers to accumulate their precious collections (Yamamoto 2008, 375; Kuchiki 2011, 159). Counter, professional art dealers could smoothly and quickly deal with their goods and make huge profits.

Characteristics of Pre- and Post-war Collections

However, compared with the above three batches of collections (see also Lists 1-3), List 4 presented different characteristics in style, genre and type, such as: (1) Yuan- and Ming-style objects increasing; (2) more diversity of genres, lacking of regularity, with several objects unrelated to tea ceremony, *Kadō* (華道 flower arrangement), or *Kōdō* (香道 incense), three crucial cultural activities during Edo period; and, (3) among few SSG-style or early Yuan-style objects, *li*-shaped incense burners seem to be more visible.

These characteristics actually reflected contemporary elite Longquan celadon antiquities market structure, governed by China's supply. For instance, *li*-shaped incense burners in pre-war China should be more readily available. As a Japanese art dealer, Mayuyama Matsutarō's (繭山松太郎 1882–1935) first transaction was a piece of SSG-styel *li*-shaped incense burner, which he acquired in Beijing and brought back to Japan to sell in 1905. Because of this successful sale, he decided on a career as a Chinese art dealer, and named his store—Ryūsendō (Mayuyama 1991, Preface and 51; Okumoto 2005, 45).

However, in pre- and post-war China, it is obvious and understandable that Yuan- and Ming-style elite Longquan celadon objects should be more easily found among the popular rather than the older SSG-style objects. Then, the latter should have a higher price in the antiquities market at that time. List 4 presents a contemporary universal structure of Longquan celadon collections, also reflected in most Western museums' collections, beginning with their collecting in conjunction with the pre-war period.

In viewing Victoria and Albert Museum (V&A), London, one of the most famous European museums, collecting ancient Chinese ceramics began in the 19th century, with an elite Longquan celadon collections' structure similar to Idemitsu Museum of Arts or Uragami Memorial Museum (see also List 4) (Kerr 2004, 10). A SSG-style dragon vase, incense box, *li*-shaped incense burner, mallet-shaped vase with fish décor, tea bowl, and an

amount of Yuan- and Ming-style elite Longquan celadon objects are housed in this museum (Kerr 2004, 84–95; Victoria and Albert Musuem 2018).

In fact, Song imperial wares, including Northern Song (960–1127) imperial Ru ware and SSG ware, were acquirable in pre- and post-war China. Particularly, a specific amount of Qing (1644–1911) Palace treasures flowed into the antiquities markets that created an upsurge of imperial ware collecting worldwide, that, at the same time, dimmed enthusiasm for SSG-style Longquan celadon objects, even among Japanese collectors (Mayuyama 1991, 10–13; Okumoto 2005, 66–67; Sakamoto 1998, 116–122, 149–153).

Moreover, various period imitations of SSG-style Longquan celadon and pre- and post-war Chinese fakes were rife in contemporary antiquities market (Chen 1946, 67; Hirota 1957, 168). For instance, SSG-style mallet-shaped vase with phoenix (or fish) décor appeared as Yuan, Ming or later imitations, as well as pre-war fakes (Figures 5 and 6; Pls. 38 and 39) (Mino and Tsiang 1986, 192–195; Tsai 2009, 272–273). Thus, the entire elite Longquan celadon antiquities market was more confused, and collectors chose more defined later products, such as Ming-style objects, over paradoxical SSG-style.

CONCLUSION

Most SSG-style elite Longquan celadon survivals were still owned and circulated in high-ranking elite class members' social network, formed by the Emperor, Shogunate families and some local Domains, during Edo period, and regarded as gifts or heirlooms. In contrast, few SSG-style and mostly early Yuan-style elite Longquan celadon objects used somewhat flexibly in tea ceremony activities, based on tea ceremony performer's idea, flocked to the other social network, consisting of tea ceremony performers, rich merchants and few elite class members.

However, with the termination of Shogunate reign after the end of Edo period, the old societal structure thoroughtly disintegrated and those previous elite Longquan celadon objects were mostly concentrated to few newly-established Zaibatsus or their museums beginning with Meiji period. They not only became the backbone of modern Japanese Longquan celadon collections, but also the most representative historical treasures of medieval Japanese art and culture.

When compared with pre- and post-war collections, under a globalized ancient Chinese ceramics collecting framework, Japanese collections' uniqueness—style and quality's simplicity and exquisiteness—is projected. Differing from Western collectors, Japanese collectors' search for Chinese Song and Yuan elite Longquan celadon, particularly SSG-style objects, represented far more than a simple collecting behavior. It mixed rich historical memory and profound cultural emotion.

Chapter 10

From China to Japan: A Cross-Cultural Transmission Case

As a worldwide famous trade ceramic, elite Longquan celadon products were distributed throughout Asia, Africa and Europe during the 13th and 14th centuries. It is a good case for exploring cross-cultural transmission in terms of ceramic trade. Trade itself is certainly not simply commodity movement, but simultaneously, relevant cultural information transmission. Beginning in the 13th century, Japan was the largest import country of Chinese elite Longquan celadon products. And, for the following few hundred years, the trade nearly never stopped.

In general, ceramics are regarded as consumables, particularly due to their fragility. However, among various periods and styles of imported Longquan celadon products, SSG-style (Southern Song Guan (imperial) style) products seemingly transcended consumables' attribute as heirlooms throughout medieval Japanese history. As Chapter 9 concluded, SSG-style objects is nearly the only surviving ancient Chinese celadon during Edo period (1603–1868), the last Shogunate regime in medieval Japan. So, why did it survive?

According to modern anthropologists' argument, survivals should be those that meet the challenge of local cultural selective mechanism (Stark et al. 2008, 5–6). Cultural selective mechanism referes to biological evolution theory; however, it is a more complicated mechanism rather than a simple analogue, particularly when faced with exotic artifacts and cultures (Distin 2011, 4–5). Each single country has their individual selective mechanism, based on local society, culture and history.

In contrast, each single style or type of exotic artifact should have its unique attributes and traits, challenging local selective mechanism. Modern archaeologists usually rely on analyzing those surviving artifacts' style to understand cultural transmission and local cultural selective mechanism (Stark et al. 2008, 1; Van Pool 2008, 191; Mesoudi 2008, 96). The present study, in terms of analyzing the style and attributes of SSG-style elite Longquan celadon, particularly focusing on mallet-shaped vases with phoenix (or fish) décor, tries to understand why it had the most survivals, and was carefully preserved in medieval Japan. Moreover, what was medieval Japan's cultural selective mechanism?

Japan and China are two adjacent countries, possessing highly homogenous culture and history. During its long history, Japan, to a considerable degree, absorbed and relied on Chinese cultural resources, including politics, legislation, economy, religion, literature, art, even medicine and others. Many Chinese elegant craft products imported to Japan, called

Karamono (唐物), were particularly cherished by elite class members. Such a historical and cultural background implied cross-cultural transmission from China to Japan should be unique.

HISTORICAL REVIEW OF IMPORTED SSG-STYLE LONGQUAN CELADON

Elite Longquan Celadon Production during China's SS

As previously mentioned, SSG-style Longquan celadon was primarily produced during late Sothern Song (SS 1127–1278), and could be categorized into three functional products: worshiping utensils, funerary artifacts and living necessities (see also Chapters 1 and 3). They supplied contemporary elite class and rich middle class consumers. Living necessities included tableware, teaware, kitchen ware, such as some universal bowls, dishes, basins, jars and pots. According to archaeological materials, SS Longquan tableware trade extended virtually worldwide, in Northeast Asia, Southeast Asia, Africa, and even Near East (Li 1982, 34; Srisuchat 1994; Aoyagi and Ogawa 1989, 105–106; Sasaki 1994, 324–325; Hasebe 2001, 11; Tampoe 1989, 64–65).

In contrast, funerary artifacts used in funeral rites or tombs, associated with users' religion, belief or local custom, exhibited very strong regionalism. Therefore, funerary products, such as paired dragon and tiger vases (jars) (*long-hu-pin*), *mei-pin* vase or other jars, primarily supplied Longquan region and its surrounding inhabitants. Its market was considerably limited. However, some certain genres of funerary objects overlapped with worshiping utensils, particularly those used in funeral rites (see also Chapter 1).

Worshiping utensils used in religious ritual or people's spiritual life have an immediate relationship with users' religion and lifestyle. Longquan celadon reached its technological and artistic zenith during late SS. At the same time, Zen school was thriving in the South of China. Zen school encouraged believers to use a simple way for their worshiping, such as offering flower, incense or tea for gods. It stimulated relevant commodities' market demand, particularly flower vase, incense burner and tea bowl.

To respond to this demand, skilled Longquan potters seriously designed various forms for the flower vase and incense burner. Particularly, they took SSG ware, the imperial ware of SS, as the paradigm to imitate and innovate, and eventually created their unique SSG-style branded products (see also Chapters 2 and 3). With SS Zen school's transmission to Japan during Kamakura period (1192–1333), SSG-style Longquan celadon worshiping utensils were also imported to Japan. In fact, in addition to few funerary products, nearly all genres and types of SSG-style products were imported to Japan during late Kamakura.

Imported SSG-style Elite Longquan Celadon in Japan

However, although SSG-style products stopped being produced after the end of SS, for several sequent decades extensive imported early Yuan-style Longquan celadon products were ususally accompanied by a few SSG-style objects, mostly distributed to grand Zen temples during late Kamakura. And, most early Yuan-style elite tableware supplied elite class members (see also Chapter 7). This distribution pattern didn't change until Nanboku-chō (1334–1392).

In the sequent Muromachi period (1392–1573), most *Karamono*, including elite Longquan celadon objects, were gradually transferred to Ashikaga Shogunate's and newly-

established elite class members' collections, partly from grand Zen temples and partly from previous elite class members. At the same time, their heirlooms and decorative objects' attributes were gradually intensified, particularly those SSG-style elite Longquan celadon objects.

However, in the final decades of Muromachi period, nearly-constant military conflicts and wars resulted in political and societal instability that rapidly worsened this country. Especially, during Sengoku period (1467–1603), Zen temples couldn't obtain appropriate protection, and several grand temples' treasures were sent to local powerful samurais in return for temple protection. Therefore, in addition to some being destroyed during wartime, specific amounts of survivals were actually undergoing another redistribution.

To terminate the political and societal chaos, Tokugawa Ieyasu established Edo Shogunate, the last Shogunate regime in medieval Japan. Tokugawa family should be the largest owner of surviving *Karamono*. Particularly, SSG-style elite Longquan celadon objects were used as precious political and diplomatic gifts, mostly circulated within a small social network, consisting of Takugawa, Emperor families and some powerful local Domains (see also Chapter 9). In addition, a few SSG-style and some early Yuan-style elite Longquan celadon objects were circulating in the other network formed by tea ceremony performers or rich merchants and some elite class members.

Estimating the Numbers of Imported SSG-style Elite Objects

Then, how many SSG-style Longquan celadon products were imported to Japan? And, how many mallet-shaped vases with phoenix (or fish) décor were circulating in medieval Japanese society? As previously stated, late Kamakura would be the peak import period for SSG-style products (see also Chapter 7). However, because the Mongolian-Yuan army was intermittently invading and attacking Japan during the 1260s and 1270s, it resulted in trade interruption between Japan and China at that time. Therefore, the estimated time frame will narrow to 1278–1342, based on relevant historical records (Wada and Ishihara 1958, 157–163). Further, Sinan wreck's Longquan celadon load data provided a useful reference.

List 1. Japanese commercial ship arrivals in Qingyuan from 1278 to 1342.

#	year	number of ships	notes
1	1279	4	Shogunate allowed only 4 ships
2	1292	4, only 1 arrived	3 ships wrecked
3	1305	4 (probably trade failure)	conflict with Yuan officials
4	1323	1	Sinan wreck
5	1325	1	Kenchōjisen dispatching
6	1328	1 (only plan?)	Kantō Daibutsu dispatching
7	1332	1	Sumiyoshi Jinjya dispatching
8	1341	2	Tenryūjisen dispatching
9	1342	1	Tenryūjisen dispatching

List 1 briefly enumerates Japanese commercial ship arrivals in China's Qingyuan (Ningpo), the primary harbor to concentrate and export elite Longquan celadon products to Japan following SS. In fact, beginning with Yuan (1271–1368), around the 1280s–1300s, several conflicts occurred between Japanese commercial ships and Yuan government. In the 1320s, a more regular trade was established between both, and periodically, Japanese dispatching ships, quasi-official commercial ships named after newly-constructed temples, headed to Qingyuan with trade goods.

However, the more time that passed following the end of SS, the fewer SSG-style Longquan celadon products could be obtained in China. According to List 1, before Sinan wreck in 1323, at least five ships arrived at Qingyuan harbor and successfully completed trade and returned to Japan. And, after 1323, there were also five ships recorded. If Sinan wreck's load, 37 pieces of SSG-style object are regarded as the customary number of this style of objects for each single ship, total would be around 370 pieces imported to Japan in 1279–1342 (Mori 2013, 152).

In fact, previous archaeological materials revealed that, before the end of SS in 1278, a certain amount of SSG-style Longquan celadon products had been imported to Japan (see also Chapter 7). For instance, three pieces of SSG-style bowls with carved lotus petal design were found in Hakata, dated 1265. Moreover, pirates were always importing goods in some unauthorized commerce. Therefore, as a rough estimate, at least around 500 pieces of SSG-style elite Longquan celadon products circulated in Japanese society during late Kamakura and early Nanboku-chō.

Furthermore, only two pieces of SSG-style mallet-shaped vase with phoenix (or fish) décor were loaded in Sinan wreck. Thus, this type of vase was in small proportion to contemporaneously imported SSG-style objects, around 5.5 %. It implies that around 30 pieces circulated in Japan. However, after early Yuan, it is believed Japanese never stopped seeking SSG-style elite Longquan celadon objects in China, but it certainly became more difficult.

EXTANT MALLET-SHAPED VASES WITH PHOENIX (OR FISH) DÉCOR IN JAPAN AND CHINA

List 2 enumerates extant SSG-style Longquan celadon mallet-shaped vases with phoenix (or fish) décor in Japan and China. Japanese collections were primarily handed down from elite class owners during Edo period (see also Chapter 9). It verifies that these vases were nearly monopolized by contemporary high-ranking elite class members. In contrast, Chinese collections mostly came from archaeological sites, primarily located in Longquan and eastern Sichuan. The former was the production location, whereas the latter was the largest domestic market of SSG-style elite Longquan celadon products during late SS.

According to List 2, there are more vases with phoenix décor than fish. However, all vases are in considerably uniform quality and well-preserved, particularly those in Japanese collections. Among 16 pieces in Japanese collections, #1–16, two pieces belonged to Sinan wreck, #11 and 16, actually housed in Korea, today (Cho 2012). However, in List 2, they are categoried as Japanese imports.

List 2. Mallet-shaped vases with phoenix (or fish) décor in Japan and China.

#	décor	h*/cm	collector (now)	#	décor	h	collector
1	phoenix	26	Yomei Bunko	14	fish	27.4	Iida C. M.
2	phoenix	30.8	Kuboso M.M.A.	15	fish	?	Ichijodani *
3	phoenix	29.0	Hatakeyama MMFA	16	fish	25	Sinan wreck
4	phoenix	29	Hakutsuru F.A. M.	17	phoenix	25.5	NPM*
5	phoenix	27.5	Tokiwayama B. F.	18	phoenix	26.5	Songyang C. M.
6	phoenix	30.3	Nezu M.	19	fish	16	Songyang C. M.
7	phoenix	28.8	MOC, Osaka	20	phoenix	25	Sanxia M.*
8	phoenix	27.4	MOC, Osaka	21	phoenix	31.4	Dongxi site (4)
9	phoenix	33.5	Gotoh M.	22	fish	31	Dongxi site (2)
10	phoenix	31.5	Tokyo N. M.	23	phoenix	16.7	Emeishan site
11	phoenix	15.7	Sinan wreck	24	phoenix	17.2	Dayao kiln site
12	fish	22.4	Tokugawa A. M.	25	phoenix	17.2	Xikou kiln site
13	fish	26.3	Seikado B. A. M.	26	fish	?	Ningpo dock

* 'h' refers to vase's height, provided by individual publications.
#15 collector: Ichijodani refers to Ichijodani Asakura Family Site Museum.
#17 collector: NPM refers to National Palace Museum, Taipei.
#20 collector: Sanxia M. refers to Chongqing Zhongguo Sanxia Bo Wu Guan (Chongqing Zhongguo Sanxia Bo Wu Guan 2011, 49).

Compared with Japanese collections, as the producer county, China's collections are relatively rare, #17–26. Moreover, in addition to kiln and dock sites' fragment findings (#24–26), the remaining total 11 pieces (#17–23) mostly came from eastern Sichuan, particularly from Dongxi hoard site, total 6 pieces (see also Chapter 3). Dongxi archaeological site was always debated. Some researchers surmised it to be an early Yuan tomb, whereas a late SS hoard site (Sichuan Shen Wen Wu Guan Li Wei Yuan Hui 1987, 71; Huang 2013; CICRA and SMM 2012, Appendix 1). However, it is also perhaps an early Yuan hoard site, belonging to a trader's stock to export to Japan, meeting urgent market demand for these objects.

STYLISTIC FEATURES

If an exotic artifact could survive and persistently be cherished, it should not only be successfully challenge that vital local cultural selective mechanism, but also have a certain special stylistic nature, social function or cultural significance to always meet local people's aesthetic and social requirements. Then, what are the unique stylistic features of the present SSG-style elite Longquan celadon mallet-shaped vases with phoenix (or fish) décor?

Shaping an Ideal Mallet-shaped Vase with Phoenix (or Fish) Décor

According to List 2, all vases' height is in two ranges: (1) 25–30 cm, large-sized; and, (2) 15–20 cm, small-sized. And, the large-sized is distinctly dominant. Among five pieces of small-sized vases, four pieces exhibit phoenix décor; further, among four, two belong to kiln site's waste (#24 and 25) (Figures 1 and 2), and the other two are in poor quality. Of the two poor quality vases, one is Sinan wreck's vase (#11), described by Mino and Tsiang (1986, 194): "... but the vases with phoenix handles have neither the size nor the sharply defined detail ..." (Figure 3), and the other (#23) came from Emeishan site in eastern Sichuan, China, with a pair of clumsy roosters décor rather than the elegant phoenix on vase neck (Figure 4) (Chen 1990, 41).

The above materials reveal that small-sized vases are seemingly either imperfect or immature products. Particularly, in design, a pair of phoenix décor attached on that too short vase neck is apparently a flaw. In fact, nearly all small-sized vases were found in the producer, China, particularly from kiln sites. It also implied that those small-sized vases were not yet an exportable commodity, probably belonging to experimental and immature products in initial stage of this type of vase's design and manufacture.

However, to analyze small-sized vase's structure, one will find that it lacked an appropriate space for that pair of phoenix décor on vase neck. It is understandable that the prototype of SSG-style mallet-shaped vase with phoenix (or fish) décor should be somewhat earlier mallet-shaped vase without any décor or design, height of 10–20 cm (Figure 5; Pl. 40). However, in initial stage, when Longquan potters attempted to attach a pair of phoenix décor on the prototype vase's neck, they should find the neck was too short to be ideal.

To those experienced Longquan potters, they should quickly realize that to regulate the size and structure was necessary, particularly elongating the neck's length to create a conformtable space for that pair of décor, and perfecting spatial ratio for a harmonious structure. The ideal achievement is similar to Figure 6, a large-sized product.

Defining Mallet-shaped Vase with Phoenix (or Fish) Décor Style

Figure 6 displays a standard large-sized product. When compared with small-sized product, in addition to elongating the vase's height (a) to 25–30 cm, at times somewhat over 30 cm, the ratio of upper portion (b), containing a dish-shaped mouth and long cylindrical neck, to lower portion (c), the belly and recessed circle-foot, was regulated to nearly 1:1. At the same time, the diameter of dish-shaped mouth (d) and bottom recessed circle foot (e) was nearly identical, d = e. In addition, the width of the outermost edges located at shoulder (g) and the pair of fish décor (f), was also nearly equal, f = g. It is apparent the structure was delicately designed and distinctly defined.

According to List 2, all large-sized vases, height of 25–33 cm, had considerably uniform quality and distinctly-defined style. It implied that large-sized vase had a standardized

manufacture technology and procedure, as well as strict quality control, after its form was defined. Thus, it typified the large-sized products in neat, symmetric and harmonious style with a pair of phoenix or fish décor elegantly and comfortably attached to the slender vase neck.

Furthermore, although vase with fish décor and vase with phoenix décor were probably designed as paired objects, the former was seemingly a later product. Archaeological materials revealed, there were almost no discarded small-sized or immature mallet-shaped vase with fish décor found. It implied that fish décor vase was created on the foundation of the perfect phoenix décor vase.

Mino and Tsiang (1986, 194) gave an identical supposition based on various inferences. Sinan wreck's large-sized mallet-shaped vase with fish décor was in perfect and defined style (see also #16 in List 2), whereas the small-sized vase with phoenix décor (#11) was in clumsy and imperfect style, surmising the latter was a later inferior imitation during early Yuan. However, in the present study, my supposition is that the latter was probably a remnant of the initial stage experimental products added to swell the total for Japanese urgent market demand during early Yuan.

MALLET-SHAPED VASE WITH PHOENIX (OR FISH) DÉCOR IN CHINA

Uniform in quality and style, the SSG-style Longquan celadon mallet-shaped vase with phoenix (or fish) décor should give Japanese users the strongest visual impression, beginning with the initial importation during late Kamakura. Then, how to determine their use and function? In fact, according to Chinese archaeological or historical materials, their practical function in SS is still not clear today; even modern researchers thought it was used as flower vase.

Function as Flower Vase in SS

Flower vase usage in SS society was common. People could choose flower vases in various materials, such as gold, silver, bronze, ceramic, and in various sizes or designs. For instance, the general population chose a small-sized ceramic flower vase for decorating a living room, using on worshiping table, or even placing in tomb. In contrast, elite class or rich people probably preferred large-sized flower vases of precious metals or high-quality ceramic for their large house. Particularly, using the famous branded products, such as elite Longquan celadon, flaunted their wealth and status.

In the mansion site of SS Gongshengrenlie Empress (恭聖仁烈皇后), some archaeological fragments revealed that at least two types of SSG-style elite Longquan celadon flower vases were used, including a mallet-shaped vase with phoenix décor and a bottle-shaped vase with bamboo nodes design, surmising to be large-sized (Figures 7a and 7b) (HMICRA 2008, 34 and 51). In contrast, some small-sized flower vases were usually found in tombs (Figure 8) (Hubei Sheng Wen Wu Guan Li Wei Yuan Hui 1964, 238; Liu 2004, 90–93).

No archaeological or historical materials revealed the mallet-shaped vase with phoenix (or fish) décor was used in detail. However, most Song or Yuan flower vases had no handles (Xi'an Municipal Institute of Archaeology and Conservation of Cultural Relics 2004, 51; Jin et al. 2010, vol. 13: 496–505; Museum of Fine Arts, Boston. 2018). It means that this

Figure 1 (left). A mallet-shaped vase with phoenix décor, height around 18 cm, unearthed from Dayao kiln site, Longquan (After Zhu 1989, Pl. 23–4).

Figure 2 (right). A fagment of mallet-shaped vase with phoenix décor, height around 17 cm, unearthed from Xikou kiln site, Longquan (After Jin 1962, 537).

Figure 3 (left). A small-sized mallet-shaped vase with phoenix décor, height of 15.7 cm, found in Sinan wreck. National Museum of Korea (After Shen 2012, 143).

Figure 4 (middle). A mallet-shaped vase with rooster décor, height of 16.7 cm, unearthed from Emeishan site, Sichuan (After Chen 1990, 41).

Figure 5 (right). A SSG mallet-shaped vase, height of 11.8 cm. National Palace Museum, Taipei.

Figure 6. SSG-style mallet-shaped vase with fish décor, unearthed from Dongxi hoard site, Sichuan, height (a) 31 cm, diameter of dish-shaped mouth (d) 11.6 cm, diameter of bottom (e) 10.5 cm (After Sichuan Shen Wen Wu Guan Li Wei Yuan Hui 1987, 71).

Figures 7a (left) and 7b (right). Two fragments of SSG-style elite Longquan celadon vase with phoenix (or fish) décor, and two fragments of bottle-shaped vase with bamboo nodes design, unearthed from mansion site of SS Gongshengrenlie Empress, Hangzhou (After HMICRA 2008, color Pls. 69–2, 69–3, 42–3).

Figure 8 (left). A small-sized Longquan celadon vase, height of 15.3 cm, unearthed from a late SS tomb. Deqing County Museum (After Zhejiang Provincial Museum. 2000, Pl. 215).

Figure 9 (right). A golden cup with a pair of fish décor, unearhed from a SS tomb. Dongyang City Museum (After Lü 2011, 5).

Figures 10a and 10b. A pair of *long-hu-pin* vases (or jars) manufactured during middle or late SS, unearthed from Longquan. Longquan Celadon Museum (After Zhu 1998, Pls. 104 and 103).

Figure 11a (left). The SSG-style elite Longquan celadon mallet-shaped vase with phoenix décor. Kuboso Memorial Museum of Arts, Izumi (After Curatorial Division, Nezu Museum 2010, Pl. 18).

Figure 11b (right). The SSG-style elite Longquan celadon mallet-shaped vase with fish décor. The Tokugawa Art Museum (The Tokugawa Art Museum © The Tokugawa Art Museum Image Archives / DNPartcom).

pair of phoenix or fish décor designed on the mallet-shaped vase's neck was obviously regarded as décor rather than as handles.

A golden cup with a pair of identical fish décor (handles?) on two sides of the cup body, symmetrically, was found in a SS tomb (Figure 9) (Lü 2011, 5). According to the archaeological report, it is a small cup, height of 5.1 cm. Therefore, if the pair of fish are handles for this cup, they are certainly too small to be functional. In fact, double fish or phoenix was a popular decorative motif during SS, and even later Yuan and Ming (1368–1644) Dynasties.

Confirming phoenix and fish designs as décor implied these vases' artistic or symbolic attribute probably surpassed their practical usability. It means they were probably actually used as decorative objects with strong symbolic associations. Then, what kind of symbolic significance was associated with this type of vases?

Decorative Object with Symbolic Significance

What was the motivation or intention to design and manufacture such delicate paired vases during late SS? In fact, the design itself had a very strong similarity to another paired SSG-style Longquan celadon products—*long-hu-pin* (dragon vase and tiger vase). *Long-hu-pin* was a pair of vases (jars) separately with dragon and tiger figures décor (Figures 10a and 10b; Pls. 41 and 42), used as funerary objects, particularly in Taoist-flourishing Longquan region and its surroundings (see also Chapter1).

The similarity between the two paired SSG-style Longquan celadon products, mallet-shaped vase with phoenx (or fish) décor and *long-hu-pin,* is clearly presented in their design. Paired objects, height of 25–30 cm, usually have the same main body with fixed paired animal motif décor on vase neck or shoulder, respectively, such as dragon paired with tiger, or phoenix with fish (Figures 11a and 11b; Pls. 43 and 44).

As previously discussed, delicate *fen-qing* or *meizi-qing* hue SSG-style Longquan celadon *long-hu-pin* vases' extraordinary exquisiteness surpassed its original function and attributes as funerary artifact, and elevated it to artistic and decorative (see also Chapter 1). However, unlike *long-hu-pin* vases' long evolutionary and developmental process, from earlier five-tube barn jar (or vase) or funerary urns to such perfect paired vases (jars) during late SS, mallet-shaped vase with phoenix (or fish) décor seemed to skip over that long developing process and quickly produced such a mature and perfect product during late SS, presuming the foundation had been established by *long-hu-pin* vases.

To a certain degree, the two paired SSG-style elite Longquan celadon products could be viewed as homogeneous products manufactured during late SS, and their attributes probably somewhat overlapped during late SS. However, décor's motifs generally represented religious symbols, usually indicating regionalism. In fact, according to their distribution, because dragon and tiger represented two crucial Taoist symbols, *long-hu-pin* vases (or jars) were commonly used in Taoist-flourishing Longquan region and its surroundings. In contrast, phoenix and fish represented Buddhist symbols, with SSG-style mallet-shaped vase with phoenix (or fish) décor primarily being distributed in popular Buddhist Sichuan area, particularly in wealthy eastern Sichuan.

Moreover, these paired animals motifs are also universally understood and welcome auspicious symbols associated with ancient Chinese traditional philosophy *yin and yang* (陰陽), positive male and female omens. Therefore, SSG-style mallet-shaped vases with phoenix (or fish) décor in SS society were certainly not only decorative objects, but also auspicious symbols. However, each single auspicious symbol should be identified locally

and socially. Thus, with these vases imported to Japan, was their attendant auspicious culture realized and accepted by medieval Japanese society? Furthermore, in addition to cultural significance coming from China, did Japan create or derive new cultural significance for them?

MALLET-SHAPED VASES WITH PHOENIX (OR FISH) DÉCOR IN JAPAN

With trade, artifacts with relevant cultural information are brought to another country or area. The information is sometimes misunderstood or contorted, but at times upheld in transmission process. It depends considerably on the import country's ability to comprehend the export country's culture (Stark et al. 2008, 2). As previously emphasized, Japan and China had highly homogeneous cultures. Therefore, Japanese assimilation of Chinese culture should be fast and easy.

Auspicious Significance Coming from China

Previous analysis of the structure of mallet-shaped vase with phoenix (or fish) décor identified two portions: the main body and a pair of décor. However, in China, people seemed to pay more attention to that pair of symbolizing auspicious animals—phoenix or fish. Phoenix bird symbolizes a positive omen, cited in old Chinese book, *Shujing's* (書經 *Book of Documents*) text '鳳皇來儀 (*Feng-huang-lai-yi*).' It is a metaphor—the phoenix comes bringing peace and prosperity for this country—the best omen to a country's or region's ruler (Sun 1967, vol. 2: 95). Therefore, objects with phoenix décor were commonly welcome, particularly by high-ranking elite class members in ancient China.

Moreover, phoenix was usually paired with dragon to separately symbolize female and male auspiciousness. The traditional *long-feng* (dragon-phoenix) culture had a very early origin and long history in China, as in the above mentioned *Shujing* period, Spring and Autumn (770–476 BC) or Warring States (475–221 BC) period, or perhaps earlier.

In addition, the fish figure on the mallet-shaped vase was allegedly a transferable to dragon animal, also called *yulong* (fish-dragon) in Chinese popular legend. Its original came from ancient Indian legendary '*mojie* (摩羯)' fish, alleged to be the most powerful oceanic animal. However, *mojie* figure with its legend was transmitted to China with Buddhism during Tang or earlier (Cen 1983, 78–79), and continuously prevailed in Liao (916–1125) and Xixia (1038–1227) Dynasties during China's Song (960–1278).

Sichuan was located on the western border of SS, adjacent to Xixia, whose Buddhism and Buddhist culture, to a considerable degree, influenced Sichuan. Therefore, *mojie* fish motif also commonly appeared on Sichuan's craft products (Sun 1986, 78; Chengdu Municipal Institute of Cultural Relics and Archaeology and Pengzhou City Museum 2003, 174–175). Furthermore, Sichuan was the largest market for SSG-style elite Longquan celadon during late SS. It is seemingly apparent that the present mallet-shaped vases with phoenix (or fish) décor were probably custom-made products for Sichuan consumers, particularly for eastern Sichuan's wealthy.

Phoenix and fish motifs' auspicious significance in Sichuan resembled tiger and dragon in Longquan region and its surroundings. They commonly reflected the popular auspicious culture in ancient China. However, was such culture realized and accepted by medieval Japanese? In fact, regardless of phoenix or fish motif, relevant cultural information was

transmitted to Japan before SSG-style Longquan celadon products' importation, at the latest during Heian period (794–1185) (Tsuji 1942, 83–84).

Thus, to most Japanese users of mallet-shaped vases with phoenix (or fish) décor, these motifs should be familiar. For instance, as previously mentioned, two pieces of mallet-shaped vases with phoenix décor owned by Tokugawa family were sent to female member—Tokugawa Kazuko—who married Go-Mizunoo Emperor (see also Chapter 9). Phoenix symbolizes female positive omen and will bring auspiciousness for her husband's family. Particularly, if her husband is the Emperor, it is more significant. In contrast, most mallet-shaped vases with fish décor were given to male successors, signifying male positive omen.

Moreover, this fish motif was also regarded as a useful talisman for avoiding fires. It was usually decorated on the roof of Japanese wood houses, particularly a temple or palace and elite class members' grand architecture in medieval Japan (Saitō 2015, 158). It further intensified the fish motif's auspicious significance. In fact, according to List 2, several vases with fish décor were owned by male members of Tokugawa family or local Domains, such as Owari Domain, one of Tokugawa family's male successors.

Such use and distribution pattern also verified Chinese auspicious culture was commonly identified and accepted by medieval Japanese society. For most medieval Japanese elite class owners, it is also apparent that the symbolic significance of this type of vase certainly surpassed its practical function.

Deriving Significances in Japan

The other unique design in this vase's structure is its main body—mallet shape—which was actually also a vase type during China's Song (see also Figure 5). Because its shape was analogous to a beating tool used in paper manufacture process, this type of vase was called '紙槌瓶 (Zhi-chui-ping)' in China (Gao 1996, 464). After being imported to Japan, it was called '槌花瓶 (Tsuchi kabin)' during Muromachi period (see also Chapter 8), following Chinese name. However, during late Sengoku, some tea ceremony performers gave it a new name '*Kinuta,*' pure Japanese, and derived some new significance with somewhat equivocal implications during Edo period.

'*Kinuta*' simply refers to a tool for beating clothing as a part of the washing process in ancient Japan. However, when it was connected with Chinese Tang Dynasty poet, Bai Juyi's (白居易 772–846) poem '*Wen ye zhen* (聞夜砧),' a poem describing the story of a sad and lonely woman missing her husband due to his lengthy absence from home while washing clothes by the side of a small stream on a very quiet autumn night, a sort of special artistic conception combining poetic and Zen's art was transferred to this term. This artistic conception was specifically emphasized by contemporary tea ceremony performers as the tea ceremony's essence.

Furthermore, Go-Sai Emperor cited Bai's poem text '*Sensei*' and '*Bansei*' for previous two pieces of mallet-shaped vase with phoenix décor inscriptions. Thus, '*Kinuta*' was not only referring to simple SSG-style Longquan celadon mallet-shaped vase, but also to the present vases with phoenix or fish décor. It deepened and localized those previously-imported SSG-style elite Longquan celadon objects.

In fact, several *Karamono* used as tea ceremony utensils were analogous to some natural things or plain tools, and given a new cultural significance during Edo period. For instance, an elite Longquan celadon cylindrical vase was called '*Tsutsu*筒', like the bamboo stem, and a bottle-shaped vase with bamboo nodes design was called '*Takenoko*竹の子 (筍),

meaning the baby bamboo, rich deriving significance to seemingly meet Zen and tea ceremony spirit (Shinshōsai 1971, 298).

CONCLUSION

Beautiful *fen-qing* or *meizi-qing* hue SSG-style Longquan celadon mallet-shaped vase with phoenix or fish décor possessed both artistic and auspicious attributes, and rich attendant cultural information achieved its position as irreplaceable treasure throughout Japan's medieval age. To most Japanese, the information should not be unfamiliar when this type of vase was imported. Moreover, although this county experienced three Shogunate regimes, from Kamakur via Muromchi to Edo periods, they were basically identical in political system, societal structure and cultural development. Such conditions are actually advantageous for learning, sharing and even transmiting knowledge, further establishing and maintaining identical cultural selective mechanism.

Societal learning conditions and ability are critical when confronting a new or exotic culture (Stark et al. 2008, 6; Mesoudi 2008, 97–98). As previously mentioned, Japan began touching and inputing Chinese culture earlier, before Heian period. Furthermore, beginning with Kamakura Shogunate period, more monks visited and studied in China, and more Chinese traders were naturalized and lived in Japan, as well as massive Chinese crafts products imported to Japan. Such extensively and thoroughly transplanting and transmitting Chinese Song and Yuan culture to Japan created the most optimal environment to learn and accept SSG-style Longquan celadon in Japanese society (Kinomiya 1927, 86–100).

Due to several centuries of dense communication and education, some specific Song and Yuan cultural elements had actually been rooted in Japanese society and became the essential portions of its cultural tradition. SSG-style elite Longquan celadon is the best endorsement of SS culture, art and Zen school. That it survived and was always cherished verified a considerable degree of indentification with Chinese SS culture in medieval Japan.

Appendix

SAMPLES AND ANALYTICAL DATA

Nine SSG-style elite Longquan celadon samples, eight coming from Dayao kiln site and one from Aotou kiln, were provided by from Palmgren's shard collections in the Museum of Far Eastern Antiquities (Östasiatiska Museet), Stockholm, Sweden, and are analyzed by the present author (Yang 2016, 57). At the same time, a Southern Song Guan shard (sample Guan-1) gathered by Palmgren at Hangzhou, China, is also analyzed here. All samples' color and thickness are enumerated in Table 1 (Pl. 45). Aotou kiln site is very close to Dayao, with few products similar to Dayao's SSG-style elite celadon (Palmgren 1963, 111).

Optical coherence tomography (OCT) and scanning electron microscopy (SEM) with energy dispersive spectroscopy (EDS) techniques, referring to previous introduction (see also Chapter 2), are used in the present analyses. Each single sample's microstructure images and composition data of body and glaze are presented, and even crystals or residuals identified.

Table 1. Samples' color and thickness in glaze and body, respectively.

Dayao-1		Dayao-2		Dayao-3		Aotou-1		Dayao-5	
glaze	body	glaze	body	glaze	body	glaze	body	glaze	body
Thickness/mm									
~0.9	4.2	~0.9	2.5	1.0	2.0	0.8	2.7	~0.9	2.2
Dayao-6		Dayao-7		Dayao-8		Dayao-9		Guan-1	
glaze	body	glaze	body	glaze	body	glaze	body	glaze	body
Thickness/mm									
~0.9	3.0	~0.8	4.5	1.0	2.8	~0.9	2.7	~1.1	1.4

The third and nine lines are the chromatography for calibrating glaze's color.

152 | Appendix

Dayao-1

Figure 1-1. OCT image of glaze in 930 nm central wavelength.

Figure 1-2a.

Figure 1-2b.

| Processing option : Oxygen by stoichiometry (Normalized) ||||||||
| All results in compound wt % ||||||||
Spectrum	In stats.	Al	Si	K	Fe	Total
Spectrum 1	Yes	21.84	71.62	4.97	1.57	100
Spectrum 2	Yes	19.64	72.52	5.14	2.69	100
Spectrum 3	Yes	20.74	72.24	5.31	1.71	100
Spectrum 4	Yes	19.24	73.63	4.94	2.19	100
Spectrum 5	Yes	21.72	71.71	4.9	1.67	100
Mean		20.64	72.34	5.05	1.97	100

Figures 1-2a and 1-2b. Microstructure image and composition data of body.

Figure 1-3a.

Figure 1-3b.

154 | Appendix

| Processing option : Oxygen by stoichiometry (Normalized) |||||||||
| All results in compound wt % |||||||||
Spectrum	In stats.	Na	Mg	Al	Si	K	Ca	Total
Spectrum 1	Yes	0.55	0.26	20.52	73.01	5.32	0.34	100
Spectrum 2	Yes	0.44	0.02	21.01	71.83	5.38	1.32	100
Spectrum 3	Yes	0.64	0.89	15.16	71.17	6.09	6.05	100
Spectrum 4	Yes	0.8	0.68	16.54	67.29	6.07	8.62	100
Spectrum 5	Yes	0.73	0.18	19.03	70.06	6.67	3.33	100
Mean		0.63	0.41	18.45	70.67	5.9	3.93	100

Figures 1-3a and 1-3b. Microstructure image and composition data of the interface between body and glaze.

Figure 1-4a.

Figure 1-4b.

Processing option : Oxygen by stoichiometry (Normalized)							
All results in compound wt %							
Spectrum	In stats.	Na	Al	Si	K	Ca	Total
Spectrum 1	Yes	1.31	30.56	54.67	2.09	11.37	100
Spectrum 2	Yes	0.95	25.45	59.49	3.2	10.91	100
Spectrum 3	Yes	1.04	22.65	63.22	4.41	8.69	100
Spectrum 4	Yes	0.85	28.48	55.71	2.78	12.18	100
Spectrum 5	Yes	0.9	17.87	70.03	7.42	3.77	100
Mean		1.01	25	60.62	3.98	9.38	100

Figures 1-4a and 1-4b. Microstructure image and composition data of glaze close to the interface between glaze and body; anorthite (A) crystallization phase (CaO·Al$_2$O$_3$·2SiO$_2$).

Figure 1-5a.

Figure 1-5b.

Processing option : Oxygen by stoichiometry (Normalized)								
All results in compound wt %								
Spectrum	In stats.	Na	Mg	Al	Si	K	Ca	Total
Spectrum 1	Yes	0.49	0.7	16.15	67.12	5.03	10.5	100
Spectrum 2	Yes	0.57	0.78	15.53	69.04	6.04	8.03	100
Spectrum 3	Yes	0.73	0.76	15.09	68.77	5.88	8.76	100
Spectrum 4	Yes	0.63	0.74	15.77	67.64	6.01	9.2	100
Spectrum 5	Yes	0.8	1.21	15.72	69.16	5.42	7.68	100
Mean		0.64	0.84	15.65	68.35	5.68	8.84	100

Figures 1-5a and 1-5b. Microstructure image and composition data of glaze.

Dayao-2

Figure 2-1. OCT image of glaze in 1030 nm central wavelength.

Figure 2-2a.

Figure 2-2b.

| Processing option : Oxygen by stoichiometry (Normalized) |||||||
| All results in compound wt % |||||||
Spectrum	In stats.	Al	Si	K	Fe	Total
Spectrum 1	Yes	19.43	73.37	4.4	2.79	100
Spectrum 2	Yes	20.05	72.49	4.55	2.91	100
Spectrum 3	Yes	20.55	72.66	4.36	2.43	100
Spectrum 4	Yes	20.39	72.13	5.19	2.29	100
Spectrum 5	Yes	20.21	71.82	5.13	2.84	100
Mean		20.13	72.5	4.73	2.65	100

Figures 2-2a and 2-2b. Microstructure image and composition data of body.

158 | Appendix

Figure 2-3a.

Figures 2-3b

| Processing option : Oxygen by stoichiometry (Normalized) |||||||||
| All results in compound wt % |||||||||
Spectrum	In stats.	Na	Al	Si	K	Ca	Fe	Total
Spectrum 1	Yes	0.36	19.7	73.3	4.25	0.43	1.95	100
Spectrum 2	Yes	0.14	19.95	72.07	5.2	0.67	1.97	100
Spectrum 3	Yes	0.71	16.15	69.93	6.37	5.02	1.82	100
Spectrum 4	Yes	0.43	16	67.41	6.39	8.21	1.57	100
Mean		0.41	17.95	70.68	5.55	3.58	1.83	100

Figures 2-3a and 2-3b. Microstructure image and composition data of the interface between body and glaze; spectrums 1 and 2 in body and spectrums 3 and 4 in glaze.

Appendix | 159

Figure 2-4a.

Figure 2-4b.

| Processing option : Oxygen by stoichiometry (Normalized) |||||||||
| All results in compound wt % |||||||||
Spectrum	In stats.	Na	Mg	Al	Si	K	Ca	Total
Spectrum 1	Yes	0.69	1.09	14.79	67.56	5.8	10.07	100
Spectrum 2	Yes	0.57	0.85	15.19	66.49	5.88	11.03	100
Spectrum 3	Yes	0.59	0.93	14.2	68.26	5.61	10.41	100
Spectrum 4	Yes	0.78	0.77	14.43	67.51	6.24	10.27	100
Spectrum 5	Yes	0.38	0.71	13.59	70.4	6.3	8.61	100
Mean		0.6	0.87	14.44	68.05	5.96	10.08	100

Figures 2-4a and 2-4b. Microstructure image and composition data of glaze.

160 | Appendix

Dayao-3

Figure 3-1. OCT image of glaze in 930 nm central wavelength.

Figure 3-2a.

Figure 3-2b.

Processing option : Oxygen by stoichiometry (Normalized)						
All results in compound wt %						
Spectrum	In stats.	Al	Si	K	Ca	Total
Spectrum 1	Yes	20.7	74.13	4.68	0.5	100
Spectrum 2	Yes	21.15	73.32	4.82	0.71	100
Spectrum 3	Yes	19.77	73.14	5.6	1.5	100
Mean		20.54	73.53	5.03	0.9	100

Figures 3-2a and 3-2b. Microstructure image and composition data of body.

Figure 3-3a.

Figure 3-3b.

162 | Appendix

Processing option : Oxygen by stoichiometry (Normalized)						
All results in compound wt %						
Spectrum	In stats.	Al	Si	K	Ca	Total
Spectrum 1	Yes	21.39	72.79	4.93	0.89	100
Spectrum 2	Yes	20.05	72.21	5.76	1.98	100
Spectrum 3	Yes	16.68	70.42	6.04	6.86	100
Spectrum 4	Yes	16.2	69.99	4.97	8.84	100
Spectrum 5	Yes	15.67	68.12	4.91	11.3	100
Mean		18	70.71	5.32	5.97	100

Figures 3-3a and 3-3b. Microstructure image and composition data of the interface between body and glaze.

Figure 3-4a

Figure 3-4b

Appendix | 163

| Processing option : Oxygen by stoichiometry (Normalized) |||||||
| All results in compound wt % |||||||
Spectrum	In stats.	Al	Si	K	Ca	Total
Spectrum 1	Yes	15.8	67.47	5.18	11.55	100
Spectrum 2	Yes	15.4	68.59	5.55	10.46	100
Spectrum 3	Yes	15.7	68.53	5.26	10.51	100
Mean		15.63	68.2	5.33	10.84	100

Figures 3-4a and 3-4b. Microstructure image and composition data of glaze.

Aotou-1

Figure 4-1. OCT image of glaze in 930 nm central wavelength.

Figure 4-2a.

164 | Appendix

Figure 4-2b.

| Processing option : Oxygen by stoichiometry (Normalized) ||||||
| All results in compound wt % ||||||
Spectrum	In stats.	Al	Si	K	Fe	Total
Spectrum 1	Yes	20.43	69.71	6.69	3.16	100
Spectrum 2	Yes	19.4	73.2	4.98	2.42	100
Spectrum 3	Yes	16.31	76.46	5.23	2	100
Mean		18.71	73.12	5.64	2.53	100

Figures 4-2a and 4-2b. Microstructure image and composition data of body.

Figure 4-3a.

Figure 4-3b.

| Processing option : Oxygen by stoichiometry (Normalized) |||||||||
| All results in compound wt% |||||||||
Spectrum	In stats.	Na	Mg	Al	Si	K	Ca	Total
Spectrum 1	Yes	0.71	0.71	13.2	70.73	6.82	7.83	100
Spectrum 2	Yes	0.92	0.33	17.22	70.78	7.23	3.51	100
Spectrum 3	Yes	0.99	0.6	14.12	70.9	6.72	6.67	100
Mean		0.87	0.55	14.84	70.81	6.93	6	100

Figures 4-3a and 4-3b. Microstructure image and composition data of the interface between body and glaze.

Figure 4-4a.

166 | Appendix

Figure 4-4b.

Figure 4-4c.

Figure 4-4d.

Processing option : Oxygen by stoichiometry (Normalized)							
All results in compound wt %							
Spectrum	In stats.	Na	Al	Si	K	Ca	Total
Spectrum 1	Yes	1.79	25.34	59.85	3.84	9.18	100
Spectrum 2	Yes	1.17	16.51	72.06	7.81	2.45	100
Spectrum 3	Yes	1.17	22.86	62.95	4.2	8.82	100
Spectrum 4	Yes	0.35	5.62	89.81	2.96	1.26	100
Spectrum 5	Yes	0.89	24.78	64.85	7.25	2.23	100
Mean		1.07	19.02	69.9	5.21	4.79	100

Figures 4-4a, 4-4b, 4-4c and 4-4d. Microstructure images and composition data of glaze close to the interface between glaze and body; spectrums 1 and 3: anorthite (A) crystallization phase; Spectrum 4: quartz (Q).

Dayao-5

Figure 5-1. OCT image of glaze in 930 nm central wavelength.

Figure 5-2a.

168 | Appendix

Figure 5-2b.

| Processing option : Oxygen by stoichiometry (Normalised) |||||||
| All results in compound wt % |||||||
Spectrum	In stats.	Al	Si	K	Total
Spectrum 1	Yes	17.99	77.25	4.76	100
Spectrum 2	Yes	19.74	75.44	4.81	100
Spectrum 3	Yes	21.73	73.49	4.78	100
Spectrum 4	Yes	18.52	76.24	5.24	100
Mean		19.49	75.61	4.9	100

Figure 5-2c.

| Processing option : Oxygen by stoichiometry (Normalized) |||||||||||
| All results in compound wt % |||||||||||
Spectrum	In stats.	Al	Si	P	K	Ti	La	Ce	Nd	Total
Spectrum 1	Yes	7.56	23.68	-0.08	1.13	67	0.98	0.34	-0.6	100
Spectrum 2	Yes	8.75	26.66	21.21	1.43	0	12.5	22.03	7.42	100
Spectrum 3	Yes	19.76	74.87	0.15	4.86	0.74	0.39	-0.43	-0.34	100
Spectrum 4	Yes	20.28	73.85	-0.02	5.27	0.24	0.25	-0.35	0.47	100
Mean		14.09	49.76	5.32	3.17	16.99	3.53	5.4	1.74	100

Figures 5-2a, 5-2b and 5-2c. Microstructure image and composition data of body, as well as some special components; spectrum 1 in Figure 5-2c: titania particle; spectrum 2: monazite (Ce,La,Nd,Th)PO$_4$.

Figure 5-3a.

Figure 5-3b.

Processing option : Oxygen by stoichiometry (Normalized)								
All results in compound wt %								
Spectrum	In stats.	Na	Mg	Al	Si	K	Ca	Total
Spectrum 1	Yes	0.86	-0.15	20.06	73.62	5.14	0.46	100
Spectrum 2	Yes	0.38	0.27	19.43	74.11	4.95	0.86	100
Spectrum 3	Yes	1.31	0.56	15.35	71.6	7.19	3.99	100
Spectrum 4	Yes	1.1	0.85	14.38	68.84	6.23	8.6	100
Mean		0.91	0.38	17.3	72.04	5.88	3.48	100

Figures 5-3a and 5-3b. Microstructure image and composition data of the interface between body and glaze.

Figure 5-4a.

Figure 5-4a. Anorthite crystallization phase in glaze close to the interface between glaze and body.

Figure 5-4b.

Appendix | 171

Figure 5-4c.

Processing option : Oxygen by stoichiometry (Normalized)

All results in compound wt %

Spectrum	In stats.	Al	Si	K	Ca	Total
Spectrum 1	Yes	14.32	71.61	5.88	8.19	100
Spectrum 2	Yes	14.31	70.55	5.85	9.28	100
Spectrum 3	Yes	14.75	70.67	5.17	9.4	100
Spectrum 4	Yes	16.07	72.21	6.43	5.28	100
Spectrum 5	Yes	15.73	72.36	5.91	5.99	100
Mean		15.04	71.48	5.85	7.63	100

Figures 5-4b and 5-4c. Microstructure image and composition data of glaze.

Dayao-6

172 | Appendix

Figures 6-1a and 6-1b. OCT images of glaze in 930 nm central wavelength.

Figure 6-2a.

Figure 6-2b.

Processing option : Oxygen by stoichiometry (Normalized)

All results in compound wt %

Spectrum	In stats.	Al	Si	K	Total
Spectrum 1	Yes	24.8	70.04	5.16	100
Spectrum 2	Yes	20.97	74.38	4.66	100
Spectrum 3	Yes	24.18	71.42	4.39	100
Spectrum 4	Yes	23.68	72.39	3.92	100
Spectrum 5	Yes	22.83	72.55	4.63	100
Mean		23.29	72.16	4.55	100

Figure 6-2c.

Processing option : Oxygen by stoichiometry (Normalized)

All results in compound wt %

Spectrum	In stats.	Mg	Al	Si	K	Ti	Fe	Cu	Zr	Total
Spectrum 1	Yes	0.35	6.35	37.82	1.43	0.21	0.83	-0.1	53.1	100
Spectrum 2	Yes	1.12	18.1	25.56	1.75	39.48	13.72	0.38	-0.11	100
Spectrum 3	Yes	0.15	12.95	43.45	2.74	37.99	1.37	0.95	0.4	100
Spectrum 4	Yes	0.16	7.67	18.03	0.74	-0.04	0.9	72.39	0.14	100
Spectrum 5	Yes	0.28	21.16	70.36	4.36	0.22	3.68	-0.05	-0.03	100
Spectrum 6	Yes	-0.01	22.26	71.73	4.22	-0.27	2.65	0.1	-0.7	100
Mean		0.34	14.75	44.49	2.54	12.93	3.86	12.28	8.8	100

Figures 6-2a, 6-2b and 6-2c. Microstructure image and composition data of body, as well as some special components; spectrum 1 in Figure 6-2c: Zircon (ZrSiO$_4$); spectrums 2 and 3: Titania.

Appendix

Figure 6-2d.

| Processing option : Oxygen by stoichiometry (Normalized) ||||||||
| All results in compound wt % ||||||||
Spectrum	In stats.	Al	Si	K	Fe	Total
Spectrum 1	Yes	35.67	58.17	3.53	2.63	100
Spectrum 2	Yes	37.22	57.63	2.9	2.26	100
Spectrum 3	Yes	29.69	63.14	4.23	2.95	100
Spectrum 4	Yes	34.97	58.87	3.81	2.36	100
Spectrum 5	Yes	35.17	58.53	3.41	2.88	100
Spectrum 6	Yes	16.55	73.66	5.74	4.04	100
Mean		31.55	61.67	3.94	2.85	100

Figure 6-2d. Mullite crystallization phase in body; spectrums 1-5 mullite ($3Al_2O_3 \cdot 2SiO_2$); spectrum 6: clay matrix.

Figure 6-3a.

Appendix | 175

Figure 6-3b.

Processing option : Oxygen by stoichiometry (Normalized)						
All results in compound wt %						
Spectrum	In stats.	Al	Si	K	Ca	Total
Spectrum 1	Yes	23.25	71.51	4.47	0.77	100
Spectrum 2	Yes	23.15	70.72	4.8	1.33	100
Spectrum 3	Yes	16.52	71.39	5.91	6.18	100
Spectrum 4	Yes	14.65	69.62	4.46	11.28	100
Mean		19.4	70.81	4.91	4.89	100

Figures 6-3a and 6-3b. Microstructure image and composition data of the interface between body and glaze.

Figure 6-4a.

Figure 6-4b.

Processing option : Oxygen by stoichiometry (Normalized)						
All results in compound wt %						
Spectrum	In stats.	Al	Si	K	Ca	Total
Spectrum 1	Yes	22.89	64.31	4.71	8.1	100
Spectrum 2	Yes	25.77	59.8	2.92	11.51	100
Spectrum 3	Yes	19.22	68.47	5.69	6.61	100
Spectrum 4	Yes	25.08	61.27	3.15	10.51	100
Mean		23.24	63.46	4.12	9.18	100

Figures 6-4a and 6-4b. Microstructure image and composition data of glaze close to the interface between glaze and body; spectrums 1, 2 and 4: anorthite crystallization phase.

Figure 6-5a.

Figure 6-5b.

| Processing option : Oxygen by stoichiometry (Normalized) ||||||||
| All results in compound wt % ||||||||
Spectrum	In stats.	Al	Si	K	Ca	Total
Spectrum 1	Yes	13.79	70.5	6.04	9.67	100
Spectrum 2	Yes	13.47	70.22	6.69	9.62	100
Spectrum 3	Yes	15.03	70.04	5.64	9.29	100
Spectrum 4	Yes	15.07	68.01	5.38	11.54	100
Mean		14.34	69.69	5.93	10.03	100

Figures 6-5a and 6-5b. Microstructure image and composition data of glaze.

Dayao-7

Figure 7-1. OCT image of glaze in 930 nm central wavelength.

178 | Appendix

Figure 7-2a.

Figure 7-2b.

| Processing option : Oxygen by stoichiometry (Normalized) |||||||
| All results in compound wt % |||||||
Spectrum	In stats.	Al	Si	K	Ti	Total
Spectrum 1	Yes	10.47	33.1	2.9	53.53	100
Spectrum 2	Yes	23.06	68.38	6.3	2.27	100
Spectrum 3	Yes	19.58	75.85	4.68	-0.11	100
Spectrum 4	Yes	24.72	70.24	5.09	-0.06	100
Spectrum 5	Yes	18.84	76.58	4.33	0.25	100
Mean		19.33	64.83	4.66	11.18	100

Figures 7-2a and 7-2b. Microstructure image and composition data of body; spectrum 1: titania.

Appendix | 179

Figure 7-3a.

Figure 7-3b.

Processing option : Oxygen by stoichiometry (Normalized)									
All results in compound wt %									
Spectrum	In stats.	Na	Mg	Al	Si	K	Ca	Total	
Spectrum 1	Yes	0.86	-0.16	20.06	73.64	5.14	0.46	100	
Spectrum 2	Yes	0.39	0.28	19.43	74.1	4.94	0.87	100	
Spectrum 3	Yes	1.3	0.56	15.36	71.6	7.19	3.99	100	
Spectrum 4	Yes	1.1	0.85	14.39	68.83	6.23	8.6	100	
Mean		0.91	0.38	17.31	72.04	5.87	3.48	100	

Figures 7-3a and 7-3b. Microstructure image and composition data of the interface between body and glaze.

Figure 7-4a.

Figure 7-4b.

| Processing option : Oxygen by stoichiometry (Normalized) |||||||||
| All results in compound wt % |||||||||
Spectrum	In stats.	Na	Mg	Al	Si	K	Ca	Total
Spectrum 1	Yes	1.79	0.11	18.22	67.81	5.53	6.53	100
Spectrum 2	Yes	1.21	0.51	19.75	65.17	5.5	7.86	100
Spectrum 3	Yes	1.18	0.5	19.17	66.69	5.48	6.99	100
Spectrum 4	Yes	1.29	0.31	21.6	64.93	4.7	7.16	100
Spectrum 5	Yes	1.25	0.48	15.76	72.58	7.18	2.75	100
Spectrum 6	Yes	1.19	0.25	18.27	69.66	6.65	3.97	100
Spectrum 7	Yes	1.52	0.49	18.56	67.47	5.67	6.29	100
Spectrum 8	Yes	0.79	0.93	16.16	72.27	7.23	2.62	100
Mean		1.28	0.45	18.44	68.32	5.99	5.52	100

Figures 7-4a and 7-4b. Microstructure image and composition data of glaze close to the interface between glaze and body.

Appendix | 181

Figure 7-5a.

Figure 7-5b.

Processing option : Oxygen by stoichiometry (Normalized)								
All results in compound wt %								
Spectrum	In stats.	Na	Mg	Al	Si	K	Ca	Total
Spectrum 1	Yes	1.1	0.97	15.1	68.52	5.88	8.43	100
Spectrum 2	Yes	0.9	0.56	14.28	69.9	6.67	7.68	100
Spectrum 3	Yes	0.74	1.24	14.22	69.44	6.21	8.15	100
Spectrum 4	Yes	0.5	0.75	14.65	69.71	6.53	7.86	100
Spectrum 5	Yes	1.31	0.12	15.79	70.48	6.44	5.86	100
Mean		0.91	0.73	14.81	69.61	6.35	7.6	100

Figures 7-5a and 7-5b. Microstructure image and composition data of glaze.

Dayao-8

Figure 8-1. OCT image of glaze in 930 nm central wavelength.

Figure 8-2a.

Figure 8-2b.

Appendix | 183

Processing option : Oxygen by stoichiometry (Normalized)								
All results in compound wt %								
Spectrum	In stats.	Al	Si	K	Ti	Fe	Zr	Total
Spectrum 1	Yes	21.05	53.71	3.64	0	1.43	20.16	100
Spectrum 2	Yes	21.13	69.59	5.98	0.99	2.62	-0.32	100
Spectrum 3	Yes	20.43	43.14	3.67	16.11	15.88	0.77	100
Spectrum 4	Yes	24.56	32.1	2	23.33	18.1	-0.08	100
Spectrum 5	Yes	20.06	64.04	5.32	9.4	1.81	-0.63	100
Spectrum 6	Yes	14.94	73.07	6.24	2.49	3.44	-0.17	100
Mean		20.36	55.94	4.47	8.72	7.21	3.29	100

Figures 8-2a and 8-2b. Spectrum 1: Zircon; spectrums 3 and 4 iron and titanium compound minerals in body.

Figure 8-2c.

Processing option : Oxygen by stoichiometry (Normalized)					
All results in compound wt %					
Spectrum	In stats.	Al	Si	K	Total
Spectrum 1	Yes	21.94	72.77	5.29	100
Spectrum 2	Yes	23.18	71.76	5.06	100
Spectrum 3	Yes	21.49	73.24	5.27	100
Spectrum 4	Yes	22.34	72.42	5.24	100
Spectrum 5	Yes	21.87	72.77	5.36	100
Mean		22.17	72.59	5.24	100

Figure 8-2c. Composition data of body.

Figure 8-3a.

Figure 8-3b

| Processing option : Oxygen by stoichiometry (Normalized) ||||||||
| All results in compound wt % ||||||||
Spectrum	In stats.	Mg	Al	Si	K	Ca	Total
Spectrum 1	Yes	0.02	23.14	72.09	4.71	0.03	100
Spectrum 2	Yes	0.17	21.42	73.19	4.8	0.42	100
Spectrum 3	Yes	0.32	20.26	69.81	6.1	3.51	100
Spectrum 4	Yes	0.82	13.96	70.05	5.27	9.89	100
Spectrum 5	Yes	0.11	14.97	69.97	6	8.95	100
Mean		0.29	18.75	71.02	5.38	4.56	100

Figures 8-3a and 8-3b. Microstructure image and composition data of the interface between body and glaze.

Figure 8-4a. Microstructure image of glaze close to the interface between glaze and body.

Figure 8-4b

| Processing option : Oxygen by stoichiometry (Normalized) |||||||||
| All results in compound wt % |||||||||
Spectrum	In stats.	Na	Al	Si	K	Ca	Total
Spectrum 1	Yes	0.55	27.06	56.36	2.68	13.35	100
Spectrum 2	Yes	0.68	22.18	63.13	4.31	9.7	100
Spectrum 3	Yes	0.6	25.43	58.35	3.35	12.27	100
Spectrum 4	Yes	0.53	21.36	65.52	5.26	7.33	100
Mean		0.59	24.01	60.84	3.9	10.67	100

Figure 8-4b. Composition data of glaze close to the interface between glaze and body; spectrums 1 and 3: anorthite crystallization phase.

186 | Appendix

Figure 8-5a.

Figure 8-5b.

| Processing option : Oxygen by stoichiometry (Normalized) ||||||||
| All results in compound wt % ||||||||
Spectrum	In stats.	Na	Al	Si	K	Ca	Total
Spectrum 1	Yes	0.45	14.85	68.17	5.39	11.14	100
Spectrum 2	Yes	0.41	14.51	69.44	5.38	10.26	100
Spectrum 3	Yes	0.32	15.59	69.55	5.81	8.73	100
Spectrum 4	Yes	0.54	16.01	71.19	6.28	5.99	100
Spectrum 5	Yes	0.74	17.63	69.48	5.9	6.23	100
Mean		0.49	15.72	69.57	5.75	8.47	100

Figures 8-5a and 8-5b. Microstructure image and composition data of glaze.

Dayao-9

Figure 9-1. OCT image of glaze in 930 nm central wavelength.

Figure 9-2a.

Figure 9-2b.

188 | Appendix

Processing option : Oxygen by stoichiometry (Normalized)						
All results in compound wt %						
Spectrum	In stats.	Na	Al	Si	K	Total
Spectrum 1	Yes	0.75	24.42	69.06	5.76	100
Spectrum 2	Yes	0.49	24.99	68.85	5.67	100
Spectrum 3	Yes	0.38	24.71	69.88	5.04	100
Spectrum 4	Yes	0.78	25.48	68.72	5.01	100
Spectrum 5	Yes	0.55	24.21	69.71	5.53	100
Mean		0.59	24.76	69.25	5.4	100

Figure 9-2c.

Processing option : Oxygen by stoichiometry (Normalized)							
All results in compound wt %							
Spectrum	In stats.	Al	Si	K	Ti	Zr	Total
Spectrum 1	Yes	8.72	41.47	2.17	0.03	47.61	100
Spectrum 2	Yes	11.47	46.46	2.94	-0.26	39.38	100
Spectrum 3	Yes	9.68	22.93	1.45	66.34	-0.4	100
Spectrum 4	Yes	9.21	23	1.93	67.21	-1.35	100
Mean		9.77	33.47	2.12	33.33	21.31	100

Figures 9-2a, 9-2b and 9-2c. Microstructure images and composition data of body; spectrums 1 and 2 in Figure 9-2c: Zircon; spectrums 3 and 4: titania.

Figure 9-2d.

| Processing option : Oxygen by stoichiometry (Normalized) ||||||||
| All results in compound wt % ||||||||
Spectrum	In stats.	Na	Al	Si	K	Fe	Total
Spectrum 1	Yes	0.59	33.46	59.8	4.64	1.5	100
Spectrum 2	Yes	0.46	33.25	60.1	4.54	1.65	100
Spectrum 3	Yes	0.67	34.23	58.41	4.27	2.42	100
Spectrum 4	Yes	0.32	28.39	64.31	5.22	1.76	100
Spectrum 5	Yes	0.43	35.8	58.24	3.98	1.54	100
Spectrum 6	Yes	0.59	18.79	72.08	6.17	2.38	100
Mean		0.51	30.65	62.16	4.8	1.88	100

Figure 9-2d. Spectrums 1-5: mullite (M) crystallization phase; spectrum 6: clay matrix.

190 | Appendix

Figure 9-3a.

Figure 9-3b.

| Processing option : Oxygen by stoichiometry (Normalized) ||||||||||
| All results in compound wt % ||||||||||
Spectrum	In stats.	Na	Al	Si	K	Ca	Fe	Total
Spectrum 1	Yes	0.66	24.83	66.52	5.13	0.59	2.28	100
Spectrum 2	Yes	0.75	23.29	67.97	5.83	0.57	1.6	100
Spectrum 3	Yes	0.6	15.15	69.83	5.9	6.62	1.9	100
Spectrum 4	Yes	0.88	14.19	69.51	5.44	8.73	1.24	100
Mean		0.72	19.36	68.46	5.57	4.13	1.75	100

Figures 9-3a and 9-3b. Microstructure image and composition data of the interface between body and glaze.

Figure 9-4a.

Figure 9-4b

| Processing option : Oxygen by stoichiometry |
| All results in compound wt % |

Spectrum	In stats.	Na	Al	Si	K	Ca	Total
Spectrum 1	Yes	1.55	26.9	54.27	2.71	10.95	96.39
Spectrum 2	Yes	1.27	25.31	57.3	3.08	10.6	97.57
Spectrum 3	Yes	1.02	24.75	58.05	3.85	10.09	97.74
Spectrum 4	Yes	1.3	17.25	63.95	6.94	4.47	93.9
Mean		1.28	23.55	58.39	4.14	9.03	96.4

Figures 9-4a and 9-4b. Anorthite crystallization phase in glaze close to the interface between glaze and body (spectrums 1, 2 and 3).

192 | Appendix

Figure 9-5a.

Figure 9-5b.

| Processing option : Oxygen by stoichiometry (Normalized) ||||||||
| All results in compound wt % ||||||||
Spectrum	In stats.	Na	Al	Si	K	Ca	Total
Spectrum 1	Yes	0.72	14.38	68.64	5.44	10.82	100
Spectrum 2	Yes	1.15	14.28	69.22	6.19	9.15	100
Spectrum 3	Yes	1.13	13.84	70.62	5.72	8.7	100
Spectrum 4	Yes	0.56	14.33	70.6	5.82	8.68	100
Spectrum 5	Yes	0.93	14.52	70.65	5.88	8.02	100
Mean		0.9	14.27	69.95	5.81	9.07	100

Figures 9-5a and 9-5b. Microstructure image and composition data of glaze.

Figure 9-5c.

Figure 9-5d.

| Processing option : Oxygen by stoichiometry (Normalized) |||||||||||
| All results in compound wt % |||||||||||
Spectrum	In stats.	Na	Mg	Al	Si	P	K	Ca	Total
Spectrum 1	Yes	0.42	0.51	10.93	56.51	11.06	4.58	16	100
Spectrum 2	Yes	0.51	0.79	11.06	54.47	11.67	4.71	16.8	100
Spectrum 3	Yes	0.99	0.59	11.57	56.65	10.55	4.66	14.99	100
Spectrum 4	Yes	0.71	0.9	8.94	45.33	18.47	3.76	21.88	100
Mean		0.66	0.69	10.63	53.24	12.94	4.43	17.42	100

Figures 9-5c and 9-5d. Spectrums 1-4 : Tricalcium phosphate (Ca$_3$(PO$_4$)$_2$, bone phosphate of lime), a common additive of glaze in ancient Chinese ceramics.

Guan-1

Figure 10-1. OCT image of glaze in 930 nm central wavelength.

Figure 10-2a.

Figure 10-2b.

Processing option : Oxygen by stoichiometry (Normalized)						
All results in compound wt %						
Spectrum	In stats.	Al	Si	K	Fe	Total
Spectrum 1	Yes	26.97	65.89	4.89	2.25	100
Spectrum 2	Yes	23.76	67.69	4.69	3.86	100
Spectrum 3	Yes	25.26	67.91	4.56	2.27	100
Spectrum 4	Yes	24.43	68.07	4.63	2.87	100
Spectrum 5	Yes	25.75	67.46	4.64	2.15	100
Mean		25.24	67.4	4.68	2.68	100

Figures 10-2a and 10-2b. Microstructure image and composition data of body.

Figure 10-2c.

Processing option : Oxygen by stoichiometry (Normalized)						
All results in compound wt %						
Spectrum	In stats.	Al	Si	K	Zr	Total
Spectrum 1	Yes	6.25	36.47	1.25	56.02	100
Spectrum 2	Yes	6.96	37.91	1.01	54.11	100
Spectrum 3	Yes	6.41	39.38	0.28	53.93	100
Spectrum 4	Yes	25.85	70.54	4.37	-0.76	100
Spectrum 5	Yes	25.94	70.03	4.64	-0.61	100
Mean		14.28	50.87	2.31	32.54	100

Figure 10-2c. Microstructure image and composition data of body; spectrums 1, 2 and 3: Zircon.

196 | Appendix

Figure 10-2d.

| Processing option : Oxygen by stoichiometry (Normalized) |||||||
| All results in compound wt % |||||||
Spectrum	In stats.	Al	Si	K	Ti	Total
Spectrum 1	Yes	20.01	41.24	3.84	34.91	100
Spectrum 2	Yes	15.23	31.04	2.07	51.66	100
Mean		17.62	36.14	2.96	43.28	100

Figure 10-2d. Microstructure image and composition data of body; spectrums 1 and 2: titania.

Figure 10-2e.

Processing option : Oxygen by stoichiometry (Normalized)					
All results in compound wt %					
Spectrum	In stats.	Al	Si	K	Total
Spectrum 1	Yes	39.19	57.53	3.28	100
Spectrum 2	Yes	13.26	82.51	4.23	100
Spectrum 3	Yes	38.52	58.05	3.43	100
Spectrum 4	Yes	39.28	57.76	2.96	100
Spectrum 5	Yes	26.81	68.36	4.83	100
Mean		31.41	64.84	3.74	100

Figure 10-2e. Microstructure image and composition data of body; spectrums 1, 3 and 4: mullite crystallization phase; spectrum 5: clay matrix.

Figure 10-3a.

Figure 10-3b.

198 | Appendix

| Processing option : Oxygen by stoichiometry (Normalized) ||||||
| All results in compound wt % ||||||
Spectrum	In stats.	Al	Si	K	Ca	Total
Spectrum 1	Yes	23.46	71.33	4.58	0.62	100
Spectrum 2	Yes	21.22	68.88	4.72	5.18	100
Spectrum 3	Yes	16.55	67.5	3.05	12.89	100
Spectrum 4	Yes	16.82	65.48	3.44	14.25	100
Mean		19.51	68.3	3.95	8.24	100

Figures 10-3a and 10-3b. Microstructure image and composition data of the interface between body and glaze.

Figure 10-4a.

Figure 10-4b.

Processing option : Oxygen by stoichiometry (Normalized)						
All results in compound wt %						
Spectrum	In stats.	Al	Si	K	Ca	Total
Spectrum 1	Yes	28.04	57.34	2.19	12.44	100
Spectrum 2	Yes	34.96	53.51	1.47	10.06	100
Spectrum 3	Yes	25.83	59.15	1.64	13.39	100
Mean		29.61	56.67	1.76	11.96	100

Figures 10-4a and 10-4b. Anorthite crystallization phase (spectrums 1-3) in glaze close to the interface between glaze and body.

Figure 10-5a.

Figure 10-5b.

| Processing option : Oxygen by stoichiometry (Normalized) ||||||||
| All results in compound wt % ||||||||
Spectrum	In stats.	Al	Si	K	Ca	Total
Spectrum 1	Yes	15.62	65.28	3.24	15.85	100
Spectrum 2	Yes	16.29	65.61	4.86	13.24	100
Spectrum 3	Yes	15.25	66.68	4.25	13.81	100
Spectrum 4	Yes	16.05	66.51	3.42	14.02	100
Mean		15.8	66.02	3.94	14.23	100

Figures 10-5a and 10-5b. Microstructure image and composition data of glaze.

Bibliography

Annis, M. Beatrice. 1985. "Resistance and Change: Pottery Manufacture in Sardinia." *World Archaeology* 17(2): 240–255.

Aoyagi, Yōji and Hidefumi Ogawa. 1989. "Chinese Trade Ceramics of 13th and 14th Centuries Discovered at Malabar Coast in South India." *Journal of East-West Maritime Relations* 1(1989): 97–116.

Appadurai, Arjun. 1986. "Introduction: Commodities and the Politics of Value." In *The Social Life of Things: Commodities in Cultural Perspective*, edited by Arjun Appadurai, 3–63. Cambridge: Cambridge University Press.

Archaeological Research Unit, the University of Tokyo. 2017. "Edo Toyama Domain Prefecture." Accessed Febrary 15, 2017, http://www.city.toyama.jp/etc/maibun/toya-majyo/edo-toyamahan/top/top.htm

Arima, Raitei (有馬 賴底). 1991. "Kinuta Seiji Chawan Mei Uryū." In *Kinkaku, Ginkaku Meihōten : Daihonzan Shōkokuji Sōken Roppyakunen Kinen (金閣 銀閣名宝展：大本山相国寺創建六百年記念)*, edited by Yomiuri Shinbun Ōsaka Honsha, 158. Osaka: Yomiuri Shinbun Ōsaka Honsha.

———. 1991. "Kinuta Seiji Ukibotan Kōro Ryūsenyō." In *Kinkaku, Ginkaku Meihōten : Daihonzan Shōkokuji Sōken Roppyakunen Kinen*, edited by Yomiuri Shinbun Ōsaka Honsha, 166. Osaka: Yomiuri Shinbun Ōsaka Honsha.

———. 1991. "Tenryūji Seiji Hōōmimi Hanaike." In *Kinkaku, Ginkaku Meihōten: Daihonzan Shōkokuji Sōken Roppyakunen Kinen*, edited by Yomiuri Shinbun Ōsaka Honsha, 165. Osaka: Yomiuri Shinbun Ōsaka Honsha.

Arnold, E. Dean. 1993. *Ecology and Ceramic Production in an Andean Community*. Cambridge: Cambridge University Press.

———. 2008. "How Has Clay Procurement Changed?" In *Social Change and the Evolution of Ceramic Production and Distribution in a Maya Community*, 153–189. Boulder, Colorado: University Press of Colorado.

Arnold III, J. Philip. 1991. "Archaeological Approaches to Ceramic Production." In *Domestic Ceramic Production and Spatial Organization: A Mexican Case Study in Ethnoarchaeology*, 83–98. Cambridge: Cambridge University Press.

Asahi Shimbun (朝日新聞) (ed). 1971. *Catalogue for Chinese Art from the Collection of H. M. King Gustaf VI Adolf of Sweden*. Tokyo: Asahi Shimbun, Cultural Project Department, Tokyo.

——— (ed.). 1998. *Fūin Sareta Nansō Tōjiten (封印された: 南宋陶磁展 = Newly Discovered Southern Song Ceramics: A Thirteenth-Century "Time Capsule")*. Tokyo: Asahi Shimbun.
Askeland, R. Donald and Pradeep P. Phulé. 2006. *The Science and Engineering of Materials* (Fifth Edition). Toronto: Thomson.
Atago, Matsuo (愛宕 松男). 1977. "Sōdai no Bunka to Tōji." In *Ceramic Art of the World Vol. 12: Sung Dynasty*, edited by Gakuji Hasebe, 139–155. Tokyo: Shōgakukan.
Bao, Weimin (包 偉民). 1986. "Song Dai Min Jiang Chai Gu Zhi Du Shu Lüe." In *Song Shi Yan Jiu Ji Kan (宋史研究集刊)*, edited by Gui Xu, 43–86. Hangzhou: Zhejiang Gu Ji Chu Ban She.
Basalla, George. 1988. "Continuity and Discontinuity." In *The Evolution of Technology*, 26–63. Cambridge: Cambridge University Press.
Bi, Yuan (畢 沅). 1957. *Xu Zi Zhi Tong Jian (續資治通鑑)*, vol. 89 and vol. 170. Beijing: Zhong Hua Shu Ju.
Biggs, Simon and Ariela Lowenstein. 2013. "Toward Generational Intelligence: Linking Cohorts, Families, and Experience." In *Kinship and Cohort in an Aging Society: from Generation to Generation*, edited by Merril Silverstein and Roseann Giarrusso, 159–175. Baltimore: The Johns Hopkins University Press.
Braun, P. David. 1995. "Style, Selection, and Historicity." In *Style, Society, and Person: Archaeological and Ethnological Perspectives*, edited by Christopher Carr and Jill E. Neitzel, 123–141. New York and London: Plenum Press.
Cai, Naiwu (蔡 乃武). 2004. "Ge Kiln and Its Relative Things: a Study on the Laohudong Kiln Site in Hangzhou." In *A Collection of Essays on Southern Song Dynasty Guan Kiln*, edited by Wu Xiaoli et al., 98–109. Beijing: Cultural Relics Publishing House.
Cai, Xiaohui (蔡 小輝). 2010. "The Relevant Research of Song and Yuan Longquan Celadon Hoards." *Dong Fang Bo Wu (東方博物)* 35: 39–50.
Carr, Christopher and Jill E. Neitzel. 1995. "Style in Complex Societies." In *Style, Society, and Person: Archaeological and Ethnological Perspectives*, edited by Christopher Carr and Jill E. Neitzel, 389–392. New York and London: Plenum Press.
Cen, Rui (岑 蕊). 1983. "Mo Jie Wen Kao Lüe." *Wen Wu (文物)* 1983(10): 78–85.
Charlton, H. Thomas, Cynthia L. Otis Charlton, Deborah L. Nichols and Hector Neff. 2007. "Aztec Otumba, AD 1200–1600: Patterns of the Production, Distribution, and Consumption of Ceramic Products." In *Pottery Economics in Mesoamerica*, edited by Christopher A. Pool and George J. Bey III, 237–266. Tucson: The University of Arizona Press.
Charlton, H. Thomas. 1968. "Post-conquest Aztec Ceramics: Implications for Archaeological Interpretation." T*he Florida Anthropologist* 21(4): 96–101.
Chen, Liqing (陳 黎清). 1990. "Emeishanshi Luomuzhen Chu Tu Song Dai Jiao Cang." *Sichuan Wen Wu (四川文物)*1990(2): 41–42.
Chen, Quanqing (陳 全慶) and Shaohua Zhou (周 少華). 1995. " The Microstructure and Color of Song Yue, Ru, Jiaotan Guan and Longquan celadon." In *The 1995 International Symposium on Ancient Ceramics—Its Scientific and Technological Insights (ISAC'95)*, 180–186.
Chen, Wanli (陳 萬里). 1946. *Ci Qi Yu Zhejiang (瓷器與浙江 = Porcelain and Zhejiang)*. Shanghai: Zhong Hua Shu Ju.
Chengdu Municipal Institute of Cultural Relics and Archaeology and Pengzhou City Museum. 2003. *Sichuan Pengzhou Song Dai Jin Yin Qi Jiao Cang (四川彭州宋代金銀器窖 = Song Gold and Silver Object Hoards in Sichuan Pengzhou)*. Beijing: Ke Xue Chu Ban She.

Chiang, Yet-Ming, Dunbar P. III Birnie and W. David Kingery. 1997. *Physical Ceramics: Principles for Ceramic Science and Engineering*. New York: John Wiley & Sons, Inc.

Cho, Hyŏn-jong (趙 現鐘). 2012. Foreword II to *Sailing from the Great Yuan Dynasty: Relics Excavated from the Sinan Shipwreck*, edited by Qionghua Shen, 9–31. Beijing: Wen Wu Chu Ban She.

Chongqing Zhongguo Sanxia Bo Wu Guan (重慶中國三峽博物館) (ed.). 2011. *Chongqing Zhongguo Sanxia Bo Wu Guan Cang Wen Wu Xuan Cui: Ci Qi (重慶中國三峽博物館藏文物選粹—瓷器)*. Beijing: Wen Wu Chu Ban She.

CICRA (Chengdu Institute of Cultural Relics and Archaeology) and Pengzhou Municipal Museum. 2009. "Sichuan Pengzhou Song Bronze Hoard." *Wen Wu* 2009(1): 54–70.

CICRA and SMM (Suining Municipal Museum). 2012. *Jinyucun Hoard of Southern Song Dynasty in Suining*. Beijing: Cultural Relics Press.

Conkey, W. Margaret. 1989. "The Use of Diversity in Stylistic Analysis." In *Quantifying Diversity in Archaeology*, edited by Robert D. Leonard and George T. Jones, 118–129. Cambridge: Cambridge University Press.

Costin, L. Cathy and Melissa B. Hagstrum. 1995. "Standardization, Labor Investment, Skill, and the Organization of Ceramic Production in Late Prehispanic Highland Peru." *American Antiquity* 60(4): 619–639.

Curatorial Division, Nezu Museum (ed.). 2010. *Heavenly Blue: Southern Song Celadons (宙をうつすうつわ: 南宋の青磁)*. Tokyo: Nezu Museum.

Daikōmyō-ji (大光明寺). 2017. Accessed May 13, 2017, http://www.kyotofukoh.jp/report1268.html

Darwish, H., Samia N. Salama and S. M. Salman. 2001. "Contribution of Germanium Dioxide to the Thermal Expansion Characteristics of Some Borosilicate Glasses and Their Corresponding Glass-Ceramics." *Thermochimica Acta* 374: 129–135.

Degawa, Tetsurō (出川哲郎). 2011. "Minsho no Kyūtei Yōjiki no Shōsei to Fūdōganyō Hakkutsu Chōsa no Igi." In *Special Exhibition:" The Flower of Jade Green – Longquan Celadon of the Ming Dyansty," Recent Archaeological Findings of the Dayao Fengdongyan Kiln Site*, edited by The Museum of Oriental Ceramics, Osaka, 122–125. Kanagawa: Asahi World Co., Ltd.

Dejitaruban Nihon Jinmei Daijiten (デジタル版 日本人名大辞典) + plus (ed.). 2017. "Oka Sessai (岡 節齋)." Accessed May 5, 2017, https://kotobank.jp/word/

Distin, Kate. 2011. *Cultural Evolution*. Cambridge: Cambridge University Press.

Dunnell, C. Robert. 1978. "Style and Function: a Fundamental Dichotomy." *American Antiquity* 43(2): 192–202.

Engakuji Butsunichian (圓覺寺佛日庵). 2017. *Butsunichian Kōmotsu Mokuroku (佛日庵公物目錄)*. Accessed February 3, 2017, http://reijibook.exblog.jp/17461808/

Feng, Xianming (馮 先銘), Zhimin An, Jinhuai An, Boqian Zhu and Qingzheng Wang (eds.). 1997. *Zhong Guo Tao Ci Shi* (中國陶瓷史 = The History of Chinese ceramics). Beijing: Wen Wu Chu Ban She.

Fontijn, David. 2008. "'Traders' Hoards' Reviewing the Relationship between trade and Permanent Deposition: the Case of the Dutch Voorhout Hoard." In *Hoards from the Neolithic to the Metal Ages: Technical and Codified Practices, BAR International Series 1758*, edited by Caroline Hamon and Benedicte Quilliec, 5–17. Oxford: Archaeopress.

Foster, M. George. 1965. "The Sociology of Pottery: Questions and Hypotheses Arising from Contemporary Mexican Work." In *Ceramics and Man*, edited by Frederick R. Matson, 43–61. Chicago: Aldine Publishing Company.

Fujian Provincial Museum and Youxi County Museum. 1991. "Fujian Youxi Fa Xian Song Dai Bi Hua Mu." *Kao Gu* 1991(4): 346–351.

Fukuiken (福井県). [et al.]. 2017. "Ichijōdani Asakura Family Ruins (一乗谷朝倉氏遺跡)." Accessed February 17, 2017, http://www.fukureki.com/itijyoudani/itijyoudani.html

Gao, Lian (高 濂). [1996]. *Ya Shang Zhai Zun Sheng Ba Jian (雅尚齋遵生八牋)*. Beijing: Shu Mu Wen Xian Chu Ban She.

Gray, Basil. 1953. *Early Chinese Pottery and Porcelain*. London: Faber and Faber.

Gu, Guozhao (顧 國詔) [1878 (ed.)], 1975. *Longquan Xian Zhi (龍泉縣志)*. In *Zhong Guo Fang Zhi Cong Shu (中國方志叢書)*. Taipei: Cheng Wen Chu Ban She.

Gu, Yingtai (谷 應泰). [1621–1627], 1968. *Bo Wu Yao Lan (博物要覽)*, vol. 2. Taipei: Yi WenYin Shu Guan.

Guo, Zizhang (郭 子章) (ed.). [1619], 2001. *Mingzhou Ayuwang Si Zhi (明州阿育王寺志)* in *Gugong Zhenben Congkan (故宮珍本叢刊)*. Haikou-shi: Hainan Chuban She.

H., W. B. 1952. Foreword to *Early Chinese Pottery and Porcelain*, by Basil Gray. New York: Pitman Publishing Corporation.

Hall, E. T., F. Schweizer and P. A. Toller. 1973. "X-ray Fluorescence Analysis of Museum Objects: A New Instrument." *Archaeometry* 15(1): 53–78.

Halsall, Guy. 2010. *Cemeteries and Society in Merovingian Gaul: Selected Studies in History and Archaeology, 1992–2009*. Boston: Brill.

Hanzhong Di Qu Wen Hua Quan (漢中地區文化館) and Lüeyang Xian Wen Hua Guan (略陽縣文化館). 1976. "Shaanxi Sheng Lüeyang Xian Chu Tu De Song Ci." *Wen Wu* 1976(11): 84–85.

Hasebe, Gakuji. 2001. "Shiruku Rōdo to Tōjiki." In *Treasures along the Silk Road: Steppe and Oasis Routes / Sea Route*, 10–11. Tokyo: Idemitsu Museum of Art.

Hasegawa, Shōko (長谷川 祥子) and Masaki Yamada (山田 正樹). 2017. In *Seikadō Chadōgu : Kanshō no Tebiki (静嘉堂茶道具鑑賞の手引き)*, edited by Seikadō Bunko Bijutsukan (静嘉堂文庫美術館) , 3–9. Tokyo: Seikadō Bunko Bijutsukan.

Hiroshima Prefectural Museum of History (ed.). 1995. *Cha, Hana, Kō: Chūsei ni Umareta Seikatsu Bunka (茶, 花, 香: 中世にうまれた生活文化)*. Fukuyama-shi: Hiroshima Kenritsu Rekishi Hakubutsukan.

——— (ed.). 2005. *Kusado Sengen-cho Site, a Medieval Port Town in Hiroshima Historical and Archaeological Analyses, Volume VII: List of the Designated Artifacts as Important Cultural Properties by the National Government*. Hiroshima: Hiroshima Prefectural Museum of History.

Hiroshima-ken Kusado Sengen-machi Iseki Chōsa Kenkyūjo (広島県草戸千軒町遺跡調査研究所) (ed.). 1981. *Kusado Sengen-machi Iseki : Dai 27-ji Hakkutsu Chōsa Gaiyō (草戸千軒町遺跡： 第27次発掘調査概要)*. Fukuyama-shi: Hiroshima-ken Kusado Sengen-machi Iseki Chōsa Kenkyūjo.

Hirota, Fukusai (廣田 不孤齋). 1957. *Kottō: Uraomote (骨董: 裏おもて)*. Tokyo: Daviddosha.

History Department, Xiamen University. 1975. "Quanzhou Gang de Dili Bianqian yu Song Yuan Shi Qi de Hai Wai Jiao Tong." *Wen Wu* 1975(10): 19–23.

HMICRA (Hangzhou Municipal Institute of Cultural Relics and Archaeology). 2008. *Report on Archaeological Excavation to the Site of Lin'an City: The Remains of the Mansion of Empress Gongshengrenlie of the Southern Song Dynasty*. Beijing: Cultural Relics Press.

Holt, B. Douglas. 2004. *How Brands Become Icons: The Principles of Cultural Branding*. Boston: Harvard Business School Press.

Hong, Mai (洪 邁). [1162–1202], 1982. *Yi Jian Zhi (夷堅志) Jia Zhi (甲志)*. Taipei: Ming Wen Shu Ju.

HPIACR (Hunan Provincial Institute of Archaeology and Cultural Relics). 2013. *Liujialing Mural Tomb in Guiyang*. Beijing: Cultural Relics Press.

HPICRA (Henan Provincial Institute of Cultural Relics and Archaeology). 2008. *Ru Yao at Qingliangsi in Baofeng*. Zhenchou: Elephant Press.

Huang, Xiaofeng (黃 曉楓). 2013. "Sichuan Jianyang Dongxi Yuanyichang Yi Ji Xing Zhi Yu Nian Dai Tan Tao." *Kao Gu Yu Wen Wu (考古與文物)* 2013(3): 80–100.

Hubei Sheng Wen Wu Guan Li Wei Yuan Hui (湖北省文物管理委員會). 1964. "Wuchang Zhuodaoquan Liang Zuo Southern Song Mu de Qing Li." *Kao Gu* 1964(5): 237–241.

Humphries, Mark. 1998. "Trading Gods in Northern Italy." In *Trade, Traders and the Ancient City*, edited by Helen Parkins and Christopher Smith, 203–224. London and New York: Routledge.

IACASS (Institute of Archaeology Chinese Academy of Social Sciences), ZPICRA (Zhejiang Provincial Institute of Cultural Relics and Archaeology) and Hangzhou Municipal Administration of Parks and Cultural Relics. 1996. *Southern Song Governmental Porcelain Workshop*. Beijing: The Encyclopedia of China Publishing House.

Iezuka, Tomoko (家塚 智子). 2011. "Muromachi Bunka to Dōhōshū." In *Biyō: Tokugawa Bijutsukan Ronshū (尾陽: 徳川美術館論集)* 7: 66–72.

Ihuel, Ewen. 2008. "Hoards and Flint Blades in Western France at the End of the Neolithic." In *Hoards from the Neolithic to the Metal Ages: Technical and Codified Practices, BAR International Series; 1758*, edited by Caroline Hamon and Benedicte Quilliec, 91–101. Oxford: Archaeopress.

Iida City Museum. 2017. Accessed May 13, 2017, http://www.iida-museum.org/

Iizuka, Yoshiyuki, Peter Bellwood, Hsia-chun Hung and Eusebio Z. Dizon. 2005. "A Non-destructive Mineralogical Study of Nephrite Artifacts from Itbayat Island, Batanes, Northern Philippines." *Journal of Austronesian Studies* 1(1): 83–107.

IMICRA (Inner Mongolian Institute of Cultural Relics and Archaeology). 2004. *Porcelain Unearthed from Jininglu Ancient City Site in Inner Mongolia*, edited by Yongzhi Chen. Beijing: Wen Wu Chu Ban She.

IMICRA and Baotou Shi Wen Wu Guan Li Chu. 2010. *Baotou Yanjialiang Yi Zhi Fa Jue Bao Gao* (包頭燕家梁遺址發掘報告 = The Excavation Report of Baotou Yangjialiang Relics), edited by La Ta, Haibin Zhang and Hongxing Zhang. Beijing: Ke Xue Chu Ban She.

Inoue, Masao (井上 正夫). 2006. "Nanchō Ki no Dōsen ni Kansuru Shogenshō ni Tsuite." In *Sōdai no Chōkō Ryūiki – Shakai Keizaishi no Shiten kara (宋代の長江流域 – 社会経済史の視点から)*, 211–229. Tōkyō: Kyūko Shoin.

Ishida, Masahiko (石田 雅彦). 2003. *'Cha no Yu' Zenshi no Kenkyū: Sōdai Hencha Bunka Kansei kara Nihon no Chanoyu e* (「茶の湯」前史の研究: 宋代片茶文化完成から日本の茶の湯へ). Tokyo: Yūzankaku.

Itokoku Rekishi Hakubutsukan (伊都國歷史博物館) and Kyūshū Rekishi Shiryōkan (九州歷史資料館) (eds.). 2016. *Kokkyō no Sangaku Shinkō: Sefuri Sankei no Seichi, Reiba o Meguru (国境の山岳信仰: 脊振山系の聖地・霊場を巡る)*. Itoshima: Itokoku Rekishi Hakubutsu Kan.

Jiang, Zhongyi (蔣 忠義). 1981. "Zhejiang Longquan Xian Anfu Longquan Yao Zhi Fa Jue Jian Bao." *Kao Gu* 1981(6): 504–510.

Jin, Weinuo (金 維諾), et al. (eds.). 2010. *Zhong Guo Mei Shu Quan Ji: Mu Shi Bi Hua (Er) (中國美術全集 墓室壁畫 二)*. Hefei: Huangshan Shushe.

Jin, Zuming (金 祖明). 1962. "Longquan Xikou Qing Ci Yao Zhi Diao Cha Ji Lüe." *Kao Ku* 1962(10): 535–538.

———. 2005. "Zhejiang Sheng Longquan Dong Qu Qing Ci Yao Zhi Diao Cha Bao Gao." *Journal of the Zhejiang Provincial Institute of Cultural Relics and Arcaheology,* 496–508. Hangzhou: Hangzhou Chu Ban She.

Jones, T. George and Robert D. Leonard. 1989. "The Concept of Diversity: an Introduction." In *Quantifying Diversity in Archaeology,* edited by Robert D. Leonard and George T. Jones, 1–3. Cambridge: Cambridge University Press.

JPICRA (Jiangxi Provincial Institute of Cultural Relics and Archaeology) and Jingdezhen Museum of Civilian Kiln. 2007. *Hutian Kiln Site in Jingdezhen: Report on Excavations from 1988 to 1999.* Beijing: Cultural Relics Press.

Kamakura Kōkogaku Kenkyūsho (鎌倉考古学研究所) (ed.). 1989. *Koto Kamakura no Maizō Bunkazai (古都鎌倉の埋蔵文化財): Kamakura Kototen: Koto Maizō Bunkazai Ten Zuroku.* Kamukura-shi: Kamakura-shi Chūō Kōminkan.

Kamei, Akinori (亀井 明徳). 2014. "Archaeological View of Longquan Celadon in the 12th Century." In *Researches in Chinese Ceramic History,* 453–473. Tokyo: Rokuichi Shobō.

Kanai, Madoka (金井 圓). 1962. *Hansei (藩政).* Tokyo: Shibundō.

Kawada, Sadamu (河田 貞). 1981. "Bokie nimiru Chōdo to Kibutsu." *Nihon no Bijutsu (日本の美術)* 187: 91–98.

Kerr, Rose. 2004. *Song Dynasty Ceramics.* London: V&A Publications.

Kingery, W. D. and Pamela B. Vandiver. 1983. "Song Dynasty Jun (Chün) Ware Glazes." *American Ceramic Society Bulletin* 62(11): 1269–1274.

Kinomiya, Yasuhiko (木宮 泰彦). 1927. *Nisshi Kōtsūshi (日支交通史).* Tōkyō: Kinshi Hōryūdō.

Kong, Qi (孔 齊). 1965. *Zhi Zheng Zhi Ji (至正直記).* Taipei: Yi Wen Yin Shu Guan.

Konoe, Iehiro (近衛 家熙). [1724–1735], 1977. *Kaiki (槐記),* In *Chadō Koten Zenshū (茶道古典全集)* (the third edition) vol. 5, edited by Sōshitsu Sen. Kyoto: Tankō Shisha.

Kopytoff, Igor. 1986. "The Cultural Biography of Things: Commoditization as Process." In *The Social Life of Things: Commodities in Cultural Perspective*, edited by Arjun Appadurai, 64–91. Cambridge: Cambridge University Press.

Koyama, Fujio (小山 富士夫). 1969. "Kinuta Seiji Sangite Hanaike." *Kobijutsu (古美術)* 28: 107–109.

Kuchiki, Yuriko (朽木 ゆり子). 2011. *Hausu Obu Yamanaka : Tōyō no Shihō o Ōbei ni Utta Bijutsushō (ハウス・オブ・ヤマナカ：東洋の至宝を欧米に売った美術商).* Tokyo: Shinchōsha.

Kyoto National Museum et al. (eds.). 1990. *Special Exhibition Sen-no Rikyū: the 400th Memorial.* Kyoto: Omotesenke, Urasenke, Mushanokōji Senke and The Mainichi Newspapers.

Lee, R. James. 2000. *Exploring the Gaps: Vital Links between Trade, Environment and Culture.* West Hartford, Connecticut: Kumarian Press.

Leeuw, S. E. Van Der. 1994. "Cognitive Aspects of 'Technique'." In *The Ancient Mind: Elements of Cognitive Archaeology,* edited by Colin Renfrew and Ezra B. W. Zubrow, 135–142. Cambridge: Cambridge University Press.

Li, Dejin (李 德金). 2004. "Nan Song Guan Yao yu Longquan Yao de Guan Xi (Relations between Southern Song Dynasty Guan Kiln and Longquan Kiln)." In *A Collection of Essays on Southern Song Dynasty Guan Kiln*, edited by Southern Song Dynasty Guan Kiln Museum, 110–122. Beijing: Cultural Relics Publishing House.

Li, Gang (李 剛). 1999. "Longquan Yao Duo Zui Ying Zhou Yi." *Dong Fang Bo Wu* 3: 129–134.

Li, Guozhen (李 國楨) and Hongming Ye (葉 宏明). 1989. "Longquan Qing Ci You de Yan Jiu (The Research of Longquan Celadon Glaze)." In *Longquan Qing Ci Yan Jiu* (龍泉青瓷研究 = The Research of Longquan Celadon), 146–170. Beijing: Wen Wu Chu Ban She.

Li, Huibing (李 輝柄). 1994. "Suining Jiao Cang Ci Qi Qian Yi." *Wen Wu* 1994(4): 29–31.

Li, Huibing. 1995. "Qin Hua Ci Qi de Qi Shi Nian Dai." In *Gu Gong Bo WuYuan Yuan Kan JianYuan Qi Shi Zhou NianJi Nian Te Kan* (故宮博物院院刊建院七十周年紀念特刊) : 63–71.

Li, Jiazhi (李 家治), Xianqiu Chen, Shiping Chen, Boqian Zhu and Chengda Ma. 1989. "Shang Lin Hu Li Dai Yue Ci Tai, You ji Qi Gong Yi de Yan Jiu." In *The 1989 International Symposium on Ancient Ceramics—Its Scientific and Technological Insights (ISAC'89)*, 336–344.

Li, Zhi-wen [Li, Zhi-yan ; 李 知宴]. 1982. "Development and Export of Longquan Celadon (龍泉青磁の發展と輸出)." *Trade Ceramics Studies* 2: 27–36.

Li, Zhiyan (李 知宴). 1981. "Zhejiang Longquan Celadon Shan Tou Yao Fa Jue de Zhu Yao Shou Huo." *Wen Wu* 1981(10): 36–42.

Li, Zhonghe (李 中和), Hongming Ye and Fugen Zhou. 1989. "Southern Song Guan Ware and Ge Ware Gu Ci de You Ceng Fen Xi (Analysis of the glaze of Southern Song Guan Ware and Ge Ware)." In *The 1989 International Symposium on Ancient Ceramics—Its Scientific and Technological Insights (ISAC'89),* edited by Jiazhi Li and Xianqiu Chen, 202–206. Shanghai: Shanghai Ke Xue Ji Shu Wen Xian Chu Ban She.

Li, Zuozhi (李 作智) and Zhiyan Li. 1986. "Zhejiang Longquan Qing Ci Shanyuaner Cun Yao Zhi Fa Jue Bao Gao (The Excavation Report of Shanyuaner Longquan Celadon Kiln Site in Zhejiang)." *Zhongguo Li Shi Bo Wu Guan Guan Kan (*中國歷史博物館館刊*)* 8: 43–72.

Lin, Shimin (林 士民). 1981. "Ningpo Dongmenkou Ma Tou Yi Zhi Fa Jue Bao Gao." In *Journal of the Zhejiang Provincial Institute of Archaeology*, 105–129. Beijing: Wen Wu Chu Ban Shi.

Lin, Shirong (林 世榮), Hailin Chen and Zhong Ji. 1994. *Longquan Xian Zhi*. Shanghai: Han Yu Da Ci Dian Chu Ban She.

Liu, Tao (劉 濤). 2004. "Longquan Yao." In *Song Liao Jin Ji Nian Ci Qi (*宋遼金紀年瓷器*)*. Beijing: Wen Wu Chu Ban She.

Loney, L. Helen. 2000. "Society and Technological Control: A Critical Review of Models of Technological Change in Ceramic Studies." *American Antiquity* 65(4): 646–668.

Lu, Rong (陸 容). 1968. *Shu Yuan Za Ji (*菽園雜記*)*, vol. 14. Taipei: Yi Wen Yin Shu Guan.

Lü, Haiping (呂 海萍). 2011. "Dongyuan Jinjiaoyi Shan Song Mu Chu Tu Wen Wu." *Dong Fang Bo Wu* 39: 5–14.

Masaki Art Museum. 2018. "About." Accessed January 13, 2018, http://masaki-art-museum.jp/

Matson, R. Frederick. 1965. "Ceramic Ecology: An Approach to the Study of the Early Cultures of the Near East." In *Ceramics and Man*, edited by Frederick R. Matson, 202–217. Chicago: Aldine Publishing Company.

Matsumoto, Kōichi (松本 浩一). 2006. *Sōdai no Dōkyō to Minkan Shinkō (*宋代の道教と民間信仰*)*. Tōkyō: Kyūko Shoin.

Mayuyama, Junkichi (繭山 順吉). 1991. *In Appreciation*. Tokyo: Junkichi Mayuyama.

Meng, Yuanlao (孟 元老). [1147], 1962. *Dong Jing Meng Hua Lu (東京夢華錄)*. Beijing: Zhong Hua Shu Ju.
Mesoudi, Alex. 2008. "The Experimental Study of Cultural Transmission and Its Potential for Explaining Archaeological Data." In *Cultural Transmission and Archaeology: Issues and Case Studies*, edited by Michael J. O'Brien, 91–101. Washington D.C.: SAA Press.
Mikasa, Keiko (三笠 景子). 2010. "Vase with Cylindrical Body." In *Heavenly Blue: Southern Song Celadon*, edited by Curatorial Division, Nezu Museum, 116. Tokyo: Nezu Museum.
Mino, Yutaka and Katherine R. Tsiang. 1986. *Ice and Green Clouds: Traditions of Chinese Celadon*. Indianapolis: Indianapolis Museum of Art and Indiana University Press.
Miura, Hiroyuki (三浦 周行). 1914. "Tenryūjisen ni Kansuru Shinkenkyū (天龍寺船に關する新研究)." *Rekishi Zasshi (史學雜誌)* 25(1): 1–40.
Miyazawa, Naho (宮澤 菜穗). 2013. "Kagahantei, Daishōjihantei, Toyamahantei ato Shutsudo no Bōeki Tōjiki ni Tsuite." In *Dai 34-kai Bōeki Toji Kenkyūkai Kenkyū Shūkai (第34回貿易陶磁研究會研究集會), "Kinsei Toshi Edo no Bōeki Tōjiki" Happyō Yōshi*, 75–80. Nihon Bōeki Tōji Kenkyūkai, September 2013.
Mori, Katsumi (森 克己). 1948. *Nissō Bōeki no Kenkyū (日宋貿易の研究)*. Tokyo: Kokuritsu Shoin.
———. 1950. *Nissō Bunka Kōryū no Shomondai (日宋文化交流の諸問題)*. Tokyo: Tōkō Shoin.
———. 2009. *Shinpen Mori Katsumi Chosakushū (新編森克己著作集), Dai 3-kan (vol. 3): Zokuzoku Nissō Bōeki no Kenkyū*. Tokyo: Bensei Shuppan.
Mori, Tatsuya (森 達也), Daisuke Tokudome, Tomoko Nagahisa and Shiho Yokoyama (eds.). 2012. *Longquan Ware: Chinese Celadon Beloved of the Japanese*. Yamaguchi: The Executive Committee of the Exhibition "Longquan Ware."
Mori, Tatsuya. 2012. "Ryūsenyō Seiji no Tenkai." In *Longquan Ware: Chinese Celadon Beloved of the Japanese*, edited by Tatsuya Mori, Daisuke Toludome, Tomoko Nagahisa and Shino Yokoyama, 4–8. Yamaguchi: The Executive Committee of the Exhibition "Longquan Ware."
———. 2013. "Nihon Shutsudo no Chūgoku Seiji." In *Proceedings of Forum on Ancient and Modern East Asian Celadon*, edited by Kuanyu Lin, 146–156. Taipei: New Taipei City Yingge Ceramics Museum.
Morimoto, Asako (森本 朝子). 2010. "Hakata to Kamakura Shutsudo no Ryūsenyō Seiji – 12-seiki Kōhan~14-seiki Zenhan no Tokushu Kikei no Tansaku –" In *Heavenly Blue: Southern Song Celadons*, edited by Curatorial Division, Nezu Museum, 131–136. Tokyo: Nezu Museum.
Morris, Ian. 1992. *Death-Ritual and Social Structure in Classical Antiquity*. Cambridge: Cambridge University Press.
Morisue, Yoshiaki (森末 義彰). 1966. "Jidai Kubun to Bunka no Tokushitsu." In *Zusetsu Nihon Bunkashi Taikei (図説日本文化史大系)*, vol. 7, edited by Kōta Kodama. Tōkyō: Shogakukan.
Mou, Yongkang (牟 永抗). 1981. "Jiangshan Xian Xiakou Sanjingkou Wanchang Diao Cha San Ji." In *Journal of the Zhejiang Provincial Institute of Cultural Relics and Archaeology*, edited by The Zhejiang Provincial Institute of Cultural Relics and Archaeology, 167–172. Beijing: Wen Wu Chu Ban She.
Mu-byŏng Yun, Korea (South), Munhwajae Kwalliguk (文化公報部, 韓國, 文化財管理局). 1981. *Sinan Haejŏ Yumul. Charyop'yŏn (新安海底遺物 資料篇 I)*. Seoul: Munhwa Kongbobu Munhwajae Kualliguk.

Museum of Fine Arts, Boston. 2018. Accessed Feburary 12, 2018, http://www.mfa.org/collections. (The Song painting, *Lady at Her Dressing Table in a Garden (靚妝仕女圖)* was painted by Su Hanchen (蘇漢臣), presenting a flower vase on the lady's dressing table.)

Naganuma, Kenkai (長沼 賢海) and Takeo Hashizume (橋詰 武生). 1952. "Chūsei no Dazaifu." In *Dazaifu Shōshi (太宰府小史)*, edited by Katsuya Takeoka, 91–189. Fukuoka-shi: Dazaifu Tenmangū.

Nakamura, Tsubasa (中村 翼). 2013. "Nichigen Bōekiki no Kaishō to Kamakura, Muromachi Bakufu – Jisha Zōeiryō Karabune no Relishi teki Ichi." ヒストリア 2013 (12): 93–121.

Neitzel, E. Jill. 1995. "Elite Styles in Hierarchically Organized Societies: The Chacoan Regional System." In *Style, Society, and Person: Archaeological and Ethnological Perspectives*, edited by Christopher Carr and Jill E. Neitzel, 393–417. New York and London: Plenum Press.

Nishida, Hiroko (西田 宏子). 2010. "Nansō no Ryūsenyō Seiji." In *Heavenly Blue: Southern Song Celadon*, edited by Curatorial Division, Nezu Museum, 9–17. Tokyo: Nezu Museum.

———. 2010. "Vase with Cylindrical Body." In *Heavenly Blue: Southern Song Celadon*, edited by Curatorial Division, Nezu Museum, 115–116. Tokyo: Nezu Museum.

———. 2010. "Vase with Ring Handles and Applied Peony Scroll Design." In *Heavenly Blue: Southern Song Celadon*, edited by Curatorial Division, Nezu Museum, 122–123. Tokyo: Nezu Museum.

———. 2010. "Mallet Shaped Vase with Phoenix-shaped Handles, Known as *Bansei*." In Heavenly Blue: Southern Song Celadon, edited by Curatorial Division, Nezu Museum, 117. Tokyo: Nezu Museum.

———. 2010. "Vase with Mallet Shape Body." In *Heavenly Blue: Southern Song Celadon*, edited by Curatorial Division, Nezu Museum, 115. Tokyo: Nezu Museum.

———. 2010. "Vase with Tall Neck." In *Heavenly Blue: Southern Song Celadon*, edited by Curatorial Division, Nezu Museum, 116. Tokyo: Nezu Museum.

Nishio, Kenryū (西尾 賢隆). 1999. *Chūsei no Nitchū Kōryū to Zenshū (中世の日中交流と禅宗)*. Tokyo: Yoshikawa Kōbunkan.

Norton, F. H. 1952. *Elements of Ceramics*. Cambridge: Addison-Wesley Press, Inc.

Okano, Tomohiko (岡野 智彦) (ed.). 2008. *Kirameki no Perushia Tōki : 11–14 seiki no Gijutsu Kakushin to Fukkō (煌(きら)めきのペルシア陶器：11–14世紀の技術革新と復興 = Brilliance of Persian Ceramics)*. Tokyo: Chūkintō Bunka Senta Hakubutsukan (The Museum of the Middle Eastern Culture Center in Japan).

Okumoto, Daisaburō (奥本 大三郎). 2005. *Tōkyō Bijutsu Kottō Hanjōki (東京美術骨董繁盛記)*. Tokyo: Chūō Kōron Shinsha.

Ōmiwa, Tatsuhiko (大三輪 龍彦) (ed.). 1983. *Chūsei Kamakura no Hakkutsu (中世鎌倉の発掘)*. Yokohama: Yūrindō.

Ono, Yoshihiro (尾野 善裕). 2012. "Seiji hōōmimi Hanaike." In *Ochō Bunka no Hana : Yōmei Bunko Meihōten : Kyūtei Kizoku Konoeke no Issennen: Tokubetsu Tenrankai (王朝文化の華: 陽明文庫名寶展: 宮廷貴族近衞家の一千年: 特別展覽会 = The Efflorescence of Heian Court Culture: Treasures from the Yōmei Bunko Collection)*, edited by Kyōto Kokuritsu Hakubutsukan. Tokyo: NHK.

Orio, Manabu (折尾 学), Joji Ikesaki and Asako Morimoto. 1984. "Chūsei no Hakata—Hakkutsu Chōsa no Seika Kara." In *Kodai no Hakata (古代乃博多)*, written by Heijirō Nakayama and edited by Takashi Okazaki, 320–364. Fukuoka-shi: Kyūshū Daigaku.

Ozaki, Nobumori (尾崎 洵盛). 1932. "Ryūsenyōshi no Chōsa Hōkoku ni Tsukite (2) (龍泉窯址の調査報告につきて(二))." *Tō Ji (陶磁)* 4(2): 1–32.

———. 1933. "Kayō no Kōro Sonota (哥窯の香爐其他)." *Tō Ji* 5(5): 1–22.

Palace Museum (ed.). 1998. *A Contrast between Genuine and Fake Porcelain and the Porcelain Specimens from Ancient Kiln Sites Collected in the Palace Museum (Pictorial Album)*. Beijing: Forbidden City Publishing House.

Palmgren, Nils. 1963. "The Golden Age of Ceramics." In *Sung Sherds*, edited by David Westman, 15–380. Stockholm: Almqvist & Wiksell.

Plog, Stephen. 1995. "Approaches to Style: Complements and Contrasts." In *Style, Society, and Person: Archaeological and Ethnological Perspectives*, edited by Christopher Carr and Jill E. Neitzel, 369–387. New York and London: Plenum Press.

Quanzhou Wan Song Dai Hai Chuan Fa Jue Bao Gao Bian Xie Zu (泉州灣宋代海船發掘報告編寫組). 1975. "Quanzhou Wan Song Dai Hai Chuan Fa Jue Jian Bao." *Wen Wu* 1975(10): 1–18.

Rakita, F. M. Gordon. 2009. *Ancestors and Elites: Emergent Complexity and Ritual Practices in the Casas Grandes Polity*. Lanham: Altamira Press, a Dicision of Rowman & Littlefield Publishers, InC.

Ren, Shilong (任 世龍). 1981. "Shantouyao yu Dabaian: Longquan Dong Qu Yao Zhi Fa Jue Bao Gao Zhi Yi." In *Journal of the Zhejiang Provincial Institute of Cultural Relics and Archaeology*, edited by The Zhejiang Provincial Institute of Cultural Relics and Archaeology, 130–166. Beijing: Wen Wu Chu Ban She.

Rice, M. Prudence et al. 1981. "Evolution of Specialized Pottery Production: A Trial Model." *Current Anthropology* 22(3): 219–240.

Rice, M. Prudence. 1984. "Change and Conservatism in Pottery Producing Systems." In *The Many Dimensions of Pottery: Ceramics in Archaeology and Anthropology*, edited by Sander E. Van Der Leeuw and Alison C. Pritchard, 233–288. Amsterdam: Universiteit van Amsterdam.

Robertson, Pamela. 1998. "New Brand Development." In *Brands: the New Wealth Creators*, edited by Susannah Hart & John Murphy, 24–33. New York: New York University Press.

Saitō, Shinichi (斎藤 慎一). 2015. *The Exhibition of Tokugawa's Castles (徳川の城)*. Tokyo: Tōkyōto Edo Tōkyō Hakubutsukan.

Saitō, Yasuhiko (斎藤 康彦). 2014. *Nezu Seizan: "Tetsudōō" Kaichirō no Chanoyu (根津青山:「鉄道王」嘉一郎の茶の湯)*. Kyōto: Miyaobi Shuppansha.

Sakamoto. Goro (坂本 五郎). 1998. *Hitokoe Senryo: Odoroki Momonoki,Watakushi no Rirekisho (ひと声千両: おどろ木桃の木, 私の履歴書)*. Tokyo: Nihon Keizai Shinbunsha.

Salman, S. M. and S. N. Salama. 1985. "Thermal Expansion Data of Some Alkali Aluminosilicate Glasses and Their Respective Glass-Ceramics." *Thermochimica Acta* 90: 261–276.

Sasaki, Ginya (佐佐木 銀弥). 1981. *Nihon Shōnin no Genryū: Chūsei no Shōnintachi (日本商人の源流―中世の商人たち)*. Tokyo: Kyōikusha.

Sasaki, Tatsuo. 1994. "Trade Patterns of Zhejiang Wares Found in West Asia." In *New Light on Chinese Yue and Longquan Wares: Archaeological Ceramics Found in Eastern and Southern Asia, A.D. 800–1400*, edited by Chuimei Ho, 322–332. Hong Kong: Center of Asian Studies University of Hong Kong.

Sato, Sarah. 2015. *Kamakura to Seiji: Tokiwayama Bunko Meihinten, 2015*. Tokyo: Tokywayama Bunko Foundation.

Schiffer, Brian Michael and James M. Skibo. 1997. "The Explanation of Artifact Variability." *American Antiquity* 62(1): 27–50.

Schurecht, H. G. and D. H. Fuller. 1931. "Some Effects of Thermal Shock in Causing Crazing of Glazed Ceramic Ware." In *The Annual Meeting, American Ceramic Society, Cleveland, Ohi,* 565–571.

Schurecht, H. G. and G. R. Polk. 1932. "Some Special Types of Crazing." In *The Annual Meeting, American Ceramic Society, Washington, D.C.*, 632–637.

Sen, Sōshitsu (千 宗室) (ed.). 1977. *Chadō Koten Zenshū (the third edition)*. Kyoto: Tankōsha.

Shen, Lingxin (沈 令昕) and Yongxiang Xu (許 勇翔). 1982. "Shanghai Shi Qingpu Xian Yuan Dai Ren Shi Mu Zang Ji Shu." *Wen Wu* 1982(7): 54–60.

Shen, Qionghua (沈 瓊華) (ed.). 2012. *Sailing from the Great Yuan Dynasty: Relics Excavated from the Sinan Shipwreck (大元帆影: 韓國新安沉船出水文物精華)*. Beijing: Wen Wu Chu Ban She.

Shen, Yiping (沈 一萍). 2009. "San Guo Xi Jin Qing Ci Dui Su Guan de Shu Xing Gai Shu." *Dong Fang Bo Wu* 30: 64–69.

Shen, Yueming (沈 岳明). 2009. "Fengdongyan Yao Zhi Fa Jue de Zhu Yao Shou Huo han Chu Bu Ren Shi." In *Longquan Dayao Fengdongyan Yao Zhi Chu Tu Ci Qi* (龍泉大窯楓洞岩窯址出土瓷器), edited by Zhejiang Provincial Culture and Archaeology Institute et al., 1–10. Beijing: Wen Wu Chu Ban She.

Shiba, Kentarō (柴 謙太郎). 1932. "Kamakura Bakufu no Kengaisen Kenchōjisen ni Tsuite: Toku ni nochi no Tenryūjisen Haken Keikaku tono Myakuraku. " *Rekishi Chiri (歷史地理)* 59(4): 329–354.

Shiba, Yoshinobu (斯波 義信). 1968. *Sōdai Shōgyōshi Kenkyū (宋代商業史研究 = Commercial Activities during the Sung Dynasty)*. Tokyo: Kazama Shobō.

———. 1988. *Sōdai Kōnan Keizaishi no Kenkyū (宋代江南経済史の研究 = Studies in the Economy of the Lower Yangtze in the Sung)*. Tokyo: Kyūko Shoin.

Shibudō (至文堂) and Kokuritsu Bunkazai Kikō (國立文化財機構) (eds.). 1981. *Boki Ekotoba (慕歸繪詞)*. Tokyo: Gyōsei.

Shimao, Arata (島尾 新). 2011. "Muromachi Jidai no Bijutsu Shisutemu: Higahiyama Gyobutsu no Sekai." *Biyō: Tokugawa Bijutsukan Ronshū* 7: 73–79.

Shimura, Kazujirō (志村 和次郎). 2011. *Fugō e no Michi to Bijutsu Korekushon : Ishingo no Jigyōka, Bunkajin no Kiseki (富豪への道と美術コレクション:維新後の事業家・文化人の軌跡)*. Tokyo: Yumani Shobō.

Shinshōsai, Shunkei (真松齋 春溪). 1971. *Bunrui Sōjinboku (分類草人木)*, translated by Kiyoshi Yokoi (橫井 清). In Nihon no Chasho (日本の茶書) 1, Tōyō Bunko; 201, edited by Hayashiya Tatsusaburō et al. Tokyo: Heibonsha.

Shiraishi, Ichirō (白石 一郎). 1973. *Hakata Rekishi Sanpo: Nisen Nen no Ayumi (博多歷史散步: 二千年のあゆみ)*. Tokyo: Sōgensha.

Sichuan Sheng Wen Wu Guan Li Wei Yuan Hui. 1987. "Sichuan Jianyang Dongxi Yuanyichang Yuan Mu." *Wen Wu* 1987(2): 70–87.

Simmel, Georg. 1978. *The Philosophy of Money*, translated by Tom Bottomore and David Frisby. London: Routledge & Kegan Paul.

Song, Lian (宋 濂) et al. 1976. *Yuan Shi (元史)*. Beijing: Zhong Hua Shu Ju.

Song, Zijun (宋 子軍) and Ding Liu (劉 鼎). 2015. "Zhejiang Songyang Song Mu Chu Tu Ci Qi (Some Ceramics excavated from Song Tombs in Songyang, Zhejiang)." *Wen Wu* 2015(7): 80–88.

SPCRARI (Sichuan Provincial Cultural Relics and Archaeology Research Institute) and Emeishan Shi Wen Wu Guan Li Suo. 2003. "Emeishan Shi Luomu Zhen Song Dai Jiao Cang Fa Jue Jian Bao." *Sichuan Wen Wu* 2003(1): 11–21.

SPCRARI, Chongqing Shi Wen Hua Ju Sanxia Ban and Zhong Xian Wen Wu Guan Li Suo. 2001. "Zhong Xian Zhong Bei Yi Zhi Song Dai Ci Qi Jiao Cang Fa Jue Jian Bao." *Sichuan Wen Wu* 2001(2): 79–80.

Srisuchat, Amara. 1994. "Discovering Chinese Yue and Longquan Green Glaze Wares and Reconsidering Their Socio-economic Roles in the Development of Ancient Communities in Thailand." In *New Light on Chinese Yue and Longquan Wares: Archaeological Ceramics Found in Eastern and Southern Asia, A.D. 800–1400*, edited by Chuimei Ho, 213–228. Hong Kong: Center of Asian Studies University of Hong Kong.

Stark, Miriam T., Brenda J. Bowser and Lee Horne. 2008. "Why Breaking Down Boundaries Matters for Archaeological Research on Learning and Cultural Transmission." In *Cultural Transmission and Material Culture: Breaking Down Boundaries*, edited by Miriam T. Stark, Brenda J. Bowser and Lee Horne, 1–16. Tucson: The University of Arizona Press.

Steger, Walter F. 1963. "Ceramic Study of Sung Ceramics." In *Sung Sherds,* edited by David Westman, 451–505. Stockholm: Almqvist & Wiksell.

Su, Bai (宿 白). 1957. *Bai Sha Song Mu (白沙宋墓)*. Beijing: Wen Wu Chu Ban She.

Su, Yulong (蘇 遇龍) and Guanghou Shen (沈 光厚) (eds.). [1863], 1984. *Longquan Xian Zhi (2),* In *Zhong Guo Fang Zhi Cong Shu (中國方志叢書)*. Taipei: Cheng Wen Chu Ban She.

Suganami, Masato (菅波 正人). 2008. "Haka." In *Chūsei Toshi: Hakata o Horu (中世都市: 博多を掘る),* edited by Yasutoki Ōba et al., 240–243. Fukuoka-shi: Kaichōsha.

Sun, Ji (孫 機). 1986. "Mojie Deng." *Wen Wu* 1986(12): 74–78.

Sun, Weichang (孫 維昌) and Jinxing Zheng (鄭 金星). 1986. "Zhejiang Longquan Anrenkou Gu Ci Yao Zhi Fa Jue Bao Gao." *Shanghai Bo Wu Guan Ji Kan (上海博物館集刊)* 3: 102–132.

Sun, Xingyan (孫 星衍). [1815], 1967. *Shang Shu Jin Gu Wen Zhu Shu (尚書今古文注疏)*. Taipei: Shang Wu Yin Shu Guan.

Sundius, Nils. 1963. "Microscopic and Chemical Investigation." In *Sung Sherds*, edited by David Westman, 381–450. Stockholm: Almqvist & Wiksell.

Takemoto, Chizuru (竹本 千鶴). 2014. "Chanoyu to Chadōgu: 1300-nen no Ayumi." In *Bunka o Henshū Suru Manazashi : Shūshū, Tenji, Seisaku no Rekishi (文化を編集するまなざし: 蒐集・展示・制作の歴史)*, edited by Tomohiro Nomura, 63–97. Tōkyō: Kyōto Zōkei Geijutsu Daigaku Tōhoku Geijutsu Kōka Daigaku Shuppankyoku Geijutsu Gakusha.

Takeuchi, Makoto (竹内 誠). 1993. *Edo to Ōsaka (江戸と大坂)*. *Taikei Nihon no Rekishi (大系日本の歴史), 10.* Tokyo: Shōgakukan.

Tamamuro, Taijyō (圭室 諦成). 1937. "Zen to Nihon Bunka." *Risō (理想)* 75: 80–90.

Tampoe, Moira. 1989. *Maritime Trade between China and the West: An Archaeological Study of the Ceramics from Siraf (Persian Gulf), 8th to 15th Centuries A. D. (BAR International Series 555).* Oxford: B. A. R.

Tanaka, Ichimatsu (田中 一松). 1977. "Shoki Suibokuga no Gaikyō: Jyoshō." In *Kaō; Mokuan; Minchō (可翁・默庵・明兆),* edited by Ichimatsu Tanaka, 38–44. Tokyo: Kōdansha.

Tanaka, Katsuko (田中 克子) and Ichirō Satō (佐藤 一郎). 2008. "Bōeki Tōjiki no Suii." In *Chūsei Toshi: Hakata o Horu,* edited by Yasutoki Ōba et al., 112–128. Fukuoka-shi: Kaichōsha.

Tang, Junjie (唐 俊杰). 2004. "A Comparative Research on Southern Song Dynasty Jiaotanxia Kiln and Laohudong Kiln." In *A Collection of Essays on Southern Song*

Dynasty Guan Kiln, edited by Southern Song Dynasty Guan Kiln Museum, 168–199. Beijing: Cultural Relics Publishing House.

Tian, Xiu (天 秀). 1982. "Ren Renfa de Sheng Nian Ying Dang Gai Zheng." *Wen Wu* 1982(7): 53.

Tichane, Robert. 1978. *Those Celadon Blues,* 45–58. New York: Elmira Quality Printers, Inc.

Tite, M. S., I. C. Freestone and M. Bimson. 1984. "A Technological Study of Chinese Porcelain of the Yuan Dyansty." *Archaeometry* 26(2): 139–154.

Tite, M. S., I. C. Freestone and N. Wood. 2012. "An Investigation into the Relationship between the Raw Materials Used in the Production of Chinese Porcelain and Stoneware Bodies and the Resulting Microstructures." *Archaeometry* 54(1): 37–55.

Tokudome, Daisuke (德留 大輔). 2012. "Ryūsenyō Seiji no Aratana Hakken." *Tōsetsu (陶說)* 712: 32–42.

Tokudome, Daisuke and Shino Yokoyama (横山志野). 2012. "Appendixes." In *Longquan Ware: Chinese Celadon Beloved of the Japanese,* edited by Tatsuya Mori, Daisuke Tokudome, Tomoko Nagahisa and Shino Yokoyama. Yamaguchi: The Executive Committee of The Exhibition "Longquan Ware."

Tokyo National Museum. 2018. *Kanpūzu Byōbu (観楓図屏風)* Maple-viewing painting. Accessed February 23, 2018. http://www.tnm.jp/modules/r_collection/index.php?controller=other_img&size=L&colid=A10470&img_id=5&t=

Tong, Tao (仝 濤). 2004. "Wu Lian Guan han Hun Ping de Xing Tai Xue Fen Xi (An Typological Analysis of the Five-linked Jar and Hun Ping, Soul Jar)." *Kao Gu yu Wen Wu (考古與文物)* 2004(2): 54–63.

Tregear, Mary. 1982. *Song Ceramics.* New York: Rizzoli.

Trodd, Colin. 2000. "Representing the Victorian Royal Academy: the Properties of Culture and the Promotion of Art." In *Governing Cultures: Art Institutions in Victorian London,* edited by Paul Barlow and Colin Trodd, 56–68. Burlington, VT: Ashgate.

Ts'ai, Ho-pi (蔡 和璧) (ed.). 1989. *Catalogue of the Special Exhibition of Sung Dynasty Kuan Ware (宋官窯特展).* Taipei: National Palace Museum.

Tsai, Mei-fen (蔡 玫芬) (ed.). 2009. *Bilǜ: Ming Dai Longquan Yao Qing Ci (碧綠: 明代龍泉窯青瓷* = Green: Longquan Celadon of the Ming Dynasty). Taipei: National Palace Museum.

Tsuji, Zennosuke (辻 善之助). 1942. *Zōtei Kaigai Kōtsū Shiwa (增訂海外交通史話).* Tokyo: Naigai Shoseki Kabushiki Kaisha.

Tuo, Tuo (脫 脫) et al. 1977. *Song Shi (宋史)* Zhi (志) 165. Beijing: Zhong Hua Shu Ju.

Uhlmann, R. D. 1972. "A Kinetic Treatment of Glass Formation." *Journal of Non-Crystalline Solids* 7: 337–348.

Vandiver, B. Pamela and D. W. Kingery. 1984. "Composition and Structure of Chinese Song Dynasty Celadon Glaze from Longquan." *American Ceramic Society Bulletin* 63(4): 612–616.

Vandiver, Pamela and David W. Kingery. 1985. "Variations in the Microstructure and Microcomposition of Pre-Song, Song, and Yuan Dynasty Ceramics." In *Ancient Technology to Modern Science, Ceramics and Civilization,* vol. 1, edited by D. W. Kingery, 181–227. Columbus, OH: The American Ceramic Society.

Van Pool, S. Christine. 2008. "Agents and Cultural Transmission." In *Cultural Transmission and Archaeology: Issues and Case Studies,* edited by Michael J. O'Brien, 190–200. Washington D.C.: SAA Press.

Victoria and Albert Musuem. 2018. "Collections." Accessed January 13, 2018, https://www.vam.ac.uk/

W., G. B. 1944. "Potteries That Are Like Landscapes." *Museum Notes* (Museum of Art, Rhode Island School of Design, Providence) 2(5): 1–2.

Wada, Sei (和田 清) and Michihiro Ishihara (石原 道博) (eds.). 1958. *Kyū Tōsho Wakoku Nihon den; Sōshi Nihon den; Genshi Nihon den (舊唐書倭國日本傳・宋史日本傳・元史日本傳)*. Tokyo: Iwanami Shoten.

Wiessner, Polly. 1985. "Style or Isochrestic Variation? a Reply to Sackett." *American Antiquity* 50(1): 160–166.

Wikipedia. 2017. "Ryōsen-ji Ato." Accessed February 14, 2017, http://ja.wikipedia.org/wiki

Wikipedia. 2018. "Hōmeishu." Accessed January 13, 2018, https://ja.wikipedia.org/wiki/%E4%BF%9D%E5%91%BD%E9%85%92

Williams, Bryn. 2010. "Foreign Objects with Domestic Meanings: The Feast of Lanterns and the Point Alones Village." In *Trade and Exchange: Archaeological Studies from History and Prehistory*, edited by C. D. Dillian and C. L. White, 149–163. LLC: Springer Science+Business Media.

Wilson, Shelagh. 2000. "The Highest Art for the Lowest People': the Whitechapel and Other Philanthropic Art Galleries, 1877–1901." In *Governing Cultures: Art Institutions in Victorian London*, edited by Paul Barlow and Colin Trodd, 172–186. Burlington, VT: Ashgate.

Wu, Donghai (吳 東海) and Jufen Guan (管 菊芬). 2007. "Zhejiang Lishui Nansong Ji Nian Mu Chu Tu de Longquan Yao Jing Pin Ci." *Dong Fang Bo Wu* 23: 37–40.

Wu, Juan (吳 雋), Junming Wu (吳 軍明), Qijiang Li, Yaoyuan Huang, Weidong Li, Haisheng Wang and Jiazhi Li. 2009. "Studies on the Composition and Microstructure of Yue Ware, Longquan Ware and Southern-Song Guan Ware." In *The 2009 International Symposium on Ancient Ceramics—Its Scientific and Technological Insights (ISAC' 09)* 206–217.

Wu, Songdi (吳 松弟). 2006. "Ryō, Sō, Kin, Gen Jidai no Chūgoku ni Okeru Nanboku Jinkō Hatten no Jūdaina Fukinkō to Sono Sōkan Mondai." In *Sōdai no Chōkō Ryūiki – Shakai Keizaishi no Shiten Kara*, translated by Takatoshi Endō, 273–296. Tōkyō: Kūko Shoin.

Wu, Zimu (吳 自牧). 1962. *Meng Liang Lu (夢梁錄)*. In *Dong Jing Meng Hua Lu (Wai Si Zhong)*, vol. 20. Beijing: Zhong Hua Shu Ju.

Xi'an Municipal Institute of Archaeology and Conservation of Cultural Relics. 2004. *Fresco Tomb of Yuan Dynasty at Hansenzhai of Xi'an* (西安韓森寨元代壁畫墓). Beijing: Cultural Relics Publishing House.

Xu, Mengxin (徐 夢莘). [1194], 1976. *San Chao Bei Meng Hui Bian* (三朝北盟會編) vol. 180, edited by Wang Yunwu. In *Si ku Quan Shu Zhen Ben (四庫全書珍本)*, series 6. Taipei: Taiwan Shang Wu Yin Shu Quan.

Xu, Song (徐 松) and Yuanan Chen (陳 援庵) (eds.). 1964. *Song Hui Yao Ji Gao (宋會要輯稿)*, Zhiguan (職官) 29. Taipei: Shi Jie Shu Ju.

Xu, Xuelin (徐 學琳). 2007. "Yuan Ming Longquan Qing Ci de Ruo Gan Wen Ti." *Dong Fang Bo Wu* 23: 26–36.

Yamamoto, Masako (山本 真紗子). 2008. "Yamanaka & Company: Outline of Ventures before Overseas Activities (美術商山中商会: 海外進出以前の活動をめぐって)." *Core Ethics* 4: 371–382.

Yang, Guanfu (楊 冠富). 1999. "Longquan Ci Qi Wu Guan Ping Tan (Longquan Celadon Five-tube Vase)." *Dong Fang Bo Wu* 3: 113–120.

Yang, Houli (楊 后禮). 1991. "Tan Jingdezhen Fang Longquan Qing Ci." *Jiangxi Wen Wu (江西文物)* 1991(4): 78–79.

———. 1992. "Jiangxi Song Yuan Ji Nian Mu Chu Tu Dui Su Chang Jing Ping Yan Jiu." *Nan Fang Wen Wu (南方文物)* 1992(1): 87–99.

Yang, Meili. 2016. "Technological Variations and the Artist's Intention: A Case Study of Chinese Southern Song Guan Imperial Ware." In *Art, Archaeology & Science: An Interdisciplinary Approach to Chinese Archaeological and Artistic Materials*, 91–105. Brighton: Sussex Academic Press.

———. 2016. "Beyond Cross-technology: A Case Study of Chinese Song Imperial Ru in Jun Glaze." In *Art, Archaeology & Science: An Interdisciplinary Approach to Chinese Archaeological and Artistic Materials*, 141–155. Brighton: Sussex Academic Press.

———. 2016. "Qinghe and Song Shards: Rethinking Palmgren's Scientific Investigation in Pre-war China." In *Art, Archaeology & Science: An Interdisciplinary Approach to Chinese Archaeological and Artistic Materials*, 57–75. Brighton: Sussex Academic Press.

Yang, M.-L., J. I. Katz, J. Barton, W.-L. Lai and Jau-ho Jean. 2015. "Using Optical Coherence Tomography to Examine Additives in Chinese Song Jun Glaze." *Archaeometry* 57(5): 837–855.

Yang, Meili, Amy M. Winkler, Justin Klein and Jennifer K. Barton. 2012. "Using Optical Coherence Tomography to Characterize Thick-glaze Structure: Chinese Southern Song Guan Glaze Case Study." *Studies in Conservation* 57(2): 67–75.

Yang, M.-L., Amy M. Winkler, Jennifer K. Barton and Pamela B. Vandiver. 2009. "Using Optical Coherence Tomography to Examine the Subsurface Morphology of Chinese Glazes." *Archaeometry* 51(5): 808–821.

Yano, Tamaki (矢野 環). 2000. *Kundaikan Sōchōki no Sōgō Kenkyū : Chakakō no Genten : Edo Shoki Ryūei Gomotsu no Kettei (君台觀左右帳記の綜合研究: 茶華香の原点: 江戶初期柳營御物の決定)*. Tokyo: Bensei Shuppan.

Yap, C. T. and Younan Hua. 1989. "Chinese Eight Famous Celadon: Yue, Longquan, Southern Song Guan, Ru, Linru, Jun, Yao and Ge Wares." In *The 1989 International Symposium on Ancient Ceramics—Its Scientific and Technological Insights (ISAC'89)*, edited by Jiazhi Li and Xianqiu Chen, 164–171. Shanghai: Shanghai Ke Xue Ji Shu Wen Xian Chu Ban She.

Yomiuri Shinbun, Seibu Honsha (読売新聞西部本社) (ed.). 2004. *Hakata Shōnin: Kōrokan Kara Gendai Made(博多商人：鴻臚館から現代まで)*. Fukuoka-shi: Kaichōsha.

Yu, Wenbao (俞 文豹). 1981. *Chui Jian Lu Wai Ji (吹劍錄外集)*. Taipei: Taiwan Shang Wu Yin Shu Guan.

Zhang, Bai (張 柏) (ed.). 2008. *Zhongguo Chu Tu Ci Qi Quan Ji (中國出土瓷器全集 = Complete Collection of Ceramic Art Unearthed in China)* 9. Beijing: Ke Xue Chu Ban She.

Zhang, Changshou (張 長 壽). 2007. 'Architectural Remains and Bronze Hoards at Zhouyuan, Shaanxi.' In *Treatises on Chinese Archaeology in the Shang and Zhou Periods*, 104–109. Beijing: Cultural Relics Press.

Zhang, Qiming (張 啟明). 1984. "Sichuan Langzhang Xian Chu Tu Song Dai Jiao Cang." *Wen Wu* 1984(7): 85–90.

Zhang, Qiuhua (張 秋華). 2011. "An Ji Zhi Shan Si Chu Tu de Yuan Dai Longquan Qing Ci Qi." *Dong Fang Bo Wu* 40: 59–65.

Zhang, Xiang (張 翔). 1989. "Longquan Jincun Gu Ci Zhi Diao Cha Fa Jue Bao Gao (The Investigation and Excavation Report of Longquan Jincun Kiln Site)." In *Longquan Qing Ci Yan Jiu* (The Research of Longquan Celadon), edited by Zhejiang Sheng Qing Gong Ye Ting, 68–91. Beijing: Wen Wu Chu Ban She.

Zhang, Xuefeng (張 學鋒). 2009. *The History of Chinese Tombs (中國墓葬史)*. Yangzhou Shi: Guang Ling Shu She.

Zhang, Yulan (張 玉蘭). 1990. "Hangzhou Shi Fa Xian Yuan Dai Xian Yu Shu Mu." *Wen Wu* 1990(9): 22–25.

Zhejiang Longquan Xian Tu Shu Guan Wen Wu Guan Li Xiao Zu (浙江龍泉縣圖書館文物管理小組). 1979. "Longquan Xin Chu Tu de San Jian Bei Song Zao Qi Qing Ci Qi (Three Pieces of the Early Northern Song Longquan Celadon Objects)." *Wen Wu* 1979(11): 95.

Zhejiang Provincial Museum (ed.). 2000. *Zhejiang Ji Nian Ci (浙江紀年瓷)*. Beijing: Wen Wu Chu Ban She.

Zheng, Jianming (鄭 建明) and Yi Lin (林 毅). 2015. "Changxing Shiquan Ming Mu Chu Tu 'Chuan Shi Ge Yao' Xing Ci Wu ji Xiang Guan Wen Ti Lüe Lun." *Wen Wu* 2015(7): 69–79.

Zhou, Lili (周 麗麗). 2013. " You Guan Longquan Yao Liang Ge Wen Ti de Zai Ren Shi (Two Issues Related to Longquan Ware)." In *Longquan Yao Ci Qi Yan Jiu (龍泉窯瓷器研究 = The Research of Porcelain of Longquan Kiln)*, edited by Zhongguo Gu Tao Ci Xue Hui, 15–29. Beijing: Gu Gong Chu Ban She.

Zhou, Ren (周 仁), Fukang Zhang and Yongpu Zheng. 1989. "Longquan Li Dai Qing Ci Shao Zhi Gong Yi de Ke Xue Zong Jie (The Brief History of Longquan Manufacturing Technology)." In *Longquan Qing Ci Yan Jiu* (The Research of Longquan Celadon), 102–132. Beijing: Wen Wu Chu Ban She.

Zhu, Boqian (朱 伯謙). 1989. "Longquan Da Yao Gu Ci Yao Yi Zhi Fa Jue Bao Gao (The Excavation of Longquan Dayao Kiln Site)." In *Longquan Qing Ci Yan Jiu* (The Research of Longquan Celadon), edited by Zhejiang Sheng Qing Gong Ye Ting, 38–67. Beijing: Wen Wu Chu Ban She.

———. 1998. "Longquan Qing Ci Gai Shu (Introduction to Longquan Celdon)." In *Longquan Yao Qing Ci (龍泉窯青瓷 = Celadons from Longquan Kilns)*, 6–23. Taipei: Yi Shu Jia Chu Ban She.

——— (ed.). 1998. *Longquan Yao Qing Ci* (Celadons from Longquan Kilns). Taipei: Yi Shu Jia Chu Ban She.

Zhu, Boqian and Shilun Wang (王 士倫). 1963. "Zhejiang Sheng Longquan Qing Ci Yao Zhi Diao Cha Fa Jue de Zhu Yao Shou Huo (The Investigation of Longquan Celadon Kilns Sites, Zhejiang Province)." *Wen Wu* 1963(1): 27–39.

Zhu, Xi (朱 熹) (author), Wang Youheng (汪 右衡) (identifier). 1997. *Zhu Zi Jia Li (朱子家禮)* (microfilm). Taipei: National Taiwan University Library.

Zhuo, Shangjun (卓 尚軍), Shen Ruxiang, Chen Shiping et al. 2005. " Chemical Composition Comparison of Porcelain Sherds Collected from Xishan and Longquan Districts Kiln Sites." In *The 2005 International Symposium on Ancient Ceramics—Its Scientific and Technological Insights (ISAC'05)*, 224–232.

Zhuzhou Shi Wen Wu Guan Li Chu (株洲市文物管理處). 1999. "Hunan Xiao Xian Chu Tu Longquan Celadon." *Hunan Kao Gu Ji Kan (湖南考古輯刊)* 7: 150–152.

Zokutōan Keidai Iseki Hakkutsu Chōsadan (続燈庵境内遺跡発掘調査団). 1990. *Engakuji Zokutōan: Maizō Bunkazai Hakkutsu Chōsa Hōkoku (円覚寺続燈庵：埋蔵文化財発掘調査報告)*. Kamakura: Zokutōan Keidai Iseki Hakkutsu Chōsadan.

ZPICRA (Zhejiang Provincial Institute of Cultural Relics and Archaeology) and Commission for Preservation of Ancient Monuments, Qinguyuan County. 2015. "The Excavation of the Couple of Hu Hong of the Southern Song Dynasty at Huixi Village in Qingyuan County, Zhejiang." *Wen Wu* 2015(7): 31–52.

ZPICRA. 2005. *Longquan Dong Qu Yao Zhi Fa Jue Bao Gao* (龍泉東區窯址發掘報告 = *The Excavation Report of Longquan Eastern Area Kiln Site*). Beijing: Wen Wu Chu Ban She.

ZPICRA, School of Archaeology and Museology in Peking University and Longquan Qing Ci Museum. 2009. *Longquan Dayao Fengdongyan Yao Zhi Chu Tu Ci Qi* (龍泉大窯楓洞岩窯址出土瓷器). Beijing: Wen Wu Chu Ban She.

ZPICRA, School of Archaeology and Museology, Beijing University and Longquan Celadon Museum. 2015. *Dayao Fengdongyan Kiln Site in Longquan*. Beijing: Cultural Relics Press.

Chronology

China

- 1912
- Qing
- 1644
- Ming
- 1368
- Yuan
- 1278
- Southern Song
- 1127
- Northern Song
- 960

Japan

- 1912 — Meiji
- 1868
- Edo (1603-1868)
- 1603
- 1573
- Sengoku (1467-1603)
- Muromachi (1392-1573)
- 1392
- Nanboku-chō (1334-1392)
- 1333
- Kamakura (1192-1333)
- 1192
- Heian (794-1185)

Index

abbots 96
Aichi Prefectural Ceramic Museum (Seto-shi) 123
analytical techniques xvii, 21–23, 58
Anfu kiln (Zhejiang) 59–60, 67
animal motif décor 19, 147
animal motifs 7
Anji site (Zhejiang) 80
anorthite ix, 26, 30, 55, 155, 167, 170, 176, 185, 191, 199
Anrenkou kiln (Zhejiang) 67
Anyang (Henan) viii, 12, 17
Aotou kiln (Zhejiang) 23, 151
Aoyama Clan 125
Appadurai, Arjun, 1949– 34
Archaeology of Longquan Kiln Sites 22, 30, 60–61
Arnold, Dean E., 1942– 59
Arnold, III. Philip J. 61
art mainstream 45
artifact style 72
Ashida River (Fukuyama, Hiroshima) 106
Ashikaga family 104–105
Ashikaga Shogunate 105, 121, 138
Ashikaga, Yoshimasa, 1436–1490 104
Ashikaga, Yoshimitsu, 1358–1408 104, 132

Baduhe (Lüeyang, Shaanxi) 36–37
Bai Juyi 125, 149

bamboo nodes design xiv, 119, 121, 132, 143, 145, 149
ban on luxury goods 34, 45
Bansei (ten thousand voice) 124–125, 149
barn jar vii, x, 5–10, 50, 147
barn jar, five tube vii, x, 5–6, 8–10, 42, 50, 147
barn jar, seven tube vii, 6, 8
biological evolution theory 137
biscuit x, 52, 56, 61
biscuit technology 29
Bishamondō Monzeki (Kyoto) 125
blue and white 80
blue-greenish hue 7, 19, 72
Boki Ekotoba Scroll 101–103, 105
bottle shape x, xiv, 17–18, 119, 124–125, 129, 132–133
bottle-shaped vase x, xiv, 41, 43, 86, 119, 121, 124, 126, 131–132, 143, 145, 149
branded products xiii, xvii, 42–45, 49, 54, 86–87, 89, 91, 98, 118, 138, 143
bronze *cong* ix, 41, 43
bronze hoard 34
brown-greenish glaze 7, 17
brownish hue 7
Buke (law or governing authority) 105, 124, 126
Bunrui Sōjinboku 120–121
buried artifacts 7
Butsunichian Kōmotsu Mokuroku 101–103

Byōbu (screen painting) xii, 105, 112

calcite 27–28
calcium phosphate 30, 193
carved lotus petal design xi–xii, 42, 80, 86, 88, 93, 105, 112, 132, 140
ceramic hoard ix, 34–40, 42
ceramic market 5, 37, 42, 45, 49, 68, 73, 75, 80, 82, 89, 97–98
chamber 6, 29, 35–36, 55–56, 61, 67
Charlton, H. Thomas 80
Chatian (Zhejiang) vii, 6–8, 11, 17
Chen, Wangli, 1892–1969 60
Cheng, Daya, 1134–1195 viii, 12, 17
chicken (or bird) decorative motif viii, 7, 11, 22, 29
circular handles 106
coefficient of thermal expansion (CTE) 28
commodity's information 43
components 23, 27, 82, 169, 173
Composition 23, 27–28, 30, 49, 54, 151, 153–200
cong-shaped vase ix, 41, 43, 49, 117, 119, 121, 124–125, 133
consumption pattern xviii, 33, 43–45, 89
costs 44, 73
craftsman 6, 43, 58
craze-free 18–19, 22, 28, 31, 49, 72
crystallization ix, 23, 26, 30, 155, 167, 170, 174, 176, 185, 189, 191, 197, 199
cylindrical incense burner 86, 104, 125, 130, 132

Daikōmyō-ji temple xiii, 129, 132
Daishōji Domain (Kaga-shi, Ishikawa-ken) xiii, 115, 117, 119
Date Clan 114, 125
Date, Masamune, 1567–1636 125
Dayao kiln (Zhejiang) viii, x, xiii, 13, 17, 22 23, 30, 49, 55, 57, 59–63, 65, 69, 141, 144, 151
decorative object 37, 43–44, 80, 103–104, 139, 147
demographic data 42
depressed-globe body 17
dig robbing rampancy 60
ding 42

dock site xi, 86, 92, 141
dog decorative motif viii, 7, 11, 14, 18
Domains xiii, 105–106, 115, 117, 119, 121, 124–125, 130, 135, 139, 149
Domains' prefecture sites xiii, 117
domestic market 33, 68, 89, 140
Dongxi (Sichuan) xiv, 36–38, 40, 42
Dongxi hoard site xiv, 89, 141, 145
dragon and tiger 7, 138, 147
dragon kiln 55, 57, 61
drinking tea 89, 91, 96, 98, 105, 130

early Ming-style xi, xii, 71–73, 77, 106–107, 113
early Yuan-style xi, xii, 49, 66, 71–74, 77–82, 86–87, 89–93, 97–98, 102–103, 107, 109, 117, 119, 129–135, 138, 139
eastern area x, xviii, 59–61, 63–65, 67–70
eastern Sichuan v, 19, 33–45, 74–75, 140–142, 147–148
ecological environment v, xviii, 59–70
EDS (Energy Dispersive spectroscopy) xviii, 23, 151
Eisai 96–97, 107
elite art v, xvii, 3–20, 75
elite class members xiii, xviii, 3–5, 19–21, 34, 36, 44–45, 48, 63, 73–74, 80, 82, 87–91, 96, 98–99, 101–107, 119, 121, 123–124, 126–127, 129–131, 135, 138–140, 143, 148–149
elite Longquan celadon market 43, 75, 89
Emei mountain (Sichuan) see Emeishan (Sichuan)
Emeishan (Sichuan) xiii, 19, 36–37, 141–142, 144
Emperor Huizhong see Huizhong (Emperor of China), 1082–1135
Engaku-ji (Kamakura) 89, 102
Enni 96–97
exchange value 34
export and import harbors 86

Fengdongyan kiln (Dayao, Zhejiang) xi, 66, 69–70, 107, 127
fen-qing ix, x, 18, 22, 24, 27, 29–30, 42–43, 49, 51, 54, 62, 65, 72, 77, 86, 103, 119, 147, 150
firing process 29, 47, 55–56

firing technology 21, 27, 29, 31, 47, 49, 55–57
firing temperature 29
first-generation x, 48–50, 58, 69, 105, 132
fish décor x, xii, xiv, 15, 18, 41, 43, 49, 53, 56, 68, 86, 89, 106, 114, 119, 125–126, 131, 134–135, 137–143, 145–150
fish figure 148
fish motif 148–149
Five Mountains and Ten Monasteries 107
fuel 56, 59, 63
Fujita Museum (Osaka) xiii, 127–130
Fujita, Denzaburō, 1841–1912 128, 132
Fujiwara family 107
Fuliang Ci ju (Jingdezhen, Jiangxi) 75
funerary artifact 6, 7, 138, 147
funerary rites 4, 6
funerary urn 6, 147

Gautama Buddha Hondō main hall 102
Ge ware xi, 79, 81–82
Geographic environment 60, 69
Ginkaku-ji (Jishō-ji, Kyoto) 104
glass ceramic material 28, 30
glaze hue and texture 6, 18, 29, 56, 72, 77
Gofukumachi (Fukuoka) 88
Gokushomachi site (Hakata) 88
Go-Mizunoo, Emperor of Japan, 1596–1680 125, 149
Gomotsu On'e Mokuroku 104
Gongshengrenlie Empress xiv, 143, 145
goods' concentration center 36
Go-Sai, Emperor, 1638–1685 125, 149
Gotō Shōzaburō family 107
Gotoh Museum (Tokyo) 125, 141
grand Zen temples 89, 91, 96, 98, 101, 104–105, 121, 131, 138–139
green-bluish hue 17–18, 22, 72
greenish hue 31
growth of crystallites 30, 55
Guanyin (Kannon) halls 102
gui 42

H. M. King Gustaf VI Adolf of Sweden, 1882–1973 x, 53, 56
Hagi Uragami Museum (Yamaguchi-ken) xiii, 129, 133–134

Hakata (Fukuoka-shi) xi, 86–89, 91, 96, 140
Hakata harbor city xi, 87, 92–94
Haku tenmoku 105
Hakutsuru Fine Art Museum (Kōbe-shi) 133, 141
Hara Museum of Contemporary Art (Tokyo) 126
heat treatment process 28–31, 47, 55–56
heat treatment technology 29–30, 55
Higashiyama villa (Kyoto) 104
Hirooka family 126–128
Hirooka, Kyūemon 130
hoard site x, xiv, 33–37, 42, 45, 52, 62, 65, 74, 89, 141, 145
Hōmeishu (brand name of medicinal liquor) 130
Hongan-ji monjo xii, 102, 105, 108–111
Hongan-ji temple (Kyoto) xii, 102, 105, 108–111
Hōrin Jōshō 130
Hu, Hong, 1137–1203 viii, 15, 19
Huizhong (Emperor of China), 1082–1135 5, 7
Humphries, Mark 97

Ichijōdani Asakura Family Castle Ruins (Fukui-shi) xii, 106, 113–114
Idemitsu Museum of Arts vii, xiii, 129, 133–134
Idemitsu, Sazō, 1885–1981 128, 133
ideological trend 44–45, 98
Iida City Museum (Nagano-ken) 125, 141
Iida Domain (Nagano-ken) 124–125
intensive production xviii, 61, 63, 68
Iwasaki family 127

Jian ware 86
Jiaotanxia kiln (Zhejiang) 22, 49
Jincun kilns (Zhejiang) 57, 59–63
Jingdezhen Qingbai porcelain vii, xi, 12, 35–37, 42–45, 56, 69, 75, 78, 86–87, 89, 97–98
Jininglu (Inner Mongolia) x, 49, 52
Jinyucun (Suining, Sichuan) 36

Kaga Domain xiii, 117, 119
Kakunyo, 1270–1351 102–103

Kakuon-ji (Kamakura) 89
Kamakura period 85–99, 101, 125, 138
Kamakura Shogunate 85, 88, 97, 107, 150
Kamakura town xi, 88, 95, 102
Kamei, Akinori, 1939–2015 67
Kanō, Hideyori, fl. mid-16th century 105
Kanō, Jihē, 1862–1951 132–133
Kanpūzu xii, 105, 112
Karamono 97, 101–105, 119, 121, 123–124, 126, 131–132, 138–139, 149
Katagiri, Sekishū, 1605–1673 127, 130
Kenchō-ji (Kamakura) 89–90
Kenchōji-sen ship 90
kiln 141, 142, 144
kilns' structure 55
Kinkaku-ji (Rokuon-ji, Kyoto) 104, 132
Kinshuku, Kentaku, 1580–1658 127, 130
Kinuta v, 101–122, 130, 132, 149
Kinuta flower vase 118, 130, 132
Kinuta-shaped dipper holder 132
Kitayama villa (Kyoto) 104, 132
Kōdō 134
Kong, Qi, fl. 1367 81
Konoe, Iehiro, 1667–1736 125
Kōnoike family 126–128, 131
Kōnoike, Dōoku, 1656–1736 131
Kuboso Memorial Museum of Arts, Izumi xi, xiv, 77, 125, 141, 146
Kuge 105, 124–126
Kundaikan Sōchōki 104
Kusado Sengen-chō (Fukuyama-shi, Hiroshima-ken) vii, 106, 107, 115–116
Kyoto National Museum ix, 24, 130

Lanxi Daolong, 1213–1278 97
Laohudong kiln (Hangzhou, Zhejiang) viii, 13
Lee, James R. 85
li 42
Li Hou viii, 16, 19
lide (Neo-Confucian *lixue*) 19
Linji-zen School 96
li-shaped incense burner ix, x, 40, 42, 49, 51, 86, 103, 119, 132
Lishui City Musuem (Zhejiang) viii, 16
literature and art activities 97–98, 126

Liujialing (Guiyang, Hunan) 6, 7
Liutian (Zhejiang) 60, 69
long-hu-pin vase (or jar) (dragon vase and tiger vase) vii–xiv, 6–7, 11–12, 14, 17–19, 138, 146–147
Longhushan (Guixi, Jiangxi) 7
Longquan celadon kilns 56, 59–60
Longquan Celadon Museum vii–xiv, 8, 11, 13–14, 17, 65–66, 77, 146
lotus petal design xi, 6, 40, 42, 80, 86, 88, 93, 105, 112, 132, 140
lower-belly body 17
Low-temperature firing technology 47
Lu, Rong, 1436–1494 60
Lu, Xiufu, 1237–1279 75
Lüeyang (Shaanxi) ix, 36–37, 39

Maitreya halls 102
mallet-shaped vase xiii–xiv
mallet-shaped vases with phoenix (or fish, etc.) décor vii–viii, x, xii–xiv, 15, 18, 41, 43, 49, 53, 56, 104, 114, 116, 119, 124–126, 129, 131, 133–135, 140, 142–144, 146–150
market price 34–35, 37, 44, 63
market value v, 33–45, 74, 80, 90
marketing v, xviii, 4, 33–45, 71, 97
Masaki, Takayuki, 1895–1985 127
Masuda Clan 125
materials preparation technology 27
Matsudaira, Fumai, 1751–1818 126
Matsue, Ryūsen 120
Mayuyama Ryusendō 134
Mayuyama, Matsutarō, 1882–1935 134
mechanism, commercial xviii
mechanism, cultural 121, 137, 142, 150
mechanism, evaluation 44
mechanism, market 33, 43, 48
meipin vase viii, 12, 15, 17, 19
meizi-qing ix, x, 18–19, 23–24, 27, 29, 31, 42–43, 49, 51, 72, 77, 86, 103, 119, 130, 147, 150
microstructure ix, 23, 25–28, 30, 55, 151, 153, 159, 161–167, 169–171, 173, 175–181, 184–186, 188–190, 192, 195–198, 200
migration 3, 17, 42, 119
Mitsubishi Zaibatsu 127

Mitsugusoku xii, 103, 110–111
Mitsui family 126–127
Mitsui, Takatoshi, 1622–1694 127
mizu sashi 119, 127
mullite ix, 26, 30, 55, 174, 189, 197
Muromachi period v, xviii, 98, 101–122, 125, 138, 139, 149
muscovite 28
Museum of Far Eastern Antiquities (Stockholm) xviii, 23, 151

Nanboku-chō period 101–102, 107, 132, 140
Nakamura, Kichibē, fl. 1659 127, 130
National Palace Museum ix, xi, xiii, 24, 79, 129, 141, 144
Neitzel, Jill E. 74
Neo-Confucianism 4, 19, 98
Nezu Museum (Tokyo) vii, xi, xiii–xiv, 77, 88, 93–95, 107, 117, 123–124, 129, 132, 146
Nezu, Kaichirō, 1860–1940 128, 132
Ningpo (Mingzhou ; Qingyuan) xi, 81, 86–87, 90–93, 97, 140, 141
Nishiyama Kōshōji temple (Fukui-shi) 106, 114
Nōami, 1397–1471 105
nucleation of crystallites 30

OCT (Optical coherence tomography) ix, xviii, 23–25, 27, 151
Oda, Nobunaga, 1534–1582 105
Oka, Sessai, 1763–1848 126
Okazarisho xii, 104, 112, 120
Ōnin War (1467–1477) 105
orthoclase 28
Östasiatiska museet see Museum of Far Eastern Antiquities (Stockholm)
Ōuchi Clan 125
Oujiang river 60, 63, 67
Owari Domain (Nagoya) 124–125, 149

Palace Museum xi, 79
Palmgren, Nils xviii, 22–23, 151
paper-mallet vase 104
phase structure ix, 24–25, 27, 30–31
phoenix 18
Phoenix bird 148

physical environment 60, 63, 67
popular art 4, 6, 18–20, 42
popular belief 6–7
popular ceramic 4, 19, 57–58
potassium 27–28
potassium oxide 27–28
potter xvii, 3, 5, 17–22, 27–31, 37, 42–45, 47–49, 54–59, 61, 63, 67–71, 73, 80–81, 98, 105, 138, 142
potter population 59, 63
potter training xvii, 47–49, 56–57
prefecture site xiii, 106–107, 117, 119
production scale 61, 63
pyric technology 47, 56, 58

Qingyuan (Ningpo) 19, 81, 86, 90, 139, 140
quantitative distribution 37
Quanzhou (Fujian) 86
Quanzhou gulf (Fujian) 86
quartz ix, 25, 29, 167

raw materials 22, 27, 29–31, 34–44, 54–55, 59, 63, 67–70, 73, 85
recipe 27, 30–31, 49, 54–55
Red Turban Rebellion (1351–1368) 81
reductive atmosphere 29, 31, 55
religious symbols 6–7, 147
Ren, Renfa. 81
Ren, Shilong 67
rich merchants 20, 35–36, 74, 105–107, 119, 121, 124, 126–127, 130, 135, 139
Rikka Zukan 121
ritual objects 5, 35, 42
Ru ware 17, 22, 55, 135
Ryōsen-ji Temple (Saga-ken) xii, 107, 116

Saggar x, 53, 55–56, 61–62, 67–68
Samantabhadra 19
Samantabhadra's Bodhimanda (*Daochang* 道場) 19
samurai xi, 89, 95, 105, 121, 125, 139
Sasayama Domain (Hyogo-ken) 124–125
second-generation 49, 51, 55–58
Seikado Bunko Art Museum (Tokyo) xiii, 125, 127, 129–130, 141
Sen no Rikyū, 1522–1591 125, 130

Sendai Domain (Tōhoku region) 125
Sensei (thousand voice) 124–125, 128, 149
services 44
Shantouyao kiln (Zhejiang) 59, 67
shard xviii, 22–23, 60, 62–63, 67, 119, 151
shard gatherers 22, 60
Shōfuku-ji (Fukuoka) 88, 96
Shōkoku-ji (Kyoto) 130
Shōten-ji (Fukuoka) 88, 96
Shufu yao 75
silica 27–28
Sinan (South Jeolla Province, South Korea) 86
Sinan Shipwreck 87–88, 97
Sinan wreck x–xii, 41, 48–49, 68, 78, 81, 89–90, 93, 103, 107, 109, 116, 127, 139–144
single-generation technology v, 47–58
Sōami, 1472– 1525 104–105, 120
social atmosphere v, 71–82, 122
solid texture 22, 28, 31, 49
Songyang (Zhejiang) viii, 12, 15, 17–18,
Songyang County Museum (Zhejiang) viii, x, 12, 15, 41, 141
southern area 59, 61–63, 67–70
SS intellectuals 19, 97
SSG ware xvii, 5, 17–18, 21–22, 27–31, 43–44, 47–49, 54–56, 71, 74, 81–82, 98, 135, 138
SSG-style Longquan celadon viii–xi, 3, 5, 14, 16, 18–22, 24, 28–30, 48–49, 51, 55–56, 72–75, 80–82, 85, 87–90, 92, 94, 96–99, 101, 103, 105, 119–122, 126–127, 130, 134–135, 138–140, 143, 147, 149, 150
stone *cong* ix, 41, 43
Sugawara, Tsūsai, 1894–1981 128, 133
Suichang (Zhejiang) viii, x, 13, 17, 48, 50
Suichang jars x, 48
Suining (Sichuan) ix–xi, 35–39, 42, 48
Suining City Museum ix–xi, 24, 40–41, 51, 65, 77
Suining hoard site (Sichuan) x, 47, 49, 62, 65, 89
Sumiyoshiya, Sōzaemon 120
symbolic significance 147, 149

Takenoko 121, 149
Taoism 4, 7
tea ceremony xiii, 101, 119–122, 124, 126–127, 129–135, 139, 149, 150
tea ceremony performers xiii, 101, 120, 124, 126–127, 129–131, 135, 139, 149
teaware xi, 37, 42, 63, 80, 88–89, 91, 95–96, 98, 102, 119, 131–133, 138
technological convergences 21, 30–31
technological divergences 21, 30, 49
technological generation 48
technological standardization 57
Tenmoku tea bowl 96, 105, 119
Tenryūji style 132, 139
Tenryūji-sen ship 90
testers x, 52, 55–56
third-generation x, 49, 51, 56, 58, 104, 125
tian-bai (white ware) 75
titania 31, 169, 173, 178, 188, 196
titanium oxide 30
Tokiwayama Bunko Foundation (Tokyo) xiii, 129, 133–134, 141
Tokugawa Art Museum (Nagoya-shi) xiii–xiv, 125, 129, 141, 146
Tokugawa, Iemitsu, 1604–1651 125
Tokugawa, Ieyasu, 1543–1616 125, 139
Tokugawa, Kazuko, 1607–1678 125, 149
Tokugawa, Yoshichika, 1886–1976 125
Tokugawa, Yoshinao, 1600–1650 125
Tokyo National Museum xi–xii, 77, 112
tomb artifacts 33
tomb wall paintings vii–viii, 7, 11–12
Tongan kiln (Fujian) 88
Tongan ware 88
Toyama Domain (Toyama-ken) 119
trade ceramics xvii–xviii, 33, 86–87, 106
transportation system 35, 44, 48, 59–60, 63, 75
Tsutsu 121, 127, 149

underfiring technology 29
Uragami, Toshiro, 1926– 128, 133–134

value system 33–35, 45, 48, 71, 74–75, 82, 99, 123
value-preserved commodity 34–35, 45

Victoria and Albert Museum (V&A) 18, 134–135

Waka 103
Wang, Zhijin vii, 6, 8
Watahan Nohara Collection (Iida-shi, Nagano-ken) 125
Wen ye zhen 149
Wen, Tianxiang, 1236–1283 75
Wenzhou 60
white porcelain 42, 44, 75, 80, 88
Wiessner, Polly 72
Williams, Bryn 99
wine jar vii, xi, 87, 89, 93, 98, 106, 133
worshiping artifacts 4–7
worshiping utensils 3–4, 6, 37, 80, 88–89, 98, 102–103, 107, 119, 121, 138
Wu, Ao viii, 16, 19
Wu, Sange viii, 13, 17
Wuyi (Zhejiang) viii, 7, 12
Wuyi County Museum viii, 12
Wuzhou ware 86

Xian, Yushu, 1256–1307 xi, 78, 80
Xiao Xian (Hunan) 42
Xie, Fangde, 1226–1289 75
Xie, Guoming, 1193–1252 96
Xikou kiln (Longquan, Zhejiang) x, xiii, 30, 53, 56, 59, 62–63, 141, 144
xing-cao (Chinese calligraphy) 18
Xiuneisi (Linan, Zhejiang) 22

Yanjialiang (Inner Mongolia) 49
Yanqing (Zhejiang) 60
yaren (transaction agents) 43
ying 5
Yishan Yining 97
Yomei Bunko Library (Kyoto) vii, xiii, 125, 129
Youxi (Fujian) vii, 7, 11
Yuankou kilns (Zhejiang) 59, 67
Yuanyichang (Dongxi, Sichuan) 36
Yue kiln (Zhejiang) 3
Yue ware 21, 48, 71, 86, 88
yulong (fish-dragon) 148

Zaibatsu xiii, 126–127, 129–130, 135
Zashiki living room xii, 103–104, 108, 119, 121
Zen doctrine 96
Zen monks xviii, 96–105, 121
Zen room xii, 103–104, 110–111, 121
Zen temples xviii, 80, 88–91, 96–105, 107, 121, 131, 138, 139
Zhang, Shenger 81
Zhang, Shengyi 81
Zhongba site (Zhongxian, Sichuan) 37
Zhu Zi Jia Li 4
Zhu, Xi 4, 98
zircon grains 30, 173, 183, 188, 195
Zokutōan 102